The Cartoon

THE CARTOON

A short history of graphic comedy and satire

John Geipel

Special Edition for the
Readers Union
Group of Book Clubs

DAVID & CHARLES

To my wife, Eileen

ISBN 0 7153 5328 4

*Set in 11 on 13pt Bembo
and printed in Great Britain
by Redwood Press Limited Trowbridge & London
for David & Charles (Publishers) Limited
South Devon House Newton Abbot Devon*

Contents

List of Illustrations

Charles Keene (*Punch*)
Phil May (*Punch*)
Raven Hill (*Punch*)
William Heath Robinson (*Mrs Heath Robinson/Penguin Press*)
Ronald Searle (*Ronald Searle/Weidenfeld & Nicolson*)
André François (*Punch*)
Bill Tidy (*Punch*)
Edward McLachlan's London Transport poster (*London Transport*)
Larry (*Punch*)
Vicky's studies of Bertrand Russell (*New Statesman*)
Kenneth Mahood (*Punch*)
Gerald Scarfe (*Peter Owen*)
William Charles (*Whitney Museum, New York*)
Edward Williams Clay (*Whitney Museum*)
Thomas Nast (*Witney Museum*)
Thomas Worth (*Witney Museum*)
Chip Bellew comic strip (*Witney Museum*)
Arnold Roth (*Punch*)
A Mort Drucker *Time* cover (*Mort Drucker/Time*)
A scene from one of Wllhelm Busch's 'Max and Moritz' stories (*Dover*)
Animation desk (*author*)
Walt Disney chipmunks (*Walt Disney Productions*)
Animation camera (*author*)
Still from Boris Kolar cartoon film (*Studio Vista*)
Gerard Hoffnung (*Dennis Dobson*)

Introduction

Today, when every kind of artistic ephemera is likely to be accorded the same degree of reverence and cultural significance as 'Great Art', it is inevitable that cartoons should be fair game for the cocktail party intellectual and the colour-supplement *savant*. Comic books have become a cult among a self-styled *cognoscente*, and hifalutin sociological and psychological interpretations are made of the most trivial strip cartoon. Many of these attempts to be clever about cartoons are themselves veritable caricatures of pretentious and misplaced erudition.

Most cartoonists have a healthy mistrust for those who subject their work to this kind of scrutiny; scraping to make a living in a cruelly competitive field, they have little time or inclination to examine the reasons why they depict the world and their fellow men in the way they do.

Few cartoonists, however, think of themselves simply as comedians who happen to be able to draw—many of them are singularly unhumorous individuals away from the drawing board. They do not necessarily regard their drawings merely as funny pictures, nor their trade as a facet of the entertainment industry. There is very often some underlying reason, some strong motivating factor (in addition to the pecuniary) that prompts them to put pen to paper. They may be violently opposed to, or in favour of, some political issue; have a strong desire to ridicule beaurocratic red tape; feel impelled to lampoon some idiotic aspect of social behaviour; or merely be expressing their sustained and obsessive hatred of women drivers.

Cartoons may be called the slang of graphic art. Like verbal slang, they tend to rely for their impact on spontaneity, playfulness, popular imagery and often deliberate vulgarity—devices that hardly commend them to the artistic puritan. But while no one (least of all the cartoonist himself) is likely to rate the comic strip, the caricature or the animated film as 'art' on the immortal scale, few would deny that cartoons provide a most suitable outlet for man's healthy and irresistible

urge to poke fun at his fellows, his institutions—and himself. They are a potent weapon of ridicule, ideal for deflating the pompous and the overbearing, exposing injustice and deriding hypocrisy.

In common with all forms of humorous expression, cartoons tend to have a deceptively naive—sometimes even a banal—exterior that is a mere camouflage for ideas and opinions that are not necessarily in the least flippant. It is hardly by chance that the most memorable cartoons are invariably produced during periods of social stress.

To the historian, cartoons represent a priceless primary source of information about the fleeting modes and mores of the passing generations. Indeed, so revealing are the insights which they offer into the 'unofficial' attitudes and reactions of ordinary folk that Emerson was once moved to refer to them as 'the truest history of our times'.

Although a flotsam of facetious pictures has always existed on the outer fringe of graphic art, it was not until the 1600s that such drawings began to be exploited as specific weapons of ridicule. Another two centuries were to pass before the cartoon achieved its mature form and definitive function in the hands of such practitioners as Rowlandson, Gillray, Daumier and Nast. Within the last few generations, cartoons have spilled over from the popular print and the satire sheet to infiltrate almost every facet of journalism, advertising and entertainment. Today, cartoons are so ubiquitous and their influence so pervasive that it is hard to picture life without them. As children, we avidly follow the weekly escapades of Keyhole Kate, Desperate Dan and Minnie the Minx, who have rudely jostled Tom Thumb, Alice and Cinderella out of the juvenile hagiology. As adults, we turn to the cartoon section of the newspaper for some apt graphic quip about the current social or political scene. While we may be loath to admit it, our concern with the vicissitudes of Flook, Andy Capp and Charlie Brown is often more sustained than our interest in the affairs of statesmen, footballers or pop-stars.

The Cartoon attempts to trace the evolution of this, the most forthright and colloquial form of graphic expression, from its stylistic incunabula in prehistory and antiquity, to the present day. In so doing, it places particular emphasis on the development of the idiom in Britain. Both history and geography have been especially favourable to the British cartoonist. Not only is he heir to an impressive legacy of humorous drawing that stretches back, via Ronald Searle, H. M. Batemen, Heath Robinson, Phil May, James Sullivan and John Leech, to the

great graphic wags of the Regency and Georgian periods; he also benefits from his central position in the western world, which gives him access to the pictorial satire of the continent on the one hand and North America on the other.

While France and Italy were the earliest crucibles of caricature, it was not until transplanted to Britain in the eighteenth century that the disparate roots of comic figure drawing and graphic slander coalesced into a distinctive and self-enriching minor genre. Over the past 200 years, Britain has fathered an unbroken succession of superlative cartoonists, whose highly original conceptions and bold stylistic innovations have exerted a profound influence abroad—particularly in other English-speaking countries.

Although the history of comic art on the continent, in the United States and in Australia has been exhaustively documented, the native British tradition has yet to be chronicled in its entirety. While this book makes no claim to being the definitive history of the British cartoon, it takes account of most of those who have made significant contributions to the growth of the idiom in Britain. Frequent reference, however, will be made to developments overseas, particularly where, as in the case of the comic strip and the animated film, these have had some influence on the British cartoon.

A non-technical survey that attempts to cover as extensive and relatively uncharted a field as the cartoon will perforce be somewhat superficial. All I have tried to do is to indicate the salient outlines and most significant milestones in the evolution of this minor yet most accessible subspecies of graphic art, and apologise at the outset for the many inevitable omissions and deficiencies.

John Geipel
May 1970

1 What is a cartoon?

As speakers of English, we are in the ludicrous position of having to define, whenever we want to be specific about 'cartoons', precisely what we mean by the term. The label is now applied to so many different forms of illustration that 'cartoon' has acquired an ambiguity almost as woolly as that encountered in such words as 'democracy', 'civilisation', 'race' and 'love'. Dan Dare and Donald Duck, Colonel Blimp and Captain Marvel, Garth and Barney Google are, despite their manifold differences, all subsumed under the same general rubric.

Ironically, not one of these answers to the original sense of the term 'cartoon'. Yet it is only during the past hundred years that the word has been stretched to the wide semantic horizons that it now commands. In our great-great-grandparents' day, all illustrations that made use of distortion and exaggeration for fatuous effect were known as 'caricatures', a term now reserved in English for 'antiportraits' of recognisable individuals. In most other languages, 'caricature' is still the catch-all for every form of comic or satirical graphic art. Although the distinction in English gives us the advantage of being able to discriminate between 'caricaturists' like Max Beerbohm and David Levine, and 'cartoonists' like Bill Tidy, the vast majority of comic artists could be classified under both headings.

To our pre-Victorian ancestors, the term 'cartoon' signified something entirely different—and much more specific—than it does to us today. Until the 1840s, the word still meant much the same as it had in the days of Raphael and Leonardo, that is: any line drawing used as a preliminary for a more finished work—a 'layout' in modern parlance. Its meaning had thus scarcely outgrown that of its parent, the Italian *cartone*—a large

sheet of paper. As the Italian word has also been adopted by every European language but English in the sense of 'cardboard' (cf, our 'carton'), we can understand why, when Bill Tidy was engaged, his Italian fiancée (now Mrs Tidy) thought he was in the cardboard box business.

The spectacular semantic expansion undergone by the term in English since the 1840s seems to have been initiated by an incident that took place in the year 1843. At that time, the present Houses of Parliament were nearing completion, and Prince Albert and his team of artistic advisers, wishing to revive the art of fresco painting as a means of decorating the vast wall spaces of the new building, held a competition to which artists were invited to submit their 'cartoons'—the term being used in its original sense. When a selection of these compositions was exhibited it was apparent that many of the artists were quite unused to producing work on so heroic a scale. The newly founded satirical weekly *Punch*— which, in its bantling days, was violently opposed to the royal family and to the Prince Consort in particular—seized the opportunity to ridicule the incompetent designs by commissioning John Leech to draw a selection of 'Mr Punch's cartoons'.

The term 'cartoon', formerly little used outside artistic circles, was thus introduced to the lay public in a new sense, that of satirical illustration. Soon it was being applied to any whimsical or facetious graphic comment intended as a parody or burlesque of some aspect of human behaviour.

While retaining this late nineteenth-century sense, the term 'cartoon' has continued to expand in all directions, so that it now embraces a wide variety of only loosely kindred species of popular illustration, from the para-realism of Batman and Barbarella to the geometric stylisation of the Flintstones. In fact, any illustration that makes use of such conventions as physical distortion, exaggerated facial expressions, 'speech balloons' or sequences of framed cameos is likely nowadays to be called a cartoon— whether or not it is supposed to be defamatory or humorous. The term has even been adopted in this current English sense by at least one continental language: a recent German advertisement, for example, announces

the publication of a humorous book 'mit 60 Cartoons von Dietmar Schubert'.

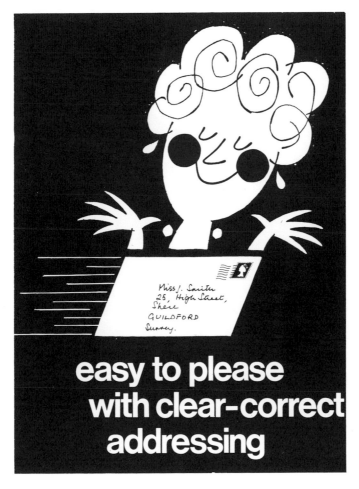

The use of the cartoon in advertising . . .

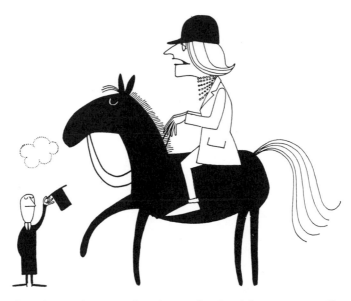

. . . and in education (Peter Kneebone drawing from 'English Pronunciation Illustrated'.)

Because of this ambiguity, it is necessary, before embarking on a survey such as this, to establish some workable distinction between those pictures to be dealt with as 'cartoons' and those which are for some reason to be disqualified and not discussed.

Drawing style is evidently of little or no value as a cartoon diagnostic. There have always been plenty of illustrators who lavish upon their humorous or satirical drawings the same meticulously academic draughtsmanship that they accord to their serious studies; and equally many sobersided artists who make use of caricature devices for strictly non-comic effect.

Even within the cartoon field itself, we are confronted by a seething and heterogeneous conglomeration of styles, and search in vain for a common denominator by which they may collectively be told apart from other forms of illustration. Cartoon styles range from the elemental,

Means Test. *James Boswell '34*

James Boswell 'Means Test'. When is a cartoon not a cartoon? Boswell is one of the many artists who have used the stylistic conventions of comic drawing to make wholly unhumorous statements.

boldly outlined kind of drawing favoured (for ease of animation) by the film cartoonist to the exquisite blend of naturalism and pixilation purveyed by Russell Brockbank and Norman Thelwell; from the insolent, slashing attack of Rushton and McLachlan to the sinuous arabesques and

smoky washes of Michael ffolkes and Roy Raymonde; from the aleatory graffiti of Larry and Lou Myers to the orgiastic frenzy of cross-hatching indulged in by Ralph Steadman, Gerald Scarfe, David Levine and their disciples, Richard Williams and Richard Smith; from the ornate grotesqueries of Arnold Roth to the linear asperity of Saul Steinberg.

Strictly speaking, there must be as many cartoon 'styles' as there are cartoonists, for no two individuals draw exactly alike. Reciprocal influences between different practitioners do, of course, take place, and often a cartoonist's nationality—even his approximate age—can be deduced, both from his stylistic mannerisms and from the flavour of his humour. We are as unlikely to mistake Chon Day, Whitney Darrow or Claude Smith for anything other than American cartoonists as we are to place Vernon Kirby or Anthony Lee Ross in the same generation as Carl Giles or David Langdon. By and large, however, it is as difficult to categorise cartoonists into groups or schools on the basis of their work as it is to pinpoint any hard and fast stylistic criterion by which 'cartoons' can be distinguished from 'non-cartoons'.

Yet surely every layman—every child of comic-reading age—is able to discriminate between the cartoon and the non-cartoon; between a picture that has been deliberately designed to make him laugh and one that has not? This is, of course, undeniable: yet style alone will not be the distinguishing mark. It is the *content* of a drawing, and by no means always its outward form, that makes it either a cartoon or not. So in the last analysis, the only true distinction between serious and comic art must lie in the attitude of the artist himself.

It is not necessary to resort to psychological gobbledegook to demonstrate that the cartoonist views life from a vastly different vantage point from that of his serious counterpart, the non-humorous artist. Where the latter is concerned with recording the more sublime aspects of his environment and his fellow creatures, the cartoonist is preoccupied with the blemishes, the shortcomings and the inconsistencies. While it is as rash to generalise about cartoonists as about any group of people, certain attitudes do seem to be endemic and well-nigh universal among the

fraternity. Most cartoonists are—to a greater or lesser degree—cynics; many are only incidentally artists; and the majority have as few illusions about the way in which they make a living as about anything else. Bill Papas of the *Guardian* believes that 'cartoonists are just parasites—they

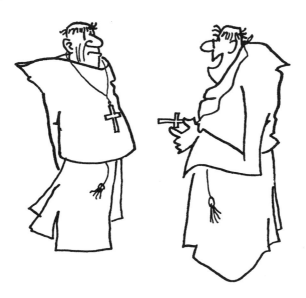

"Snap—!"

Hugh Burnett, 'Snap'. Many cartoonists draw their inspiration from a restricted range of subjects. Hugh Burnett and the Revd Graham Jeffrey (Brother Graham) concentrate on monkish themes; Rowland Emett and Rube Goldberg specialise in preposterous machines; Tony Escott, Gahan Wilson and Charles Addams are strong on ghouls, Paul White, Arthur Ferrier, Raymond Peynet and Colin Earle on girls. Clayton favours the Wild West, Joe Jonsson drunks, Gurney and Hargreaves birds, Thelwell motor cars and Brockbank riding ponies.

knock everybody else', while the *Mirror's* Stanley Franklyn sees his craft
as the mere 'extraction of bad teeth with laughing gas'.

Even if he had no skill with the pencil, the cartoonist would still take a
fundamentally sardonic view of life; and his cynicism would doubtless
find an equally satisfactory outlet in some other, non-graphic, form of
satire. It is the exceptional cartoonist, the occasional John Tenniel or
Ronald Searle, who turns from serious to whimsical illustration. Much
more often, the reverse occurs; an inveterate cynic or misanthrope will
find he has a certain aptitude for transliterating his ideas into lines on
paper, and another cartoonist is born. Frank Dickens, creator of Bristow,
epitomises this group; he does not regard himself as an artist at all, and is
frankly amused by the colossal success of his cartoons. Others, such as the
film director, Federico Fellini, and the comedian, Bob Monkhouse,
seldom exploit commercially their ability to cartoon, treating humorous
drawing merely as a sideline to their major activities.

For the particular purpose of this book, therefore, an artist will be
reckoned a cartoonist only if he uses his ability (or sometimes, as we
shall see, his apparent *in*ability) to draw as a means of making statements,
usually of a somewhat derisory nature, about the absurdities and
incongruities (real or imagined) of human behaviour. According to this
definition—which many will inevitably consider much too narrow—
artists like George du Maurier and Charles Dana Gibson qualify as
cartoonists, despite the fact that their drawing styles were strictly
'orthodox', while Chester Gould (creator of Dick Tracy) does not.
Although he makes copious use of such stock cartoon devices as distortion,
exaggeration, speech balloons and banks of framed pictures, Gould does
so in order to achieve effects and attain ends that are quite alien to the
graphic humorist.

Looking at Gibson's or du Maurier's cartoons today, we may wonder
what their contemporaries found so funny in them. Yet, however effete
their humour may seem to the modern sophisticate, it is obvious that
these two artists of a bygone generation were trying to be amusing,
whereas Chester Gould (who may look more like a conventional

cartoonist) is not. He is a superlative raconteur, an inventor of inspired fantasy, but he would not claim to be a graphic wit. Although he occasionally infuses a dash of political or social satire into his stories, Gould is a graphic narrator rather than a satirist *à outrance* in the sense of a John Kent or a Tony Rafty.

Even further outside the purview of this survey fall such adventure cartoon series as Rip Kirby, Carol Day, Modesty Blaise and all the denizens of the ambiguously named 'action', 'horror' and 'suspense' comics. Any affinity these may have with certain kinds of pictorial humour is solely stylistic—and the fact that they often appear in publications alongside comic or satirical features presupposes nothing more than typographical coincidence.

Much closer in spirit to—indeed often overlapping with—those I have chosen to call 'cartoonists' are those pictorial journalists who, from Gustave Doré to Feliks Topolski, have resorted to devices identical to those beloved of the graphic humorist. These cartoonlike effects were particularly favoured by such draughtsmen as James Boswell, Paul Sample, Franz Masereel, Karl Holtz, Käthe Kollwitz, William Gropper and other contributors (many of them occasional cartoonists themselves) to the radical and Dada journals that flourished in Europe and America from 1916 until well into the 1930s. However, while there was nothing to distinguish them stylistically from many of their full-time cartoon contemporaries, the lack of comic content in the illustrations featured by the *Left Review*, *The Bankrupt*, *Deadly Earnest* and *Every Man his own Football* means that they, like the horror comics, fall outside this survey—though only just.

Having defined the cartoon as a form of graphic jibe, we may examine a little more closely some of the techniques employed by its practitioners. Regardless of the purposes to which it is put, which may range from scorching satire to harmless persiflage, the cartoon is at base an aggressive medium, an offensive weapon whose effect can be devastating.

The defamatory personal caricature—the *portrait chargé*—is the least subtle and potentially most damaging form of cartoon; its basic techniques,

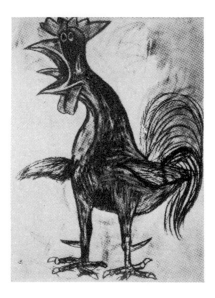

Picasso and the Children's book illustrator, Richard Scarry, have both used identical caricature devices—distortion and exaggeration—in portraying their subjects. Yet we perceive Picasso's rooster as a 'serious' work of art and Scarry's goose merely as a 'funny picture': (above) Picasso; (opposite) Scarry.

its undertow of cruelty and derision, are the very taproots of all comic art. More than merely a direct graphic assault on an individual's physiognomy, the personal caricature attempts to convey, as unambiguously as possible, whatever mental or moral attributes the cartoonist cares to attach to his victim. This sort of caricature has inherited much of the potency of the medieval effigy; it is essentially an updated version of the 'straw man', the dummy used as a surrogate target for abuse by simple folk in lieu of the feared or hated person himself. By reducing his victim to a childish scribble, or by resorting to distortion or exaggeration in order to draw our scornful attention to some pertinent physical attribute (of which we may not previously have been aware) the cartoonist shows that he has discovered just what 'makes him tick'. The portrait caricature is, in effect,

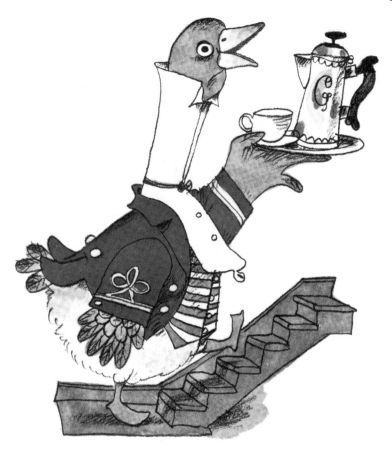

an unmasking process: the victim becomes a marionette, completely at the mercy of the cartoonist. Gerald Scarfe, perhaps the most withering of the contemporary caricaturists, has offered some illuminating remarks about his attitude whilst executing a personal caricature: he openly admits feeling an intense hatred for his subject, and adds, 'I can only express good by a comparison between evil and greater evil'. 'If Scarfe couldn't draw,' someone recently remarked, 'he'd be an assassin.'

Significantly, it is Scarfe who, with his experiments in three dimensional caricature—exemplified by his papier-maché studies of well-known victims and the Buddha-like armchair inspired by the figure of Chairman Mao—has recently brought the personal caricature round full circle to the carved effigy and the medieval gargoyle that played such an important part in its genealogy.

The fundamental kinship between the power of caricature and that of such black magic practices as hanging or otherwise abusing the effigy of an individual has frequently been alluded to by students of satire. This primitive affinity between black magic and caricature may, on occasions, become so unambiguous that it even alarms the perpetrator of the drawing himself. Michael ffolkes speaks revealingly of what seemed to him a particularly malevolent study of the actor Jeff Chandler, which he drew for *Punch*. Ffolkes' reservations about the effect of his drawing increased when, some days before that particular issue of *Punch* was released, Chandler fell ill. The artist confessed later that he was alarmed that, if Chandler had died, he, ffolkes, and his derisive cartoon might in some way be held responsible.

Although the pictorial artist was fairly tardy in realising the devastating effect that this sort of graphic 'plastic surgery' could achieve (the earliest *ritratti caricati* of individual subjects were produced no earlier than the 1600s), the technique was long anticipated in low comedy, in which selected personages were travestied by vocal imitation and mimicry of their physical characteristics. Nothing is more discomfiting to the individual than to have his voice, gestures, mannerisms and appearance aped by another, and the value of this kind of parody as a weapon against the ostentatious and the overbearing must have been appreciated very early in man's history. It is certainly a device well known to children, who employ it with crippling accuracy.

There are many examples from cartoon history of the power of personal caricature—the best known being the reaction of 'Boss' Tweed of Tammany Hall at the height of Thomas Nast's cartoon crusade against him in the 1870s. 'I don't care what they print about me,' Tweed protested,

'. . . most of my constituents can't read any way—*but them damn pictures*!'
Napoleon had much the same to say of Gillray—Hitler had David Low
short-listed for liquidation.

Occasionally, a cartoonist's burlesque of a public figure has an effect
different from the one intended. Such an instance occurred recently when
Lou Grant of the *Oakland* (California) *Tribune* emphasised the corpulence
of gubernatorial candidate, Jess Unruh. Unruh was reportedly so distressed
by Grant's representation that he went on a diet. 'I've been sorry ever
since', lamented the cartoonist, 'The new lean and hungry look makes for
a lousy caricature'.

Not only did Grant exaggerate Unruh's most salient physical char-
acteristic—his obesity—he added insult to injury by depicting him as a
Buddha. This clothing of a person in some appropriate fancy dress,
or casting him in a ridiculous role, is one of the commonest additional
devices which the cartoonist uses in order to enhance the impression of
absurdity. The fatuous appearance of the prime minister as a traffic warden
or the president of the United States as an Indian chief is guaranteed to
kindle public derision, particularly if the guise is justified by some
popularly recognised association. One of Nast's anti-Tweed cartoons
shows his arch enemy in a convict's arrowed uniform; while David Low
was wont to represent Hermann Goering as Brünhilde, an allusion both
to the marshal's bloated figure and to his effeminate mannerisms. Another
favourite caricature device—one going back beyond the graphic slanderers
of the Reformation to the medieval grotesque is the incorporation into the
victim's anatomy of some object associated with him; David Levine's
recent portrait of Sir Bernard Lovell with radio-telescopes for ears makes
use of a graphic trick that predates the caricature proper by many centuries.

Several degrees more sophisticated than the full-blown antiportrait is
the trick practised by many cartoonists of reducing a victim to a few
salient strokes of the pen. David Low, who referred to the selected earmarks
as 'tabs of identity', was a great virtuoso of this technique, and the
tradition has been perpetuated by Haro Hodson of the *Telegraph* and
Mail, 'Abu' of the *Guardian*, and a few others. The method goes back to

the infant days of caricature drawing; one of its finest exponents being
the seventeenth-century Italian artist Giovanni Lorenzo Bernini. William
Hogarth recalled seeing 'a famous caricature of a certain Italian singer that
struck me at first sight, which consisted only of a straight perpendicular
stroke with a dot over it'. It is perhaps one of the most refined forms of
graphic expression, this distillation of an entire personage into one or two
essential characteristics. A cocked hat, a hand shoved into the front of a
greatcoat and the cartoonist offers us Napoleon; an eye-patch and we have
Moyshe Dayan; three erect hairs—Bismarck. Such hieroglyphics may be
said to 'stand for' the individual as a whole; as such, they ensure not only
immediate recognition of the cartoonist's subject, but—equally impor-
tant—they conjure up a host of attributes popularly associated with the
individual. These 'tabs of identity' act, therefore, as an aphoristic symbol
encapsulating all we know and feel about the person for whom they stand.
When, for example, West German students recently added a lick of hair
and a postage-stamp moustache to a poster of Adolf von Thadden, leader
of the National Democratic Party, they were not merely implying that
he looked like Hitler—which he emphatically does not: they were
expressing in caricature terms their mistrust of the apparent 'neo-Nazi'
associations of Herr von Thadden's party.

This kind of cartoon symbolism lends itself even more easily to malicious
ends than does the elaborate portrait caricature; this is especially true of
the conventional cartoon types of certain nationalities and ethnic groups.
Like all stereotypes, the stock cartoon 'Dagos', 'Micks', 'Jocks', 'Taffs' and
'Krauts' are made up from a random aggregation of allegedly characteristic
physical traits, preselected and emphasised to imply a multitude of mental
and behavioural attributes. Bearing in mind the potency of the visual
image over most other forms of presentation, the dangers inherent in this
kind of practice must be palpably obvious; and the purpose of these
cartoon stereotypes is invariably to vilify rather than to adulate. The stock
cartoon personification of the Jew, for example—swarthy, cringing and
outrageously proboscid—occurred repeatedly in antisemitic propaganda
long before its resuscitation in Julius Streicher's infamous Nazi rag,

Der Stürmer. When lampooning their own kind, Jewish cartoonists either omit these stereotype features altogether, or, like Milt Gross, make a virtue of them. Instances of the more charitable, less destructive use of stock caricature types are much rarer in cartoon history. A memorable example was Bruce Bairnsfather's Old Bill, the apotheosis of all the sterling qualities of the long-suffering British Tommy during World War I.

Although the steps from Old Bill via Strube's Little Man to Low's Colonel Blimp may seem short, these three characters in fact represent three subtle gradations in the spectrum of cartoon personification. Old Bill was a real-life, flesh-and-blood character—one's uncle, perhaps—certainly a credible old fellow who enjoyed his pint and, after the war, would return to his allotment and his rabbits. Bill Mauldin's American equivalent, the perennial GIs, Willie and Joe are, like Alex Gurney's 'Digger' soldiers, Bluey and Curly, 'flesh and blood' characters in much the same way as was Old Bill. In Strube's Little Man, the personification becomes more diffuse; he mirrors the reactions of the man in the street, to be sure mirrors his impotence in the face of social and political machinations, yet as 'the common denominator of mankind', he has no identity himself. He is a symbol of prevailing attitudes rather than an almost tangible individual like Old Bill. Colonel Blimp's appeal was subtler still: he represented a stratum of pomposity that, while present in most of us, we recognise more readily in others than in ourselves. Low's famous character is one of the few cartoon creations to find immortality in our language—the Random House Dictionary, for example, defining a 'Colonel Blimp' as 'an elderly, pompous, British reactionary'.

These are idealised characters, created by the cartoonist to epitomise a host of abstract associations, and they are inspired by the same sort of imagery that, millenia ago, gave birth to the gods of pre-Christian Greece and Rome. These deities were not merely personifications of the various elements and natural phenomena whose names they often shared; they were themselves the actual embodiment of those elements. Rollin Kirby's

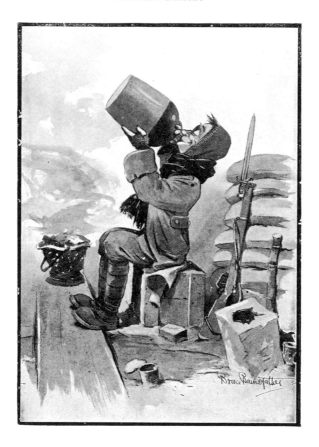

By laying bare the reality of a situation, the cartoonist can point up the irony of a complacent official pronouncement. Bruce Bairnsfather's drawing, 'The spirit of our troops is excellent' (**above**) *is from World War I; Bill Mauldin's Pullitzer Prize cartoon from* **Stars and Stripes** (**opposite**) *from World War II.*

Mr Dry was as much the embodiment of the prohibition to Americans during the 1920s as Demeter was the grain and Boreas the north wind to the men of ancient Hellas.

From the incarnation of abstract concepts in human form, it is but a short transition to their representation as non-human animal symbols, and here again there are analogies between mythology and the cartoon. To the heathen Scandinavians, the Fenris Wolf was regarded as the carnal embodiment of fire; similarly, to the twentieth-century American, the donkey and the elephant are more than merely heraldic beasts symbolising the Democratic and Republican parties. Thanks to the political cartoonists, who first devised these particular emblems, the significance of these twin beasts now runs so deep in the American imagination that it has become almost totemic. The British Lion and the Russian Bear are other well-ensconced examples from the symbolic bestiary—both began life as graphic devices in popular polemic art—although many others have proved more evanescent. When Theodore Roosevelt on one occasion pronounced himself 'as fit as a bull moose' there was a short-lived fad among political cartoonists of representing him as a moose; yet the

association was a fleeting one, the occasion was soon forgotten and the significance of this particular symbol passed into oblivion.

Graphic art in the past was invariably replete with symbolic references of this type, the works of Bosch and Brueghel being particularly rich in recondite pictorial allusions. Although serious painting in the West has, since about the seventeenth century, been gradually drained of such imagery, symbols still play a very active role in the cartoon. This copious use of figurative devices, symbolic imagery and colloquial metaphor tends to make the topical cartoon somewhat inscrutable to later generations. While we can appreciate the artistic wizardry of Rowlandson and Gillray, many of the allusions and cryptic associations with which their prints are crammed are utterly lost on even the most perspicacious social historian. Interpreting the arcane insinuations and innuendoes enshrined in the polemical pictures of a bygone age can be as frustrating as the decipherment of a rebus from some lost civilisation. 'Can it be surprising' asks Professor Ernst Gombrich, 'that both the historians and art historians have shied away from cartoons, and that such books or articles as *are* devoted to graphic journalism usually become so engrossed in the task of explanation that the medium and its history are largely unexplored?'

A certain amount of cartoon symbolism may be inspired by verbal usage—from the simple and obvious device of representing a Mr Wolf, say, as a wolf, to the graphic expression of colloquial clichés, slang and such journalistic coinages as 'rat-race', 'wage freeze', 'cliff-hanger' and 'trade gap'. Much more often, however, the cartoonist will create his own symbolism, cunningly weaving all kinds of allusions into his picture by juxtaposing and blending concepts that are physically quite incongruous yet share some subtle allegorical association. Thomas Nast again offers an example of this familiar cartoon practice with his composition 'The Priests and the Children'. This shows Catholic bishops crawling from a river labelled 'The American Ganges' towards a huddle of terrified children on a narrow beach. The children have been herded onto the beach by a group of familiar figures—Nast's arch enemy, 'Boss' Tweed of Tammany Hall and his henchmen. The villains are watching with interest

as the clerics, their heads down, their gaping mitres equipped with serried teeth, crawl out of the surf. Like all outstanding examples of graphic satire, this picture is an ingenious condensation of a whole range of unconnected associations: Nast's intransigent loathing of the Church of Rome; his revulsion against sectarianism in the public schools; and his hatred of Tammany's 'sacrifice' of children's education in favour of catholic votes.

This particular Nast drawing is one of the many examples from cartoon history of a satirical print providing subject matter for another. Soon after the publication of 'The Priests and the Children', Frederick Burr Opper, a rival cartoonist, designed a cover for the satire sheet, *Wild Oats*, in which he lampooned Nast's catholic phobia. In Opper's drawing, Nast himself is seen cringing in a corner of his studio, beset by gaping, mitre-headed serpents that make a mockery of his own brilliant visual equation between crocodiles and popish prelates. Opper's cartoon contains an even crueller and more personal graphic slight against Nast; almost identical portraits of Nast and Doré, pinned to the studio wall behind the artist, convey Opper's opinion that Nast is a plagiarist of the great French caricaturist.

Of all the characteristics of the cartoon, there is one in particular which critics of the genus are apt to cite as proof of the mediocre artistic prowess of its practitioners: the banal quality of much humorous drawing. Infuriatingly for the critic, the modern cartoonist would have no argument to make with such an indictment, for to him the makeshift, untutored-looking drawing is often a much more appropriate vehicle for a joke than is a slavishly academic piece of draughtsmanship. One of the basic pre-requisites of the comic or satirical drawing is that it should appear impulsive, spontaneous and 'dashed off', with as little evidence of cerebration as possible. Dozens of artistic ingenues, from Benjamin Franklin to Enrico Caruso, have produced superbly witty drawings whose lack of technical sophistication in no way detracted from their brilliance. Indeed, the success of such creations is largely attributable to the naiveté of their draughtsmanship.

In the cartoonist's order of priorities, it seems that artistic adroitness
has nearly always ranked several notches below the ability to put across
an idea with a minimum of effort and a maximum of comprehensibility.
William Hogarth, the 'father of English caricature', was well aware of the
appeal of the infantile doodle, and most of his successors have striven to
stamp their work with the same kind of blunt immediacy that gives the
child's drawing its impact. Rollin Kirby, one of the outstanding American
political cartoonists of the 1920s, calculated that a good cartoon consists
of 75 per cent idea and 25 per cent drawing, adding that 'a good idea has
carried many an indifferent drawing to glory, but never has a good
drawing rescued a bad idea from oblivion.' Anatol Kovarsky—famous
for his spirited *New Yorker* covers—is one of the many cartoonists who
deliberately bypass the pencil stage of a drawing, going straight into pen
and ink so as to convey as much *brio* as possible.

Such a technique, however, was by no means always permissible. From
Victorian times until the end of World War I, there was a tendency for
the satirical or humorous drawing to be as heavily documented as the
serious book illustration—as witness the elaborate cartoons of du Maurier,
Gibson, Linley Sambourne and Bernard Partridge. John Ames Mitchell, a
cartoonist and co-founder of the American satirical journal *Life*, lamented
the staidness and lack of vitality that characterised much high-class humor-
ous illustration in the late nineteenth century. 'It is a melancholy fact', he
noted, 'that the tendency of a formal artistic education is to tone down
and frequently to eliminate, in a majority of students, that playfulness and
fancy which are the very life of a drawing'. He would hardly be able to
make the same observation of today's cartoonists.

Starting in the 1920s, content began once again to triumph over form
in pictorial humour; a development that evolved alongside—and even
accelerated—the usurpation of the ponderous, word-heavy caption by the
verbally laconic, or completely wordless, joke. In their continued striving
for greater impact and directness, the cartoonists have studiously abused
the traditional canons of orthodox draughtsmanship, so that today the
most successful cartoon is invariably the graphic epigram that needs no

verbal amplification. The current ideal is that a cartoon should be not only an entirely self-sufficient graphic aphorism, but that its very appearance should be intrinsically risible. Primitive though it may be, as a drawing, the modern cartoon is incomparably wittier than most of its lumbering, detail-encrusted predecessors.

But why *should* the hasty, the unkempt and the slovenly be more effective than the painstaking and the precise in the expression of a graphic joke? One reason for the potency of the untutored doodle was suggested above in connection with portrait caricature: the reduction of the victim's features to a childish scribble is a form of denigration, a literal case of *reductio ad absurdum*. So it is with all successful pictorial comedy: the cartoonist ridicules the fads, foibles and behaviour of mankind by reducing them to a ludicrously simple formula. The stylistic affinity between this kind of cartooning and child art (frequently used as an explanation of the appeal of the cartoon) is more apparent than real, and any infant teacher will affirm that the cartoonist's methods have virtually no counterpart in genuine children's drawing. The deception that his techniques *are* identical with those of the infant, however, is deliberately used by the cartoonist to enhance the illusion of simplicity. In reality, there is nothing in the least ingenuous even in the most superficially infantile cartoon styles: the ability to reduce an intricate and bewildering aspect of the social or the political scene—the Indo-China war, say—to its basic ingredients and to express these in the simplest possible graphic terms, thereby implying that even a child can grasp the salient features of the situation, is evidence of extreme intellectual sophistication, not of naiveté. The cartoonist's use of primitive and apparently childish graphic effects in such a context cannot but accentuate the essential imbecility of the situation depicted.

It should not, of course, be assumed that, as 'even a child can scribble', anyone is capable, with the right ideas, of producing cartoons that would be acceptable to the highly discriminating art editors of *Punch* or the *New Yorker*. Whilst children's drawings *may* have an irresistible appeal, and the graffitic squiggles of the adult doodler may often be unintentionally

amusing, the depth of our reaction to them is hardly comparable to our response to a Thurber cartoon or to one of Tomi Ungerer's scrawled inanities. When the child's perspective goes haywire, we sense that something is wrong: when the cartoonist deliberately abuses the laws of perspective, or of scale, the effect is entirely appropriate. In most cases, the disarming immediacy and clumsy abruptness of much contemporary comic art is the result, not of an inability to draw, but of a systematic and fully conscious process involving the relentless manipulation of every refinement of draughtsmanship. No one can begin to perpetrate the sort of outrages that the cartoonist commits without first being wholly familiar with his idiom; and it should therefore come as no surprise to learn that even the most reckless and apparently untutored of today's cartoonists—Mel Calman, say, or John Glashan—are very often wholly competent practitioners whose artistic roots are firmly bedded in orthodox, representational draughtsmanship.

It is not, however, for their appeal alone that so many modern cartoonists resort to uncouth and infantile effects; the trend towards ever greater immediacy is also attributable to an increasingly demanding outside pressure—the very pace of modern living. In our grandparents' day, the enjoyment of a waggish or satirical illustration was a leisurely affair; a Charles Keene or a Joseph Keppler was intended to be savoured like fine brandy or a mellow cigar. Today, however, with life accelerated to fever pitch, cartoons—like every other commodity—must be designed for instant consumption. Few connoisseurs today keep folios of press cartoons to peruse at leisure, as in the days of Leech, Tenniel, Pellegrini or the Gibson girls, and modern man has little time to 'waste' interpreting a cartoon, appreciating its subtle allusions or enjoying the expertise of its draughtsmanship. His demand is for something to stab him into momentary laughter before he plunges back into the neurotic vortex of a life consecrated to those implacable gods, Time and Productivity.

By no means all cartoonists, however, employ the 'shorthand' devices discussed above: the 'epigram' label could scarcely be attached to the work of Ralph Steadman, Richard Willson or Bill Sanders. These, and a

growing number of younger cartoonists—particularly in Britain and America—are resorting more and more to elaborate forms of presentation that are often as densely textured and as conscientiously detailed as the most laborious Bernard Partridge illustration. Yet one suspects that the motives behind this sudden prodigality of detail are not at all identical with those that prompted Partridge to cover an entire sheet with a finespun reticulum of shade lines. To Partridge, as to others of his and preceding generations, these effects were used to enhance the exquisite sensitivity of the draughtsmanship; they were an obligatory veneer to an impeccable piece of realistic drawing and a final act of courtesy to the percipient. The modern cartoonist, in contrast, is likely to combine these filigree embellishments with a drawing style that is usually crude to the point of insult; one gets the impression that the feverish cross-hatching is purely gratuitous, and suspects that the artist is in some way lampooning the immaculately-documented drawing style of his grandfather's generation. Superficially, this current tendency may be a reaction against the stenographic approach that has dominated cartooning since the 1940s. Or it may be prompted by a desire to revitalise pictorial satire by harking back to the stylistic mannerisms of the great Georgian and Regency practitioners. Whatever the reason, the incongruous mélange of deliberately clumsy draughtsmanship and perfervid texturing increasingly favoured by today's avant garde cartoonists has achieved an overall effect that is not only admirably suited for satirical purposes and intrinsically witty in itself, but also has no apparent precedent in earlier comic art.

The impetus for this current tendency may, of course, have come from outside the field of humorous illustration altogether, and this brings us to a facet of the contemporary cartoon that has been frequently overlooked: the influence exerted on the genus by post-Impressionist innovations in the field of non-comic graphic art. One reason why this influence has been somewhat neglected by art historians may be its insidious nature—yet there are probably more cross-currents between the cartoon and the non-cartoon today than ever before. From Hogarth's time to Cruickshank's,

comic art still had a grotesque and uncouth quality that distinguished it immediately from all other forms of illustration. Later, with the advent of the more genteel and decorous style of cartoon drawing, as initiated in *Punch*, for example, by John Doyle and his imitators, an almost total *détente* was effected between humorous and non-humorous illustration. Only the coarser, more vernacular comic styles—exemplified by some of the pioneer strip cartoons and gutter-level satire sheets—retained any stylistic distinctiveness. Then, during World War I, the long submerged influence of caricature, with its shock effects of distortion and gross exaggeration, began to reassert itself, gradually breaking through the veneer of respectability until, by the 1930s, its tricks and clichés were dominant once again.

This recrudescence of genuine caricature effects coincided with the arrival, within the field of comic drawing, of graphic mannerisms derived from contemporary, non-humorous art. In the 1920s, the work of certain American cartoonists, most conspicuously Virgil Partch and Miguel Covarrubias, bore the unmistakable imprint of Picasso, Braque and other cubists who were themselves heavily indebted to the bold effects of African plastic art. Later, the influence of Kandinsky, Modigliani, Leger, Dubuffet and other distinctive stylists began to make itself felt in cartoon, whilst the deliberately coarse-grained quality of much post-war humorous drawing suggests more than a passing acquaintance, on the part of the cartoonists with the work of such exponents of the 'new objectivity' movement as Max Beckmann, Otto Dix and George Grosz. Many cartoonists have openly acknowledged their debt to specific artists outside their field. Saul Steinberg, for example, points to the influence of Paul Klee on his work; H. M. Bateman has mentioned his debt to Aubrey Beardsley; and if we seem occasionally to detect a hint of Rouault in the work of Anthony Lee Ross or Emanuele Luzzati, a pinch of Campigli in the cartoons of Peynet, the influence of Miro in the animated films of UPA, or a suggestion of Bernard Buffet's vigorous verticality in John Fischetti's cartoons, we may not be far off the mark.

It has seldom been possible entirely to disengage the drawing styles

favoured by the graphic humorist or satirist from those employed by the serious draughtsman. Many cartoonists are serious illustrators in their own right, while plenty of 'legitimate' artists, from Rembrandt and Goya to Picasso and John Bratby, have produced pictures that are emphatically cartoonlike in both style and spirit.

It was the late Anton Ehrenzweig who pointed out how inconceivable would be the physiognomic displacements indulged in by Frank Dickens— creator of Bristow—but for the kind of facial fragmentation pioneered in the field of serious art by Picasso. So assimilated has this device become into the modern cartoon that the homebound commuter, leafing through the *Evening Standard,* is no less disturbed by the fact that both of Bristow's eyes remain on the front plane of his face—even in profile—than by the same dislocation on the face of Picasso's 'Farmer's Wife on a Stepladder'. Nor does the Flook-addict find the malproportions, distorted perspectives and flattened elipses drawn by Trog in the least inacceptable, for this kind of graphic jiggery-pokery has been an integral part of modern art since the experiments of Braque, Gris, Léger and Picasso almost seventy years ago. Nor is the debt of the modern cartoon to contemporary 'serious' art solely one of style. The irrationality of much present day graphic humour for example, would have been unthinkable but for the outrageous and anarchic philosophy of the surrealists and their Dada precursors.

The traffic of influences between comic and non-comic art has, however, never been entirely one way—with the cartoonist invariably on the receiving end. Indeed, many of the devices characteristic of twentieth-century 'serious' art were anticipated hundreds, if not thousands, of years ago by humorous draughtsmen. Fragmentation and distortion were being perpetrated on the human face and figure by graphic satirists centuries before the cubists began to exploit the technique, and there was 'tachism' in the field of comic art long before such a designation was coined to describe a particular brand of abstract expressionist painting. Seldom, however, has the influence of the cartoon on the non-cartoon been as direct and unambiguous as in the recent field

of 'pop' art, some of whose exponents use established cartoon styles as their primary source of inspiration. Bill Copley, for example, describes his paintings as 'graphic jokes'; Philip Guston, one of the leading American abstract expressionists of the 1950s, has recently reverted to pictorial satires inspired by 'some of the comic strips I really used to love—Mutt and Jeff and Krazy Kat'; while Roy Liechtenstein, perhaps the best known of the 'pop' practitioners, specialises in titanic blow-ups of frames culled from comic strips. Peter Blake, Oyvind Fahlstrom, James Rosenquist and Eduard Paolozzi are among the many other 'pop' painters to have confessed an inspirational debt to the cartoon, while the distinction between caricature and pop painting breaks down altogether in the work of Barry Fantoni, whose cruel satires of public figures are frequently featured in *Private Eye*.

The influence of contemporary humorous drawing is also apparent in the work of such book illustrators as Ludwig Bemelmans, Tony Munzinger, Max Velthuijs, Palle Bregnhøi and Celestino Piatti on the Continent, Richard Scarry, Peter Firmin, David McKee and John Burningham in Britain, Gelett Burgess, John Huehnergarth, Maurice Sendak and Theodor Geisel (Dr Scuss) in America.

The symbiosis that has always existed between comic and serious illustration is in no small measure due to the fact that a whole string of influential artists, such as Ernst Barlach, František Kupka, Louis Corinth, Louis Marcoussis, Alexander Calder and Juan Gris, first served their apprenticeship as caricaturists or cartoonists. Lyonel Feininger began his artistic career as a cartoonist, and contributed a regular strip, which he signed 'Your Uncle Feininger', to the *Chicago Tribune*.

Multistranded though the stylistic genealogy of the modern cartoon may be, it is infinitely easier to trace its artistic pedigree than to account for its underlying appeal. A wholly satisfactory explanation of why people react in a particular way to cartoons—or to *any* form of humorous expression—would require an exhaustive discussion about what is understood (beyond mere dictionary definitions) by such concepts as 'satire', 'wit' and 'comedy', and why certain stimuli evoke, under certain

critical conditions, a laughter response.

Fortunately for the reader, I have neither the space nor the qualifications to conduct him on an intellectual safari into the jungle of psychological and philosophical speculation about such imponderables. Despite the prodigious amount of lucubration that has been devoted to the subject of humour, and the many gallons of ink that have been spilled on its behalf, no one has yet come up with a completely convincing explanation of why certain things are humorously combustible while others, differing only slightly in their ingredients, are not. Exhaustive perusal of the works of Immanuel Kant, Henri Bergson and others who have attempted to plumb the wellsprings of human merriment, leaves the layman little the wiser. Even the most distinguished practitioners of graphic humour themselves are stumped when asked to define the essence of their medium. 'The things we laugh at are awful while they are going on, but get funny when we look back', James Thurber once said: 'Humour is a kind of chaos told about calmly and quietly in retrospect'—but this is obviously far from being a satisfactory explanation.

In his brilliant monograph, 'Wit and its relationship to the unconscious', (1905) Sigmund Freud probed deeply into the psychic mechanisms under-lying man's irrepressible urge to poke fun. Freud's theory, particularly as elaborated and applied to the caricature by his disciple, Ernst Kris, made an enormous contribution to our understanding of the laughter impulse. Freud drew a clear-cut distinction between the 'harmless' joke—the spontaneous 'Scherz' (jest) produced solely for pleasure—and the calcula-ted or 'tendentious' joke—the stock-in-trade of the cynic and the satirist. This latter species of joke, the stuff of so much graphic humour, Freud saw as a means of liberating, in a socially acceptable form, primitive and aggressive impulses which, because of their obscene, hostile or otherwise 'unspeakable' nature, we should normally be at great pains to repress. Freud recognised in the mechanisms responsible for the outward expression of a joke unconscious processes analogous to those that run riot in the dream: condensation, displacement, oblique presentation, the fusing of seemingly incongruous associations and a frequent regression to infantile

or pre-logical patterns of thinking. In the sleeping state, these processes are beyond our control; the humorist, however, deliberately taps and exploits the self same mechanisms to cloak his thoughts before expressing them, often so cunningly that we fail to perceive their aggressive or indelicate content. However, the most casual perusal of the cartoon page of a newspaper, or of our favourite comic strip, with their repeated allusions to such themes as the mother-in-law, the woman driver, the patriarchal 'boss' figure, nonconformist behaviour, bureaucratic red tape and sexy girls, is sufficient to demonstrate the essentially vulgar or anti-social nature of most of the things that make us laugh, however innocuous the drawing's outward form.

An opportunity to laugh openly, without inhibitions or fear of censure, at some tabooed object or forbidden impulse—combined with the sheer intellectual pleasure derived from the appreciation of the ingenious way in which the joker has made reference to it—this, held Freud and Kris, accounts for much of the appeal of both verbal and graphic wit.

Even this explanation, however, comprehensive though it may be, is not sufficient to account for *all* the things that make us laugh. If asked to give a truly satisfactory and all-embracing definition of this, man's unique and universal birthright, we are forced to conclude, with W. C. Fields, that: 'the funniest thing about comedy is that you never know *why* people laugh. I know *what* makes them laugh, but trying to get your hands on the *why* of it is like trying to pick an eel out of a tub of water.'

2 The Prehistory of Cartoon

Considering the present ubiquity of cartoons, their prodigious efflorescence during our own lifetime, the universality of their appeal and the increasingly wide range of uses to which they are put, it is surprising to learn that they have by no means always been such an ever-present accompaniment to human activity. Comic papers, as we know them, began life less than a hundred years ago; newspapers in Britain only started to feature regular cartoons during World War I (although their genealogy in America stretches back to the 1890s); whilst animated cartoon films go back no further than the turn of the present century. Of all the many varieties of comic art, only portrait caricature and satirical illustration can boast a fairly extended pedigree, and even these can be traced, in their definitive form, no further back than 500 years at the most. Yet, despite the relatively brief lifespan of the full-blown cartoon, the seeds of the idiom, its techniques and devices, were sown at the very moment when men first began to express themselves through graphic images.

We of the late twentieth century have come to associate cartoons with a severely simplified, elliptical kind of drawing, and it is often difficult for the modern researcher wishing to unravel the tangled roots of comic art to discriminate between the artless doodling of the untutored draughtsman or the child, and the deliberate use of distortion, simplification and gracelessness for jocose effect. While such a distinction must be made, it is by no means always obvious—especially when an example of what appears to us to be humorous art comes from an early, pre-literate culture or from a

different society from our own. Any conclusions reached in the initial stages of this survey, the 'archaeological' period of cartoon history, must therefore be speculative, for an object or a drawing whose appearance impresses *us* as whimsical or entertaining need not have seemed in the least laughable to those who made it.

It is hardly conceivable that our remotest human forbears, the skin-swaddled cavemen of the Old Stone Age, were any more deficient in humour than are we. Although there is nothing, amid the plethora of Palaeolithic cave paintings that have so far come to light, that we could possibly class as a Clactonian caricature or a Solutrean strip-cartoon, there are a few hints that, even at this early, fumbling stage of man's evolution, our forebears found the antics and appearance of their own kind amusing enough to represent graphically in an unequivocally light-hearted fashion. Among the welter of masterly animal paintings, that they scratched and painted with such loving detail on the slimy walls of their subterranean art galleries, are a sprinkling of crude, cartoon-like effigies of the human face and figure that would not look in the least out of place in the *Beano* or on the centre page of *Oz*.

It would, however, be rash to claim these rude graffiti as prefigurations of the cartoon, or to jump to the conclusion that Palaeolithic man was prompted to produce them by the same desire to ridicule or make merry that motivates the modern graphic comedian. It has even been argued that the Stone Age artists, whose elegantly executed animal studies show them to have been superlative representational draughtsmen, resorted to an uncouth, cartoon-like treatment when depicting their own kind more from a sense of fear than of humour. Although we twentieth-century sophisticates can scarcely hope to be attuned to the thought processes of people removed from us by upwards of a thousand generations, it has been suggested that, by accurately portraying the human form—which he was technically quite able to do—the Stone Age artist felt that he was in some way endangering the soul or life-essence of his own species. While it was perfectly safe to make realistic representations of the beasts of the chase—indeed, he may have imagined that, in so doing, he was acquiring some

kind of mystical power over his quarry—the Palaeolithic hunter/artist assiduously avoided drawing or modelling faithful likenesses of human types from fear of exposing his subjects to supernatural and potentially harmful forces beyond his control.

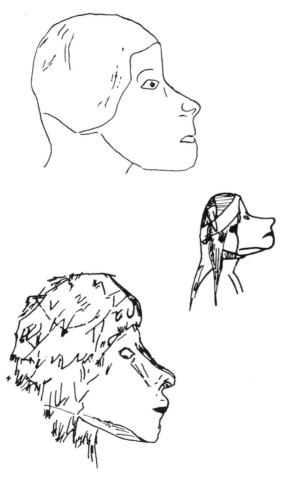

Stylised Upper Palaeolithic representations of the human face

Such a hypothesis—and that is all it is—seems even more credible in the light of the behaviour of present day primitives, whose lifeways, we infer, have much in common with those of our own ancestors in the pre-metal stage of human evolution. Such modern 'mesolithics' as the Greenland Eskimo, Kalahari Bushmen and Australian Aborigines all exhibit a reluctance to produce accurate human portraits, although, like our own Stone Age progenitors, they have proved themselves to be accomplished at making lifelike representations of other living creatures. When first encountered by Europeans, many of these latterday hunters and foragers displayed, significantly, a marked aversion to being painted or drawn, or to having their images 'captured' by the camera. To permit an outsider to make and possess a likeness of themselves was, they reasoned, tantamount to placing themselves, body and soul, in the stranger's power, and to lay themselves open to all kinds of unimaginable sorcery.

This apparent reluctance to make realistic effigies of human types seems to have been well-night universal among the men of the Stone and early Metal Ages. Prehistoric man resorted to gross caricature—sometimes laughable, more often horrendous—when representing his own kind. On the little 'Venus' figurines and other Palaeolithic human effigies, we see the proportions of limbs to trunk and of features to face exaggerated and abused; we see human heads substituted by those of alarming beasts, and faces either planed smooth of features or disfigured to the outer margin of recognition. How then did our remote ancestors dare to represent the human form at all? The answer can only be that the desire to portray their own kind was as irresistible to them as it is to us.

Is the motivation that gives rise to the portrait caricature *really* so far removed from that responsible for the Palaeolithic 'Venus' or the African devil mask? Possibly not, for while the primitive artist was, we suspect, attempting to deflect the unwanted attentions of elemental destructive forces *away* from humanity by deliberately distorting his subject's visible characteristics almost beyond recognition, the caricaturist employs the self same device to focus the equally aggressive attention of his viewers *onto* his chosen victim—be he prince, prime minister or pop star. The underlying

intentions may be diametrically opposed, yet both primitive artist and present day cartoonist resort to the same techniques of distortion and exaggeration to convey a specific—almost always a ludicrous or unfavorable—impression of their human subject to some potentially hostile outside agency—in the first case the malevolent spirits, in the second the equally vindictive public.

The theory outlined above is by no means universally accepted by anthropologists and those concerned with the psychodynamics of the creative impulse. The similarity in style and, apparently, spirit between so many of the representations of the human form found at early habitation sites, and the modern cartoon, is surely too close to be merely fortuitous, and whilst it cannot be denied that some primitive human effigies *do* have a horrific, masklike aspect which might have ritualistic or supernatural connotations, equally many seem to be the products of an unmitigated sense of the ridiculous. The Indians of the American north-west—carvers of towering totem poles—frequently turned their prodigious wood-working talents to the whittling of what can only be called personal caricatures. Some of the small carvings of the Salish tribe of British Columbia bear an almost uncanny stylistic resemblance to the little clay effigies that Daumier habitually made of his 'victims' and the more recent papier maché studies of Gerald Scarfe.

Further evidence of early man's seemingly irrepressible desire to make merry with his own kind through pictures is furnished by the art of the great Bronze Age civilisations that flourished along the valleys of the Tigris, Euphrates and Nile from c3000BC. It is customary to think of the Egyptians, for example, as a pretty staid and tight-lipped lot, cowed by their tyrannical pharaohs into a state of perpetual servility; an impression that seems to be underlined by a peremptory examination of their papyrus paintings. Human figures are represented in a highly formalised manner; their features, gestures and expressions are, although lifelike, stiffly stereotyped. Yet a closer acquaintance with these paintings reveals that the Egyptians by no means lacked a sense of irreverent fun. Not only do we find otherwise imposing personages depicted in ludicrous and undignified

situations (vomiting for example, or toppling out of boats) but we discover a whole range of animal figures (lions, wolves, jackals, hawks, vultures, goats and pigs) assuming manlike poses and performing familiar human functions in a manner that inescapably calls to mind the antics of such latterday cartoon characters as Felix the Cat, Donald Duck and Chilly Willy. However, while the temptation to see these anthropomorphic protagonists of the Egyptian 'strip cartoon' in the same light as the denizens of our own comic strips is almost irresistible, we must remember that our reaction to them is not necessarily identical to that of the audience for whom they were first intended. While they appear comic to us, their original function may have been far from humorous; they may, perhaps, be acting out some animal fable charged with all kinds of moralistic, didactic or even religious associations.

When depicting their own kind, the Egyptian artists employed techniques that were the absolute antithesis of caricature; they drew exclusively in profile, facial features were idealised (almond-eyed, straight-nosed, neatly lipped and chinned) and the only differences between individuals were those of rank—indicated by scale, costume, hairstyle and bearing. The Egyptians were also clearly fascinated by human types and their physical differences. However, while their portraits of definitive Nubian, Egyptian and European subjects are instantly recognisable for what they are, they must, despite their stylisation, be regarded as serious ethnographical observations, far removed from caricature. Only one Egyptian portrait, a representation of the heretic pharaoh Akhnaton, husband of Nefertiti and father-in-law of Tutankhamen, is notable for the distortion and exaggeration of its facial features. However, even this 3,000-year-old portrait, which looks so remarkably like a defamatory caricature (especially as we know that Akhnaton was cordially disliked by most of his contemporaries) may be no more than a fairly faithful rendition of an exceptionally ugly man. It is believed that Akhnaton may have actually encouraged his court artist to depict him in this seemingly unflattering manner and it was certainly during his reign that Egyptian figurative art in general experienced a short-lived infusion of playful graphic

effects—possibly as the result of an officially-sanctioned breaking down of the barriers between the sedate official art and a more informal folk idiom.

Passing on to the high civilisations of Greece and Rome, we know, through the comic dramas and verses of Aristophanes, Lucilius and Juvenal, that the peoples of classical antiquity were as addicted to farcical and satirical comedy as we. And there is plentiful evidence to show that they, too, frequently channelled their exhuberant sense of fun into graphic forms that closely resemble those employed by the modern cartoonist. Many of the terracotta vases of ancient Hellas, and the wall paintings and mosaics of Pompeii, Herculaneum and Rome, are decorated with burlesque figures—pot-bellied, drop-nosed and ludicrously cavorting—intended as profane parodies of the high gods of the Olympian pantheon. Stylistically, Greek vase painting went through a short 'caricature period' —marked by a free, unselfconscious and apparently skittish use of distortion—between the rigid geometricity of the archaic period and classical realism. From the Roman period comes one of the earliest examples of what appears to be a graphic satire; this is a crude caricature (now in the Collegio Romano) ridiculing Alexamenos, a Christian, who is shown at the foot of a crucifix upon which is impaled the Son of God with the head of an ass.

Although a number of such impudent graffiti survive from Roman times, including some Pompeian doodles that were evidently intended by legionaries as lampoons of their officers, images equivalent to our facetious personal caricatures seem to be totally lacking from the official art of this period. The portrait busts and paintings of distinguished dignitaries— caesars, generals, senators, philosophers and patricians—are exclusively realistic, idealised and doubtless as flattering as the modern society portrait. Only when he turned his attention to socially degraded types—to beggars, slaves, pariahs or to those afflicted with some physical malformation—was the professional draughtsman or sculptor permitted, it seems, to take outrageous and insulting liberties with the human form. While the socially exalted were immune to the ridicule of the graphic humorist, the lowly and contemptible could be travestied and held up to public derision

with a sadistic lack of humanity that is far removed from the benign badinage with which such modern misfits as the myopic Mr Magoo or the doltish Goofy are presented.

The proscription against making libellous graphic representations of individuals other than the lowlier sweepings of society seems to have extended even to the enemies of Greece and Rome. Among the seething phalanxes of warriors who mill in perpetual battle about the victory column of Trajan, even the barbarians—Dacians, Illyrians and Scyths— are noble-visaged. What modern graphic commentator would have been able to resist such an opportunity to vilify the foe by making him foul-featured in the way that Napoleon, the Nazis and, more recently the Viet Cong, have been represented in patriotic cartoons since the Reformation?

So, while there is evidence that the techniques of personal caricature were frequently exploited by the graphic satirists of antiquity, it is clear that their victims were very different from those civil, military and religious dignitaries beloved of the cartoonists of our own time.

3 Madde Desygners and Early Phizmongers

Moving forward to the European Middle Ages, we continue to encounter stylistic graphic devices apparently akin to those of later caricature, especially in the gargoyles and other grimacing quasi-human creatures with which masons and carpenters made hideous the capitals, bench-ends and obscurer nooks and crannies of their places of worship. Striking though the outward resemblances between these drolleries and the modern cartoon may be, we must be circumspect in attributing their fiendishly leering and distorted features to an identical sense of humour or even to a light-hearted fascination with the grotesque. It may be just as likely that—at any rate initially—the function of the Gothic gargoyle was to fend off unwholesome demons (many of them doubtless retained in folk-memory from pagan times), or to remind the wayward Christian of the denizens of Hell, rather than entertain. If this is so, then the gargoyle was closer in conception to the scowling dragon-prow of the Viking longship, the leering, demonic beasts of Oriental and native American tradition and the barbaric devil masks of Melanesia and the Upper Congo than to the flippant newspaper caricature. Even the boggarts, magots, hobgoblins and other nightmarish creatures that grapple together in the margins of medieval manuscripts may, despite their stylistic affinity with the creations of Arthur Rackham and Walt Disney, represent unsavoury diablotins rather than figments of a humorously fecund imagination. Yet who can say for sure?

Professor Freud and his successors have demonstrated beyond all

doubt that the wellsprings of horror and of spontaneous mirth lie buried cheek by jowl in the deepest bedrock of the human psyche, so that the selfsame stimulus to which we may, in one context, respond with terror, may, under only slightly different circumstances, cause an eruption of volcanic laughter. The method of overcoming an irrational fear by bringing the object of our terror into full consciousness and then toying with it until its alarming aspects are transmuted into those that most endear it to us is a process resorted to by men of all ages and in every society. It could well be that, by conjuring up the loathsome creatures that afflicted an imagination enflamed with thoughts of sin, guilt and divine retribution, and by giving them graphic expression, the medieval artist believed that he .was in some way performing an act akin to exorcism.

Colloquial English frankly admits the kinship between the comic and the uncanny; in everyday usage the adjective 'funny' has for so long been ambiguous that we sometimes find it necessary to distinguish between what we popularly call 'funny ha-ha' and 'funny peculiar'. The same ambivalence attaches to the German *komisch* and the French *drôle*.

Even during and after the mutation of the medieval diableris into the facetious portrait caricature (a process that took place during the sixteenth-seventeenth centuries)—the macabre graphic elements rooted in grotesque Gothic imagery suffered little dilution, and we need only turn to the creations of Roland Topor, Walter Schmögner, Gerald Scarfe, the Japanese animator Yoji Kuri—and even early Ronald Searle—to realise how strongly these frightful strains still run through the cartoon and the caricature.

Away from the fanciful graphic conceits exemplified by the gargoyle and the marginal grotesque, the medieval European artist's treatment of the human physiognomy in more realistic and conventional settings tended to be as formalised as that of his predecessors in antiquity. Features appear characterless and non-distinctive to us; poses cardboard, gestures standardised and facial expressions unmovingly deadpan. Of the hundreds of doe-eyed saints peering at us from Byzantine and later ikons, all look like brothers from the same beatific yet dull-witted family, as do the

Norman and Saxon warriors frozen in action on the Bayeaux Tapestry, and the effigies of Crusading knights and their ladies inscribed into the memorial plaques beloved of brass-rubbers.

Scholastic discipline, a carving from Sherbourne Minster

Hurdy Gurdy, from the church of St John, Cirencester

Cardinal Scipio Borghese

This is not to say that our medieval forbears were incapable of making accurate representations of individual subjects; the art of drawing, painting and modelling recognisable human likenesses has a long and distinguished history in Europe that stretches back to the portrait busts of antiquity. But what was evidently *not* attempted until a relatively advanced date was the deliberate distortion of the features of some identifiable individual in order to make him into a figure of fun.

This active desire to caricature recognisable human types for purely facetious effect seems not to have properly surfaced in Western tradition until the fifteenth and sixteenth centuries, when we find it in inchoate form, in the work of certain Netherlandish painters. Most notable in this respect were Hieronymus Bosch and Pieter Brueghel the Elder, prolific creators of hellish anthropomorphic beasts whose combination of the attributes of both the earlier medieval diablerie and the definitive portrait caricature, evoke in us an ambivalent reaction in which the impulse to laugh is restrained by more than a slight frisson of revulsion. Of the two painters, Brueghel is closer in spirit to the caricaturists proper. While Bosch's horrific repertoire of hell-fiends seems to have been dredged from

The Doctor, a sixteenth-century German woodcut

the putrescent detritus of a delirious imagination, even the worst of Brueg-
hel's ghouls are endowed with more endearingly human traits—not that
we should want to keep one in the spare bedroom. Brueghel's bucolic
villagers, romping and wenching their way across his pastoral paintings,
are surely honest, unflattering yet wholly sympathetic studies of familiar
Flemish country types, who may be all the more credible by dint of the
fact that Brueghel has emphasised their grosser, earthier aspects at the
expense of grace and finesse. One of the most significant of the early

followers of Bosch and Brueghel was the Frenchman, François Desprez, whose illustrations for 'Pantagruel' gave graphic incarnation to Rabelais' preposterous creations.

Although the advent of the jibing personal caricature was by now almost within hailing distance, the traditional employment of grotesque illustration for didactic and moralistic purposes continued to flourish and proliferate. The Reformation, dragging in its wake all manner of unspeakable bestialities, provided a rich and noisome mulch from which new, lusty and macabre forms of graphic obscenity were spawned. Illiteracy was the norm among the ignorant, superstitious and susceptible peasant masses, and Catholics and Protestants alike made copious use of crude woodcuts, disseminated in poster form, on which were congealed all the detestable iniquities attributed to the opposition. In these gauche and invariably artless forerunners of the propagandist cartoon, we see Papist, Lutheran and Calvinist alike held up to ridicule and undergoing a gamut of outrageous indignities. These abusive and often downright obscene clapperclaws appealed enormously to a primitive European population hysterical with religious mania, and their success in intensifying the already rampant hatred and mistrust was unqualified. Among the most remarkable of the graphic calumnies to emerge from the turmoil of the Reformation were those commissioned from the Cranach family by Luther himself. It is noteworthy that, even at this relatively late stage along the road towards personal caricature, the Cranachs made no attempt to distort the features of their victim—the Pope—and his cohorts. Where a later political cartoonist of rabid anti-Catholic persuasion would almost certainly have disfigured the Pope's effigy, the Cranachs portrayed His Holiness conventionally, reserving their horrific effects—and of these they had a fund—for the fiends who torment him. From the Catholic side come the near-caricatures of Calvin and other Protestants, drawn by Giuseppe Arcimbaldo, who achieved fantastic effects with his heads composed, in true surrealist style, of an agglomeration of unlikely ingredients—flowers, fruit, vegetables and other incongruous bric-a-brac. Subtler still was Schoen's print—dating from c1535—of the devil playing

Luther as a set of bagpipes, using his nose as the chanter.

It is from this period of cartoon prehistory that an ingenious graphic device, later to become one of the stock-in-trades of the caricaturists, began to be employed. This was the 'token' or 'emblem'—the *physionomie à double visage* in which a profile head was drawn in such a way that it could be upturned to reveal another—the chin of the first becoming the nose of the second, and vice versa. The first profile was invariably the recognisable likeness of some familiar personage, while his *double visage* showed him metamorphosed into a grimacing fiend that allegedly embodied his bestial attributes. A favourite emblem at this time was, of course, one showing the Pope with his counterpart, the Devil, although there were equally many invidious *double visage* representations of the Protestant luminaries. The *double visage* device has not been much exploited by cartoonists nearer our own time, although the early twentieth-century American artist, Gustave Verbeek, applied the technique to the weekly features he drew for the Sunday *New York Herald*. Verbeek designed his strips (such as 'The Upside-Downs of Little Lady Lovekins and Old Man Muffatoo') so that the reader could, by turning the page upside down, follow two totally different stories in the same sequence of frames, birds becoming boats, children flowers, and fish clouds.

It is often claimed that Leonardo da Vinci and Albrecht Dürer—both of whom lived at this time—were the earliest exponents of portrait caricature. Their tireless experiments with the uglier aspects of the human physiognomy, however, appear to have drawn more on imagination than on the observations of living subjects and it seems unlikely that their grotesques were actually based on existing individuals.

Much closer in spirit to the caricaturists proper were the studies of fruity types—drunkards, gamblers and other reprobates—produced by a growing clique of Dutch artists during the early years of the seventeenth-century. The most outstanding of these were Adriaen Brouwer, Abraham Bosse and Cornelis Dusart, whose studies of bibulous yokels, lechers, bawds and cardsharks, though not quite caricatures in the strictest sense, foreshadowed, with their attention to homely, apparently trivial detail

and obvious delight in coarse facial expressions, two of the most beloved devices of portrait caricature.

The credit for the first deliberate exploitation of the more grotesque physical attributes of recognisable human types for humorous effect must go to the brothers Carracci—Agostino and Annibale. Annibale it was who first gave the name *Caricatura* (from the verb: *caricare*=literally, 'to load' or 'surcharge'—as with exaggerated detail) to the comic drawings he made to entertain his friends. After their day's work as orthodox painters was over, the Carraccis, so their biographer, Malvasia, tells us, delighted in prowling the streets of Bologna, making—doubtless as discreetly as they could—trenchant caricatures of any passer-by whose cast of feature caught their fancy. It can scarcely be doubted that the Carraccis were familiar with, and probably to some extent influenced by, the theories of their contemporary, Giovanni Battista Della Porta, whose book, *On the Human Physiognomy*, illustrated with woodcut drawings the startling similarity that can so often be described between certain human types and their animal counterparts. It is to Annibale Carracci that we owe our earliest definition of the caricaturist's aims: 'Is not the task of the Caricaturist exactly the same as that of the classical Artist? Both see the lasting truth behind the surface of mere outward appearance. Both try to help Nature accomplish its plan. The one may strive to visualize the perfect form and to realise it in his work, the other to grasp the perfect deformity, and thus reveal the very essence of a personality. A good caricature, like every work of art, is more true to life than reality itself.'

The term 'caricature' was carried to France in 1665 by Giovanni Lorenzo Bernini, the Italian painter, sculptor and architect whose influence as a proto-cartoonist is frequently glossed over. Bernini's caricatures were the first of individuals whose names are known to us; although many other seventeenth-century Italian artists, Domenichino, Guernico, Mola, Maratti, have left sketchbooks and folios of facetious portraits of anonymous victims. Bernini's facile technique and disarming simplicity, and the drastic economy of line into which he distilled the essence of his subject's physiognomy, have scarcely been equalled by any subsequent cartoonist.

Even before Bernini's arrival in France, Jacques Callot—who could conjure up graphic ghouls as diabolical as any of Brueghel's—had been making satirical studies of types from all levels of Parisian society, from tramps, gypsies and beggars to foppish aristocrats. However, whilst he, Bernini and the Carraccis were all part-time caricaturists—serious artists who indulged in humorous drawing merely for relaxation—Pier Leone Ghezzi appears to have been the first to make a living exclusively from caricaturing. Until his death, Ghezzi was in constant demand for his satirical portraits of Roman worthies, art lovers and foreign tourists visiting Italy. No one (at least among the more enlightened strata of society) seemed to take exception to having their physical characteristics distorted and made ludicrous on paper—provided that the drawings were not made public. Indeed, thanks to Ghezzi and his imitators, caricature was rapidly becoming a fashionable fad in late eighteenth-century Italy and France. When the vogue reached England, with prints by Ghezzi and others, it was pounced upon with relish and its devices exploited by many artists, including the young Joshua Reynolds, who made use of Ghezzian mannerisms in 'Conversation Pieces' featuring groups of his friends.

In Britain, graphic techniques akin to caricature had first been put to political use at the time of the Great Rebellion of the 1640s, and cartoon-like polemic prints continued to flourish through the succeeding years of the Commonwealth, Protectorate and the restoration of the monarchy with Charles II. Among the favourite targets of the earliest polemic prints were the Long Parliament, the alleged encouragement by Charles I and his Queen, Henrietta Maria, of popish activities, illegal taxation and the unpopularity of the King's advisers. Despite their banality and often execrable standard of execution, many of the so-called 'Madde Desygnes' that have survived from this turbulent period have a raw and pungent wit that almost equals that of Gillray's defamatory political cartoons, and there is little doubt that their appeal to a largely illiterate public was enormous.

Later in the same century, the production of propagandist prints in Britain experienced a further shot in the arm when the works of Romeyn de Hooghe, an unremitting graphic pornographer, and other Dutch

artists in his circle—all of whom aimed their bolts at the absolutism and influence of Louis XIV—were imported to London in large quantities. Where the truckling, sycophantic artists of Louis' court would represent their patron in all his splendour, de Hooghe and his colleagues portrayed him in undignified and ludicrous situations. Even so, their obloquy fell short of actual portrait caricature and, like the Cranach's effigies of the pope, the visage of *le Roi Soleil* remained impassive while all about him swarmed the trappings of derision. These vitriolic graphic slanders were published intermittently in pamphlets (already known as broadsides) on a serial basis—much like the editorial cartoons of today's newspapers— and enjoyed an unalloyed success on the Continent and in Britain. In London, they provided a catalyst for a gaggle of aspiring graphic journalists, who found easy victims in the detested Hanoverian Kings and in the London dandies and socialites, whose affectations they remorselessly lampooned.

Although the rage for caricature spread like an epidemic through fashionable London, it had not yet struck deep root in British soil and its origin as a lately imported continental fad were still acknowledged. 'Young man', said the Duchess of Marlborough to Bubb Doddington (later Baron Melcombe) in 1710, 'You come from Italy. They tell me of a new invention there called Caricatura drawing. Can you tell me someone that will draw me a caricature of Lady Masham, describing her covered with running sores and ulcers, that I might send to the Queen to give her a slight idea of her favourite?'

Ten years later, the climate had grown even more propitious for the satirical artist. By the 1720s, satire had attained the stature of a minor literary genre in the hands of Pope, Swift, Gay and Fielding, so that the public were already predisposed towards all species of facetiae—graphic or otherwise.

4 The Cartoon Comes of Age

The new genus received a further boost in London with Arthur Pond's publication, in 1740, of an album of twenty-five *Caricaturas*—including prints after Ghezzi, the Carraccis, 'Guernico' (G. F. Barbieri), Pierfrancesco Mola, Raymond la Fage and other founder fathers of the style. These were enormously popular and soon a number of English illustrators, most significantly William Hogarth, were beginning to employ the devices of caricature—monstrous distortion and gross exaggeration—in their graphic observations of the political and social scene.

Hogarth had been fascinated by drawing since his early childhood, and had served as an apprentice to an engraver who specialised in inscribing heraldic arms onto silver plate. The workshop was near Leicester Fields in London, and it was in this neighbourhood that the young Hogarth came into contact with the immigrant Huguenot community who had fled France to escape persecution at the hands of Louis XIV. The prints that these exiles smuggled over from France fired Hogarth's enthusiasm for satirical illustration. Shortly after his father's death in 1720, and with his interest in heraldry ebbing fast, he set himself up in business as an engraver on copper. Although the bulk of his early output in this capacity consisted of shopbills, he also began to illustrate books, and continued to indulge his inclination for making satirical drawings that ridiculed the fashions of the day. His first series in this genre, 'Masquerades and Operas', was published in 1724, when he was twenty-two. Although his first attempts to establish himself as a satirical illustrator on a commercial basis met with only fleeting

success, his worth was immediately recognised by lesser talents in the field, and his style began to be plagiarised from the outset. Hogarth studied figure drawing early in his career, but he very soon reached the conclusion that mere slavish copying from life was of limited value as a drawing exercise, and he began to rely increasingly on his own method of training

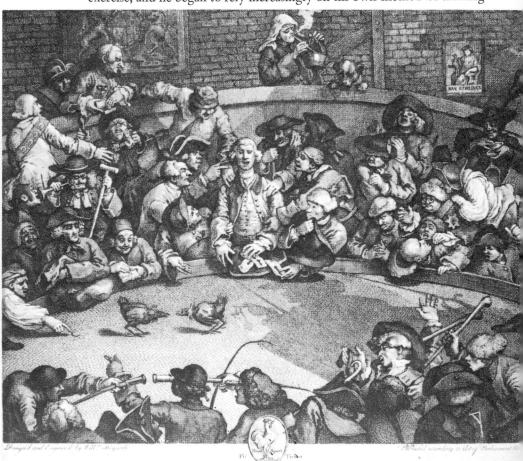

'The Cockpit' by William Hogarth

memory and eye by close observation of persons and scenes—a faculty
that he refined to such a degree that he was eventually able to reproduce
the characteristics of his subjects in their absence.

After eloping with Mistress Jane Thornhill, Hogarth was forced to
support himself and his wife by serious painting, and he made a reasonable
living with his small portrait groups of London worthies, their families
and retinues. Graphic satire, however, continued to hold him in thrall,
and in 1731 he completed the series of six pictures entitled 'A Harlot's
Progress'; its intent was moralistic rather than strictly entertaining, for
Hogarth was appalled both by the moral corruption that was rife through-
out eighteenth-century high society, and by the abysmal conditions under
which the London slum-dwellers were forced to live. Although Hogarth's
prime intention was to draw attention to both these evils, the great
success of his prints was undoubtedly due to their rich comic content
rather than to their exposure of iniquities. Not that Hogarth's intentions
were solely moralistic; many of his prints, such as 'Southwark Fair', 'The
Distressed Poet', 'A Midnight Modern Conversation' and 'Strolling
Actresses dressing in a Barn', with their wealth of sharply observed and
deftly executed detail, were produced for sheer entertainment. Hogarth
was no respecter of rank, and the victims of his predatory pen were drawn
from every stratum of society. Despite the indisputable fact that his style
owed so much to the devices of caricature, Hogarth himself denied any
such connection. The sole preoccupation of the exponents of 'that
modern fashion, Caricature', was, as he saw it, to make clever juxta-
positions of incongruous objects, whereas *his* intention was to reveal the
characters of his subjects through their facial expressions.

Nevertheless, his influence on the subsequent development of caricature
was profound and indelible; the new style, which, when it first reached
England, some seventy years before Hogarth attained the zenith of his
power, had been little more than a sophisticated fad, matured, in his
hands, into a valid graphic form worthy to take its place in the fabric of
western representational art.

In 1734, Jane Hogarth's father, Sir James Thornhill, died, and left the

free art school in St Martin's Lane, which he had founded some ten years previously, to his son-in-law. Ambitious to succeed in the most profitable branch of his profession, Hogarth painted a number of portraits during the next few years. Yet, despite his proven ability as a portrait painter, his reputation as a satirist dogged him; people were wary of sitting for him for fear of having their likenesses portrayed unflatteringly or even insultingly and Hogarth did not meet with the success for which he had hoped. He did, however, manage to make enough money to enable him to pursue his own first love of satirical illustration and, during the late 1740s and early 1750s, produced a number of masterly suites of pictures, all of them intended to reform rather than to amuse. The best known series were: 'Marriage à la Mode'—six plates depicting the disastrous chain of events following on a marriage of convenience; 'Industry and Idleness'— a series of didactic prints; and the vulgar 'Beer Street', 'Gin Lane' and 'The Four Stages of Cruelty', in which the activities of urban man are unmasked in all their repugnant animality.

Hogarth was by no means a popular figure in his own time. His habit of making disparaging remarks about all artists but himself made him the target of malicious and blatantly jealous cartoonists ('the whole nest of Phiz-mongers', as he called them), and he was lampooned without mercy; especially after his appointment in 1757 to the Office of Sergeant-Painter of All His Majesty's Works—'The King's Chief Panel Painter', jeered his enemies. Hogarth's relationship with his ever-growing number of opponents degenerated still further after he had crossed swords with his former associate, the influential John Wilkes. Retaliating to Wilkes' venomous attack on his personal life and professional career in the *North Briton*, Hogarth published his famous caricature of Wilkes. This calumny was countered in its turn by an invective poem entitled 'An Epistle to William Hogarth', by Wilkes' colleague, Charles Churchill, who shortly afterwards found himself represented as a hideous bear in Hogarth's cartoon riposte. Towards the end of his life, the attacks on Hogarth intensified from every quarter; his works were cruelly parodied and his personal appearance and behaviour castigated in a number of deprecatory prints in which his name

was crudely punned as 'Hoggart', 'O'Garth' and 'Hog-arse'. It is hardly surprising that when Hogarth died, in October 1764, he was broken, embittered and utterly disillusioned.

Among Hogarth's most distinguished successors was Thomas Rowlandson (1756–1827), whose penchant for caricature first became apparent

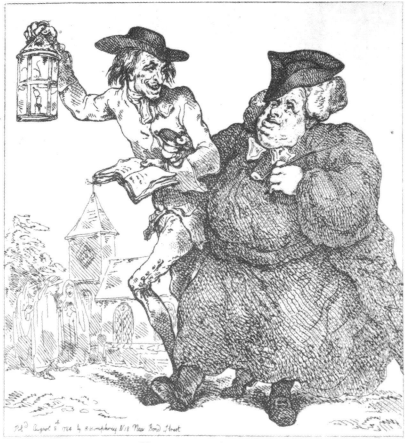

VICAR and MOSES.

'The Vicar and Moses' by Thomas Rowlandson

during his school days, when he covered the margins of his exercise books with acutely observed studies of his teachers and fellow pupils. Even at this early age, Rowlandson's impressive talent was evident, and at fifteen he was admitted to the newly founded Royal Academy School. However his career as a London art student was not outstanding, and he eagerly accepted the invitation of an aunt to go and live in Paris, where he not only applied himself diligently to his serious studies but also continued to refine his skill as a caricaturist, executing a number of devastating studies of Parisian types. While he was still in Paris, his aunt died, leaving him a fortune of £7,000 in cash and a treasure trove of valuable objets d'art.

Rowlandson proceeded to dissipate this windfall, throwing himself into a vortex of riotous living. His fortune gambled away, Rowlandson returned to London to renew his studies at the Royal Academy, supporting himself the while by publishing the first of the caricatures that were shortly to win him renown. Commissioned to illustrate the novels of those three masters of the literary caricature—Fielding, Smollet and Sterne —Rowlandson provided plates that were wholly appropriate and in 1812 introduced the first series of illustrated escapades featuring Doctor Syntax, the first regular cartoon character. The hugely successful *Tour of Dr. Syntax in search of the Picturesque* was followed in 1820 by *Dr. Syntax in search of Consolation* and in 1821 by *The Third Tour of Dr. Syntax in search of a Wife*. Although 'speech balloons' and horizontal banks of framed pictures had been employed in popular prints and flysheets as early as the 1400s, Rowlandson was the first continuously and systematically to exploit these two stock conventions of the strip cartoon. An incorrigible spendthrift to the end, Rowlandson died in near penury in 1827.

While Hogarth and Rowlandson dominated the formative years of graphic comedy in England, the names of Sandby, Collet, Sayer, Bunbury and Woodward must be singled out from the mass of lesser exponents as worthy of mention. Paul Sandby, better known as a topographical draughtsman than as a caricaturist, was one of the most remorseless of the many graphic satirists who had shied their caustic squibs at Hogarth. John

Collett, a disciple of Hogarth, produced a prodigious number of engrav-
ings, the best of which are his small-scale cameo comments on the social
vanities of the beaumonde. James Sayer was a political cartoonist par
excellence; an attorney by profession, he had little time for the law and
his considerable talent for satirical caricature was soon recognised and
exploited by his friend, William Pitt the Younger, who, in his aspirant
days, used Sayer's vituperative pen in his campaign against the Rocking-
ham Ministry. Sayer was thus among the first of the cartoonists to sell his
services—in the manner of a hired gun in the old Wild West—to promote
the cause of an influential patron.

The patrician social background of Henry William Bunbury was very
different from that of most of his fellow caricaturists. A zealous comic artist
with a bold and spirited style, Bunbury specialised in pointing up the
more ludicrous aspects of social life and was particularly adroit at guying
incompetent equestrianism—as in his celebrated series, 'Geoffrey
Gambado's Horsemanship'. G. M. Woodward was another noteworthy
practitioner of the burgeoning art of graphic satire; like Bunbury, he con-
centrated on parodies of social mannerisms, and many of his ingenious
designs were engraved by Rowlandson, who, inevitably, imprinted his
own distinctive style upon them. Among the host of occasional cartoonists
who operated during the closing decades of the eighteenth century were
John Boyne, William Dent, Richard Newton, John Nixon, James Hook,
the Rev John Sneyd and Lt Col Thomas Braddyll—the last two of whom
frequently supplied their colleague, Gillray, with designs. Away from
London, caricature was already firmly rooted in certain provincial
cities, and it was in Edinburgh that a former barber, John Kaye, built up
an impressive local reputation as a portrait caricaturist with a prodigious
output of etchings.

By now, caricature, no longer an ephemeral fad, had struck deep root
in English soil; it had, indeed, become so commonplace that the *Morning
Chronicle* of 1 August 1796, was moved to observe that 'the taste of the
day leans entirely to caricature. We have lost our relish for the simple
beauties of nature . . . we are no longer satisfied with propriety and neat-

ness, we must have something grotesque and disproportioned, cumbrous with ornament and gigantic in its dimensions.'

A cartoonist need not, as we have observed elsewhere, be an accomplished draughtsman in order to succeed in his field, and among the shoal of amateur graphic humorists that tumbled in the wake of Hogarth and his great successors—Rowlandson, Gillray and Cruikshank—were many dilletante caricaturists whose drawings, though inferior in quality to those of the masters, are nevertheless of intrinsic interest for the vivid insights they offer us into the social foibles and political machinations of Georgian and Regency England. Typical of these part-time 'Phiz-mongers' was George (later Marquess) Townshend, whose graphic raileries against Hogarth had been among the most scathing. Townshend's 'remarkable gift for buffoonery', as Horace Walpole described it, produced a series of devastatingly witty—if crudely executed—graphic slanders against his political opponents; these were drawn both for private circulation and for publication in such ephemeral gossip-sheets as *The Political Register*, *The London Magazine* and *The Town and Country Magazine*, that flourished in such profusion during the closing years of the eighteenth century.

Indisputably the most outstanding of the graphic commentators of Georgian England was James Gillray, whose position as the grand patriarch of political caricature in Britain has yet to be challenged. Gillray began his artistic career as an apprentice letter-engraver, a craft at which he became adept and which stood him in excellent stead when he later decided to follow his natural inclination for satirical illustration. The conventional image of Gillray, which has him as a bibulous old reprobate, is evidently misleading; Gillray was brought up in a strict and pious Moravian household and, while his political caricatures seethe with pungent invective, he was retiring and unobtrusive in his personal life. To those who knew him he was a 'thin, dry, bespectacled man' and the popular story of his breaking his apprenticeship to join a company of strolling players may well be apocryphal. Soon tiring of letter-engraving, Gillray was admitted to the Royal Academy and supported himself during his student years by engraving and perhaps, by issuing a number of

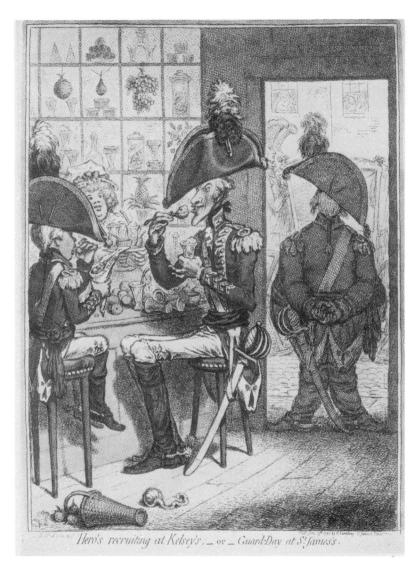

Hero's recruiting at Kelsey's, — or — Guard-Day at St. James's.

'*Heroes recruiting at Kelsey's*' by James Gillray

caricatures under fictitious names—although the first of these known for certain to be his—'Paddy on Horseback'—dates from as late as 1779, when Gillray was twenty-two. The first of his memorable series of political cartoons were the two published in 1782 on Rodney's Naval Victory over the French in the Caribbean.

Gillray's enthusiasm for satirical caricature was very possibly ignited by his acquaintance with the *Portraits Chargés* of Robert Dighton and his imitators, which enjoyed great popularity among afficionados at the fag-end of the eighteenth century. Dighton was a direct stylistic descendant of Ghezzi, whose cartoons were familiar to him through the reproductions disseminated by Arthur Pond and other print-publishers, so that Gillray's artistic genealogy may truly be said to link him with the founder fathers of caricature.

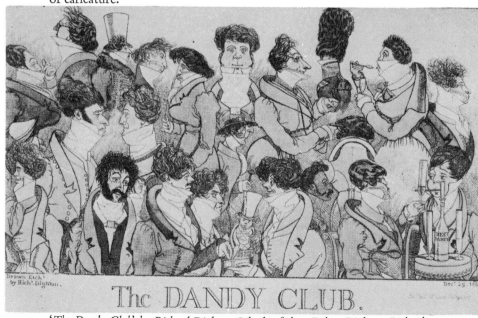

'The Dandy Club' by Richard Dighton. Like his father, Robert Dighton, Richard was one of the many early nineteenth-century British artists specialising in facetious graphic satires and portrait caricatures.

Gillray lodged, for almost the whole of his career, with his publisher and print seller, Mrs. Humphrey, who exhibited his plates in her shop windows in Bond Street and St James Street. A violent opponent of George III, many of Gillray's bitterest and choicest satires featured the King as 'Farmer George'. The King's remark, on being shown a set of Gillray drawings—'I do not understand these caricatures'—stung the artist into producing his libellous study of 'A Connoisseur examining a Cooper', (ie: a miniature by Samuel Cooper), in which the King's pretentions to knowledge of art and his parsimonious habits are cruelly ridiculed. Other graphic slights against the royal family were his two satires of 'Farmer George and his Wife'—one showing the King toasting muffins for breakfast, the other depicting the Queen frying sprats—and, 'The Anti-Saccharites', in which the royal pair propose—to the horror of the family—to dispense with sugar. So prolific was Gillray's output during the opening decade of the nineteenth century, that his works can be regarded as a critical graphic narrative of the latter part of the reign of George III—indeed, they were used for this purpose by Thomas Wright in his *Caricature History* of George III in 1851.

The French Revolution sickened Gillray, and turned him into both conservative and intransigent Francophobe; and he issued a deluge of cartoons vilifying France and Napoleon, and glorifying John Bull. Among the most celebrated of his prints on the subject of the Revolution is 'The Apotheosis of Hoche', in which he condensed all the monstrous excesses of the uprising; whilst 'A Family of Sans Culottes Refreshing after the Fatigues of the day', which takes the form of a grisly cannibal feast, is even more repugnant. Although Gillray had his counterparts in France, not even the best of them—Philibert Louis Debucourt, Carle Vernet, Louis Leopold Boilly and Jean Baptiste Isabey—could approach the English avatar for sheer unbridled contumely.

Gillray's pungent satire was by no means reserved for the French, and his caustic graphic comments were turned with equal venom on such prominent British politicians as Fox, Burke and Pitt—all of whom he scandalously caricatured. One print, published on the day that war was

declared on Napoleon, shows Prime Minister Addington, dressed as an
infantryman, defiantly facing his antagonist across the Channel. 'Who's
afraid, damme?' he expostulates, while admitting to himself 'Oh Lord,
Oh Lord, what a Fiery Fellow he is. Oh dear, what shall become of ye
Roast Beef?' while a belligerent Boney is seen muttering 'Ah Ha—Sacré
Dieu! Vat do I see yonder? Dat look so invitingly Red and de Vite?
Oh, by Gar! I see 'tis de Roast Beef of Londres, vich I vill chop up, at
von letel bite!' Another, entitled 'Blood on Thunder fording the Red
Sea', represents Chancellor Thurlow carrying a complacent, lucre-laden
Warren Hastings through a sea of gore, whilst another, etched in the
same year of 1788, is 'Market Day', showing the ministerialists of the
time as horned cattle being offered for sale.

Among the many prints that he drew satirising the Peace of Amiens
(the 'Peace all men are glad of, but no man can be proud of'—as Sheridan
described it), the most memorable was: 'The First Kiss these Ten Years',
featuring a sinister-looking Citizen François, who is bestowing a sly buss
on the lips of a buxom Britannia. 'Madame', says the embodiment of
Gallic rascality, 'Permittez me to pay my profound esteem to your
engaging person and to seal on your divine Lips my everlasting attach-
ment,' to which Britannia retorts: 'Monsieur, you are truly a well-bred
Gentleman, and tho' you make me blush, yet you kiss so delicately that
I cannot refuse you, tho I was sure you would Deceive me again . . .'
Even Napoleon, it is said, was unable to stifle his amusement when shown
this particular cartoon.

While working on the last of his prints, 'Interior of a Barber Shop in
Assize Time' (1811), Gillray became insane. In August of that year, the
Examiner reported that 'On Wednesday afternoon Mr Gillray, the
Caricaturist who resides at Mrs Humphrey's, the caricature shop in St
James' Street, attempted to throw himself out of the window of the attic
story. There being iron bars his head got jammed and being perceived
by one of the chairmen who attends at White's and who instantly went
up to give assistance, the unfortunate man was extricated, and proper
persons appointed to take care of him.' Despite occasional flashes of

sanity, Gillray's condition was exacerbated by his by this time intemperate habits, and he died two years later. His influence on subsequent cartoonists was enormous and although his rumbustuous and full-blooded approach was eclipsed for over a century by more reticent styles of satirical illustration, it has lately begun to make itself felt again in the work of such modern cartoonists as Ralph Steadman and Gerald Scarfe.

It was in 1788, when Gillray was at the height of his power, that the antiquarian, Francis Grose, published his pamphlet *Rules for drawing caricatures*. Although several others before him had published their theories about caricaturing (a notable predecessor had been Charles le Brun, whose *Méthode pour apprendre à dessiner les passions* had come out a century before Grose's brochure) Grose made a number of singularly penetrating observations about the techniques and effects of comic facial distortion as practised by the caricaturists. Particularly perceptive was his remark that we in the West are conditioned to experience as 'beautiful' only those representations of the human physiognomy that conform to the canons of Greek art, which are, by definition, 'expressionless'. As soon as the element of facial expression is introduced, this ideal is shattered; the subject becomes humanised, entirely credible and is thus no longer aesthetically sublime.

The most outstanding of Gillray's immediate successors was George Cruikshank, who had known the great caricaturist and inherited not only his work table but also much of his artistic gusto. The son of Isaac Cruikshank, himself a distinguished political cartoonist, George was one of the most prolific satirical draughtsmen of the last century, and spread his prodigious talent across the entire field of humorous illustration.

A vast number of his spirited drawings were published as separate caricatures—each one tinted by hand, whilst others formed series or were submitted to such journals as *The Satirist, Town Talk, The Scourge* and other scurrilous publications that led an ephemeral existence during the first two decades of the nineteenth century. Among the most widely acclaimed of his collections of drawings lampooning the political figures of his day were those published under the title: 'The Political House that

Jack Built', which he produced with the pamphleteer, William Hone, in 1819. Pamphlets such as these, which sold for a shilling and were the first publications to weld the talents of the political cartoonist to those of the verbal propagandist, were the direct precursors of Philipon's Parisian journals (see below) and, in England, of *Punch*. Before the appearance of Hone's periodicals, cartoons were obtainable only as single sheet illustrations or in serial folios, which were displayed and sold in the dozens of London 'print shops', such as Mr. Humphrey's, Ackermann's, Forest's and McLean's. A selection of Hone's pamphlets—complete with Cruikshank's drawings—has recently been reprinted by Messrs Adams & Dart under the title *Radical Squibs and Loyal Ripostes* (1971).

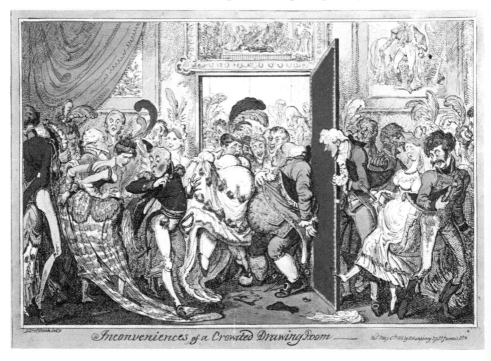

'Inconveniences of a crowded drawing room' by George Cruickshank

In contrast to the reputedly profligate Gillray, Cruikshank was a life-long advocate of abstinence, and his attitude is reflected in the three series of plates entitled 'The Bottle', 'The Drunkard's Children' and 'The Worship of Bacchus'. In a more genial vein were the masterly illustrations etched for such publications as *The Humorist* (1821), *Life in Paris* and its successor, *Life in London*. It was in this latter anthology that George and his brother, Robert, appear as the original 'Tom and Jerry', although 'Jerry Hawthorne, Esquire, and his elegant friend, Corinthian Tom' had nothing in common with the latterday cat-and-mouse duo of cartoon film fame.

During the early 1820s, Cruikshank produced twenty-two sympathetic and wholly characteristic illustrations for the first English edition of Grimm's *Fairy Tales*, and these were followed by a steady stream of etchings for, among others, the first fourteen volumes of *Bentley's Miscellany*; the first six volumes of W. Harrison Ainsworth's magazine, which flourished during the early forties; for C. Lever's *Arthur O'Leary* (1844) and for Maxwell's *History of the Irish Rebellion of 1798* (1845). In 1841 appeared the first anthology devoted entirely to his work, *George Cruikshank's Omnibus*, and this was followed, in 1845, by *George Cruikshank's Table Book*. Among the best known of his later productions are the twenty full-page illustrations drawn for *The Life of Sir John Falstaff*, which he completed in 1858.

The death of James Gillray in 1815 marks the end of the 'Old Testament' era of English satirical illustrations, and, while Gillray's imitators and disciples—such as William Heath—continued to produce coloured etchings in his spirit of uninhibited gusto until well into the 1820s, the savage Georgian tradition of graphic satire was already beginning to recede in favour of a more genteel approach to political cartooning. The new style was given its initial boost by the restrained and decorous lithographs of John Doyle—or H.B., as he preferred to style himself. Compared with the rollicking vulgarity of the old Georgian and Regency etchings, Doyle's illustrations seem positively effete, yet his discreet approach was widely imitated from the start. Political cartooning was destined to be

marked, throughout the long reign of Victoria, by reticence, tactfulness and good taste. This transmutation of the cartoon from an offensive weapon to a vehicle for jocose but well-mannered comment is almost entirely attributable to Doyle's influence.

During the third decade of the last century, the cartoon centre of gravity shifted from England to France, an event heralded, in 1830, by the founding by the journalist and cartoonist, Charles Philipon, of a weekly magazine, *La Caricature*, which carried illustrations by some of the most distinguished graphic satirists of the day. Gustave Doré, Jean Ignace Isidore Gerrard, Paul Garvarni, Henri Monnier, August Raffet, Charles Joseph Travies de Villers and Honoré Daumier all worked for Philipon. His magazine, which raised the caricature from a print-seller's venture to a valid form of journalism, coupled good-natured ridicule of social mannerisms with more sharply barbed slights aimed at eminent figures of the political stage. From the outset, Philipon found himself running a relentless gauntlet of litigation.

The most widely publicised suit against him was provoked by his sequence of four drawings showing the transmogrification of King Louis Philippe—the detested *Roi Bourgeois*—into a bulbous pear; a graphic pun made all the more telling by a verbal association—the word *poire* (pear) having the alternative, colloquial meaning of 'fathead'. Ricocheting from one action to another, *La Caricature* was finally suppressed in 1834, following the publication of a Daumier cartoon depicting the King as Gargantua—a drawing which earned the artist six months in prison.

Meanwhile, Philipon had already brought out a second satirical journal, a daily named *La Charivari* (lit: hubbub), which featured a new cartoon each day and, in 1837, he began to reissue *La Caricature*—adding to the title the cautious adjective *Provisoire*. The magazine's success was so great, however, that Philipon was soon able to drop the qualifying adjective. From 1849, he began to issue yet another journal—this time in the form of large newspaper sheets illustrated with woodcuts and entitled *Le Journal pour Rire*—which later became *Le Journal Amusant*. This, however, was only one of his many later ventures into publishing, which, alongside

a steady stream of political brochures, included such occasional periodicals as *Les Physiologies* and *Le Musée Philipon*.

The most eminent, and one of the most regular, of Philipon's contributors was his lifelong friend, Honoré Daumier, who had gravitated to caricature after several false starts, as booksellers' assistant and law-court messenger. After his release from jail following the 'Gargantua' incident, Daumier's lithographic style—hitherto marked by sharp outlines and a welter of detail—rapidly altered, and his preoccupation with sculpture— (an interest first awakened by an early encounter with the director of the *Musée des Monuments de France*) begun to show through in his drawing. In order to visualise the three dimensional form of his subjects, Daumier took to making small reliefs and busts in clay and these, cast into bronze after his death, became highly prized by collectors. Sharp outlines now began to give way to a vibrant web of sculptural contours, and feverish modelling to an ever-increasing selectivity of detail. This gradual process of maturation may be traced from such series of the early 1830s as 'Le Ventre Legislatif' and 'La Rue Transnonair', through the hundred superb lithographs he produced on the life of Robert Macaire (hero of a popular melodrama) to the many series executed during the 1840s and 1850s; these were, for the most part, caustic lampoons on the evils of the law courts, of which he had plenty of first hand experience!

It was Daumier who was responsible for breaking down the barriers that had traditionally segregated 'serious' from comic art. His work is a fusion of pedantic draughtsmanship with the peculiar devices of caricature—hitherto the almost exclusive preoccupation of the graphic wag. In effecting this stylistic mélange, Daumier made it possible for the 'serious' artist to experiment with physiognomic expression and distortion in order to achieve effects that were often far from humorous, and paved the way for the tragic and often terrifying visages of Munch and the other Expressionists.

Daumier produced a total of nearly 4,000 lithographs, and his prodigious talent was acclaimed by the novelist, Balzac, who saw him not as a mere entertainer, but as a satirist equal in stature to Molière or

Cervantes. Towards the end of his career, and during the long intervals
when he was not working for Philipon, Daumier took to painting in oil,

'The Little Rentier' by Honoré Daumier

but in 1872 his eyesight began to fail and within six years he was totally blind. Neither of the exhibitions of his work organised in 1878 by such painter friends as Corot and Charles Daubigny and by the art dealer Durand-Real, had much effect; for the public, while conceding his talent as a graphic humorist, were not prepared to agree with Balzac's assessment of him as one of the greatest satirists of all time.

Gustave Doré, one of the most prolific and successful book illustrators of the nineteenth century, worked regularly for Philipon. Apart from his numerous contributions to the Philipon press, Doré won deserved acclaim for his wood-engraved book illustrations. Employing more than a hundred wood-cutters, he illustrated nearly ninety books, including a large folio bible, an edition of Rabelais, Balzac's *Contes Drôlatiques* and Dante's *Inferno*. Many of his techniques, such as the use of 'zoom lines' to suggest speed, rapid 'jumps' from distance-shot to close-up, and the sudden plunging of the action into silhouette—all of which he exploited to great effect in his early cartoon history of Russia—foreshadowed the stock devices of the modern strip cartoonist.

Paul Gavarni, a lithographer and painter, who, like Daumier, was a friend of Balzac, also contributed regularly to Philipon's numerous publications. Although his style lacks the vigorous panache of Daumier's, Gavarni had an urbane and polished wit and a technical finesse. His observations of French social manners are remarkable for their accuracy and attention to detail. Gavarni came to fame during the early 1830s with his illustrations depicting scenes of everyday life, which he began to issue regularly in his own publication *Journal des gens du Monde*. Despite its initial popularity, both on the Continent and in England, this enterprise failed, and the artist was imprisoned for debt for the best part of a year. Undaunted by this experience, Gavarni issued, between 1839 and 1843, his three spirited series: 'Les Lovettes', 'Les Débardeurs' and 'Les Fourberies de Femmes', but his mother's death in 1845 made a lasting impression on his work. His former power of irony, though undiluted, was now laced with melancholy and cynicism, and he began to concentrate on the more distasteful aspects of humanity and family life. In 1847, bringing with him

a reputation as 'The best-dressed man in France', Gavarni visited England, and spent the next two years observing the life of the poor and producing some of his most sympathetic and compelling work. He made a trip to Scotland, and contributed many fine drawings to British publications. Returning to Paris, Gavarni began to devote more time to water colour, took up lithography again and produced the fourth of his great series under the title '*Thomas Vireloque*'. At the time of his death in 1866, he was still working energetically—on etchings, lithographs, water colours and the popular new process of electric engraving.

Gavarni's senior by a year was J. H. Gérard ('Grandville'), another of Philipon's distinguished contributors. He had begun his cartoon career in 1828 with a series of seventy scenes entitled '*Metamorphoses du Jour*'— in which individuals with the heads of animals and the bodies of men enact the human comedy. Grandville was a devastating satirist, with a remarkably acute eye for the ridiculous.

5 Good Enough for Punch

In the same year that Philipon brought out *La Caricature*, a London publisher, Thomas McLean, began to issue a *Monthly Sheet of Caricatures*, or *The Looking Glass*, which featured the drawings of such fashionable satirical artists as William Heath (one of the last of the old Gillravians), the lithographer Robert Seymour, and, later, John Doyle. Like its counterparts across the Channel, MacLean's sheet ran straight into a thicket of litigation and, despite its wide appeal, its life was predictably short. Equally ephemeral were the many penny weeklies and monthlies, containing woodcut cartoon comments on social and political affairs, that made brief appearances during the remainder of the 1830s. One of the earliest of these was Gilbert á'Beckett's *Figaro in London*, which sparked off a galaxy of provincial namesakes such as *Figaro in Birmingham* and *Figaro in Sheffield*. Kindred publications were *The Devil in London* and *Punchinello—or Sharps, Flats and Naturals*, which carried illustrations by George Cruikshank's elder brother, Robert.

Out of this scrimmage of scabrous and frequently scatological sheets emerged, on a July Saturday in 1841, a new magazine entitled *Punch*, which was destined to long outlive its more vulgar contemporaries. A brainchild of the journalist, Henry Mayhew—who had succeeded á'Beckett as editor of *Figaro in London*—and the engraver, Ebenezer Landells, *Punch* acknowledged in its subtitle, *The London Charivari*, its inspirational debt to Philipon's Parisian *Charivari*. The idea for an English equivalent to Philipon's magazine had been conceived some six years before the actual

launching of *Punch* by Mayhew and two associates, the novelist W. M. Thackeray (himself an adroit amateur cartoonist) and Douglas Jerrold, who, as early as 1832, had begun to issue a prototype entitled *Punch in London*.

There are grounds for suspecting that *Punch* came perilously close to being launched under the title *The Funny Dog with Comic Tales*, and it is questionable whether the publication—however sterling its qualities— would have survived as long as has *Punch* under such an encumbrance. The advance publicity announced the forthcoming journal as 'a new work of wit and whim, embellished with cuts and caricatures' and des- cribed it as a 'Guffawgraph, intended to form a refuge for destitute wit, an asylum for thousands of orphan jokes, the superannuated Joe Millers, the millions of perishing puns, which are now wandering about without so much as a shelf to rest upon'. The public were hugely impressed by the decorous tone of the new magazine, and the *Somerset County Gazette* gave it a typical reception: '. . . it is the first comic we ever saw which was not vulgar. It will provoke many a hearty laugh, but never call a blush to the most delicate cheek'. Throughout the 130 years of its existence, *Punch* has consistently maintained the extremely palatable blend of intellectual sophistication and inoffensive joviality that endeared it to its earliest subscribers.

Although a comprehensive inventory of all the many hundreds of superlative graphic humorists who have contributed to *Punch* during its long career would be inappropriate in a survey as cursory as this, mention at least must be made of a representative sampling of the distinguished artists who have enabled the magazine to sustain its long-established reputation as a repository for the choicest elements in British pictorial satire.

It was John Leech, an associate of Thackeray's since their schooldays together at Charterhouse, who quickly rose to eminence as the leading political cartoonist with the infant *Punch*. He rapidly outstripped in popularity such earlier contributors as H. G. Hine, William Newman and Kenny Meadows and, after a couple of years, usurped Halbôt K. Browne

(famous as 'Phiz' for his Dickens illustrations) from *Punch's* pride of place. Leech had abandoned his medical studies to drift into the art profession, and had, in 1835, published a series of comic character studies from the London streets under the title *Etchings and Drawings by A. Pen, Esq.* He began his regular journal contributions with an anthology of etchings for *Bentley's Miscellany*, and collaborated with George Cruikshank, whose mannerisms left an indelible impression on Leech's own style. Leech's mature work, shorn of its earlier Gillravian effects of grotesque satire, appeared first in his four etchings for Dickens' *Christmas Carol* in 1844; and his bantering approach—which poked good-natured fun at the comfortable urban middle class—is epitomised in the numerous etchings and

LATE FROM THE NURSERY.

Governess. "NOW, FRANK, YOU MUST PUT YOUR DRUM DOWN, IF YOU ARE GOING TO SAY YOUR PRAYERS."

Frank. "OH, DO LET ME WEAR IT, PLEASE; I'LL POMISE NOT TO THINK ABOUT IT."

John Leech

woodcuts of sporting scenes he produced for the novels of R. G. Surtees and in his *Comic Histories* of England and of Rome, which appeared in the late 1840s. In the same year that he joined the *Punch* staff, Leech issued his lithographic *Portraits of children of the Mobility*, in which the life of the London street-urchins was depicted with a poignant mixture of pathos and sympathetic humour. More masterly still were the illustrations for a subsequent series entitled *Fly Leaves*.

While the bulk of his earlier contributions to *Punch* consisted of jovial observations of social manners, Leech later turned his attention to political themes, closely dogging the careers of Lord Brougham, Lord Palmerston, Disraeli and Lord John Russell. Of the many cartoons he produced on the Crimean war, the most memorable was the 1853 drawing of 'General Fevrier turned Traitor'. In 1850, when Mark Lemon, *Punch's* editor, recruited John Tenniel, who had already established a reputation as a political satirist, Leech was glad to relinquish the task of producing the weekly topical 'big cut' to Tenniel. For the remainder of his career, Leech concentrated on parodies of the social scene, and some of his best work on this subject was published two years before his death in 1864 in an anthology entitled *Pictures of Life and Character from the Collections of Mr Punch*.

In the early days of *Punch*, John Doyle's son, Richard (father of Sir Arthur Conan Doyle) was second only to Leech in popularity. Evidently somewhat prim and aloof in his bearing, Doyle seems to have shared little of the ebullience exhibited by most of his colleagues on the staff; but he produced a steady stream of distinguished work (including the design that graced the magazine's cover until 1956) and his many series—such as 'Manners and Customs of ye Englyshe'—were immensely popular. Both Leech and Doyle, however, were gradually eclipsed by the formidable talents of their new stablemate, John Tenniel. Shortly after Tenniel's arrival, Richard Doyle, a devout Catholic, left *Punch* after an altercation arising from the magazine's anti-papal attitude, and took with him his three popular characters, Brown, Jones and Robinson, whose adventures at home and abroad he published in book form in 1854.

Richard Doyle's famous **Punch** *cover*

Long before he joined *Punch*, Tenniel had gained recognition as one of the most distinguished of the young British illustrators; among his several early achievements was a commission for a fresco in the Upper Waiting Hall of the House of Lords. Tenniel's output as a regular *Punch* cartoonist was prodigious. He produced some 2,300 illustrations, countless vignettes and minor drawings, double page cartoons for special numbers of the magazine and 250 designs for *Punch's Pocket Book*. In Tenniel's hands, the last shreds of venom and vulgarity were sloughed from the political cartoon, and his finest work is remarkable for its strong sense of composition and stamp of nobility. Probably his best known *Punch* cartoon was 'Dropping the Pilot' (1896), on the subject of Bismarck's resignation. Monumental though his illustrations may be, Tenniel's irrepressible good humour illuminates all his work, and is particularly in evidence in the exquisite drawings he made for Lewis Carroll's *Alice in Wonderland* and *Through the Looking Glass*, which won him international acclaim.

THE WONDERS OF SCIENCE

The Principal (from the City, through the Telephone, to the Foreman at the "Works"): "HOW DO YOU GET ON, PAT?"

Irish Foreman (in great awe of the instrument): "VERY WELL, SIR. THE GOODS IS SENT OFF."

The Principal (knowing Pat's failing): "WHAT HAVE YOU GOT TO DRINK THERE?"

Pat (startled): "OCH! LOOK AT THAT NOW! IT'S ME BREATH THAT DONE IT!"

(1881)

Charles Keene

In 1851, Leech, Doyle and Tenniel were joined on *Punch* by Charles Keene. The somewhat conventional quality of Keene's early work for the magazine was soon replaced by a sturdier and more individualistic style, and Keene began to display the inimitable qualities of draughtsmanship that made his work both the delight and envy of his fellow illustrators. In 1859, his services were requisitioned by *Once a Week;* and it was for this periodical that he produced two remarkable series of illustrations, for Charles Reade's *The Cloister and the Hearth,* and for George Meredith's *Evan Harrington.* During the last twenty years of his association with *Punch,* Keene quarried deeply into the scrapbooks of his friend, Joseph Crawhall, an amateur artist whose lifelong hobby it was to jot down any amusing situation or anecdote that took his fancy. A volume of Keene's drawings was brought out by *Punch* in 1881 under the title *Our People.*

George du Maurier joined *Punch* in the early 1860s, soon after his arrival from Paris, where he had spent the early years of his life. George had begun his artistic career as a painter; after a terrible accident in which he lost the sight of an eye, however, he was forced to abandon painting and from then on concentrated on drawing. Du Maurier's 'Society Pictures' in *Punch* were acute observations of the Victorian scene, but even more representative of his elegant and sophisticated style were his exquisite book illustrations and those he contributed to the periodicals *Once a Week* and *Leisure Hour.* Later in life, du Maurier became a highly successful novelist: *Peter Ibbetson* (1891) was based on his happy childhood in Paris, and *Trilby* (1894), on his days as an art student in the Latin Quarter. In his last novel, *The Martian,* du Maurier relived the tragic accident that had robbed him of the sight of one eye.

After Tenniel's retirement, Linley Sambourne inherited the weekly political cut. Modelling himself on his great predecessor, and on Leech and Keene, Sambourne was a dedicated and indefatigable draughtsman, working from a variety of props and from an enormous collection of photographs. His methods were extremely thorough, and it was one of his practices to draw his subjects in the nude before clothing them.

Bernard Partridge, who joined *Punch* on the recommendation of du

Maurier, was, as he himself confessed later in life, a reluctant cartoonist. His professional career had started in an architect's office, whence he gravitated to a firm of stained glass designers. Here, he studied drapery and ornament and went on to work on the embellishment of churches. Partridge was in some doubt about entering the field of humorous and satirical illustration, and, immediately before joining *Punch*, he had performed on the stage under the name of 'Bernard Gould'. As a leading *Punch* contributor, which he was for nearly fifty years, Partridge produced a steady stream of work; but the dedication, the spark of humour, was conspicuously lacking and his illustrations, although grandiose and technically competent, strike us today as lifeless and sometimes monumentally dull. While it is impossible to fault Partridge's draughtsmanship, it is fair to say that his undoubted talent could have been put to much more appropriate use outside the field of humorous illustration. Towards the end of his career, Partridge was a veritable coelocanth among cartoonists—his ornate, sesquipedalian style an ossified relic of a bygone age.

Harry Furniss was, by contrast, a born cartoonist. A swashbuckling Irish raff with a volcanic sense of humour, Furniss joined *Punch* in the 1870s. While there was little Gillravian about his actual manner of execution—which owed much to the style of Richard Doyle—Furniss' observations on society were quite as caustic and his jibes against specific public figures as unerring as those of his Georgian and Regency predecessors. Furniss was strongly critical of the Royal Academy, and in 1887, held an exhibition of parodies of the leading exhibitors. His distaste for the RA was sustained and prompted him, in 1889, to produce a series of devastatingly witty sketches under the title: 'Royal Academy antics'. His many fine book illustrations include the memorable sets he produced for Lewis Carroll's *Sylvie and Bruno* in 1889 and for the complete edition of Dickens (1911). A writer of novels, essays and art-instruction manuals, Furniss later became involved in film-making and during 1912-13 worked for Thomas Edison, on both sides of the Atlantic, as a script-writer, producer and actor. Like many cartoonists before and since,

Furniss was frequently called upon to design advertisements—his best-known being one for soap, showing a scrofulous tramp saying: 'I used your soap two years ago; since then I've used no other.'

E. T. Reed, who joined *Punch* after Furniss, is one of the earliest contributors to the magazine whose style of drawing and species of humour strike us as modern even today. His 'Prehistoric Peeps' (an Edwardian counterpart of Punch's current 'Stanley' by Murray Ball) with their studious attention to authentic detail, appealed enormously to a generation still uneasily ambivalent in its attitude towards the disclosures of Darwin concerning man's primate origins, Reed's use of grotesque distortion—a device seldom exploited by British cartoonists since the roaring days of Rowlandson and Gillray—provided a timely and invigorating infusion to an art form that had all but lost contact with its roots under a stifling layer of photographic realism.

The spare and linear style of Phil May was less instantly acceptable to a public accustomed to seeing dense and richly detailed illustrations. May, an ashen faced Yorkshireman with a weakness for the bottle, (his signature is said to be the only one carved *under* the famous *Punch* round table), had started work at the age of twelve as a timekeeper in a foundry. One of his early ambitions was to become a jockey, but he gravitated instead to the theatre—with which he had a brief and undistinguished association as an actor. On his arrival in London, May was forced at first to earn his living by begging on the streets, but, by the age of sixteen, he had found regular employment as an apprentice designer with a firm of theatrical costumiers. It was at about this time that he began to contribute drawings of stage celebrities fairly regularly to the *St Stephen's Review*—an association that lasted for two years. May always suffered from indifferent health and he was advised by his doctors to emigrate to Australia, where he worked for three years on the *Sidney Bulletin* before returning to London in 1892 to renew his contact with the *St Stephen's Review*. May's studies of familiar London types, coster girls, news-vendors and gutter-snipes, whom he portrayed with a genial yet utterly unsentimental feeling, were hugely appreciated, and his circle of admirers began rapidly to

Q. E. D.

"WHAT'S UP WI' SAL?" "AIN'T YER ERD? SHE'S
MARRIED AGIN!"

(1894)

Phil May

expand. He joined *Punch* in 1893, and added to his seemingly inexhaustible repertoire of London street types a number of fine caricature studies of leading political figures. May's breathtaking economy of line—which was considered, even by his brother cartoonists, as daringly innovative—was the end product of a laborious process involving countless preliminary drawings, each one being drastically refined until all irrelevant clutter had been ruthlessly pruned away. May had been exploiting this method since he first began to draw, and one of the many anecdotes about him (once as common among cartoonists as are the Beecham stories among the musical fraternity) recalls a director of the *Sidney Bulletin* challenging him with the mewling observation: 'Of course, your work is awfully clever, but, I say, you know, we're paying you an enormous salary—and that last drawing of yours—why, there were only seven lines in it.' To which the cartoonist is said to have replied: 'My dear man, don't you realise that if I could have done it with five, I'd have charged you twice as much?' Another May anecdote relates that, although he was invariably paid in advance and was always hard up for cash, he had an arrangement with the *Sketch* whereby he was allowed to make a drawing at the counter and could cash it, like a cheque, for £5.

Phil May, who died before his fortieth birthday, was unquestionably one of the most influential draughtsmen in the history of humorous illustration, and elements of his distinctive drawing style were absorbed, and carried forward, by such younger cartoonists as Tom Browne in Britain, J. S. Allen in the United States, and Alf Vincent and David Low in Australia.

The richly cross-hatched drawing style of Lewis Baumer—another witty commentator of the Edwardian social scene—was cut from a very different cloth from May's distilled sparsity of line. His subject matter, too, differed from May's, for, where May was preoccupied with colourful street types and cockney tatterdemalions, Baumer's inspiration was the tennis club, the house party and the *thé dansant*. Like Harry Furniss, Baumer experimented with film, and made a memorable series of burlesque shorts punctuated with hilarious captions. Both he and May

left an enduring imprint on later *Punch* stylists. May's concern for street characters, though scarcely his inimitable manner of execution, was echoed a generation later by G. L. Stampa, whilst Baumer had a worthy scion in D. L. Ghilchick, whose social cuts on commonplace domestic situations represented a between-the-wars counterpart to Baumer's satirical Edwardiana.

George Morrow's work, like that of E. T. Reed, has a distinctly modern flavour, both in the vivacity of its execution and in the lunatic humour that sparked so many of his ideas. The same may be said of the cartoons of W. B. Yeats' brother, Jack, who styled himself 'W. Bird'. Yeats' humour was even more maniacal than Morrow's, and his interest in new developments in serious painting is apparent in his cartoon technique. In the work of Reed, Morrow and Jack Yeats, the germs of a new, irrational brand of graphic whimsy are already apparent.

On the death of Linley Sambourne in 1910, Bernard Partridge took over the job of producing the weekly political cartoon, and he in turn was succeeded as *Punch's* second cartoonist by Raven Hill—already a successful pictorial journalist—who occupied the chair for the next twenty-five years. Hill resembled Sambourne in temperament, artistic style and in his burning interest in political affairs. He approached his subject matter with a ferocious gusto, deftly sketching in his figures with a drastic economy of line and ruthlessly eschewing inconsequential detail. Where Partridge tended to be static, Raven Hill was frantically mobile, with a forceful, sinewy line reminiscent of the best of Illingworth. His friend, Rudyard Kipling, was a great admirer of his pungent and dynamic style, and chose him to illustrate his novel *Stalky*.

George Belcher's spare, economic line distinguishes his work from the denser and more ornate style of many of his contemporaries, and, although his favourite medium was charcoal or soft chalk rather than pen and ink, some of his drawings have an apparent stylistic kinship with those of Phil May. The resemblance is, however, merely superficial; beside May's vivacious urchins and lissom coster girls, Belcher's charladies appear cardboard and rigidly posed. Unlike May, Belcher was not a *comedian à*

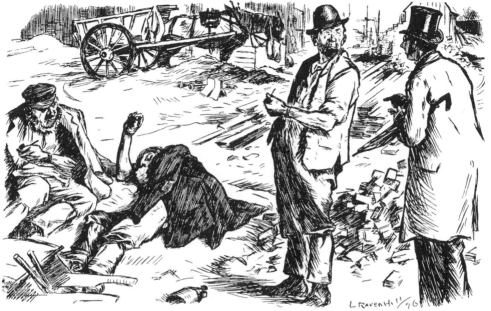

Sympathetic Passer-by: "BUT IF HE'S BADLY HURT, WHY DOESN'T HE GO TO THE HOS-PITAL?"
British Workman: "WOT! IN 'IS DINNER-TIME!!"

(1896)

Raven Hill

outrance, and many of his jokes were supplied for him by others; indeed, his obtuse sense of humour occasioned a number of anecdotes—many, doubtless, apocryphal—concerning his inability to understand some of the jokes he illustrated. One tells of his being sent an idea whose whole point depended on its being set in a fishmongers; Belcher, however, drew it in a greengrocers instead, simply because, he reasoned, 'there's a very good greengrocers just by my home'.

Among the most outstanding of Raven Hill's contemporaries on *Punch* during the World War I were Ernest Shepard (equally celebrated for his exquisite illustrations to A. A. Milne's *Pooh* books and Kenneth Grahame's *Wind in the Willows*); Bert Thomas (best remembered for his

famous ' 'Arf a mo', Kaiser' cartoon from 1914); and Kenneth Bird, who took his pseudonym, 'Fougasse', from the name of a type of land mine. Badly wounded in action during the early part of the war, Bird—an engineer by training—made his cartoon debut with military subjects drawn in a fairly conventional style. As his manner of drawing evolved, however, he began to employ the devices that make his work so readily identifiable. Ruthlessly whittling his subject matter down until only the essential penstrokes remained, Bird carried to a logical conclusion the process of linear simplification that had been initiated by Phil May; in Bird's definitive work much of the drawing is left unstated, leaving the blank spaces to be linked in by the onlooker's imagination.

After the war, Frank Reynolds, who had been contributing to *Punch* regularly since 1906, replaced F. H. Townsend (the 'archetypal *Punch* cartoonist of the Edwardian era') as art editor. Reynolds' line was harsh, uncompromising and occasionally downright ugly; but it had a cutting edge that gave his work a vitality and raw strength that marked it off from the more decorous effects favoured by so many of his contemporaries. Fougasse, who was himself striving to shrug off the weight encumbrance of representational drawing, was full of admiration for Reynolds' coruscating attack. 'His line', he writes, 'possessed a freedom and energy which makes us recognise it now as the forerunner of much of the freestyle drawing of today. He played, in fact, an important part in the transition from the comparatively tight, naturalistic drawing of the beginning of the century (a legacy from the old wood-engraving) to the freer and more fluid and very much less documented styles that followed.'

Among the most popular of the regular *Punch* contributors between the wars were H. M. Bateman, William Heath Robinson and Rowland Emett, all of whom became to some extent 'type-cast', almost despite themselves, as specialists within a restricted range of situations. Bateman, whose judicious use of chiaroscuro and sinuously decorative line suggests the early influence of Beardsley, was initially a very versatile comic artist; later, however, he concentrated almost exclusively on situations involving various types of social gaffe. His favoured method of presentation was to

dilute a theme into literally dozens of small frames that pursued the action in every detail to its conclusion. Occasionally, Bateman found it necessary to stretch such an idea over as many as four pages in tier upon tier of frames. The similarity of so many of his situations to those exploited by Charles Chaplin, Buster Keaton and Ben Turpin, is no mere coincidence; Bateman was intensely interested in the cinema, and a devotee of the early screen comics.

Rowland Emett and William Heath Robinson were also gifted illustrators whose talents were perforce narrowed down to the two specialities for which they were best known; Emett for his very decorative and filigree locomotives and Heath Robinson for his preposterous machines.

It was W. L. Ridgewell and, later, G. S. Sherwood, who, during the early thirties, developed the fluid style established in the post-war years by Frank Reynolds. Of the two, Ridgewell was the less derivative; he managed to infuse into his own restless and experimental approach unmistakable dashes of both Bateman and Fougasse. The Bateman influence is even more perceptible in the work of Arthur Watts, whose highly individual sense of humour was perhaps closest to that of Ridgewell. Watts invariably tended to view his subjects from an unusual, overhead angle, a gimmick whose initial appeal began to stale with repetition. He was, however, very much a cartoonist as opposed to an illustrator of funny ideas, and his figures, like those of Bateman and Ridgewell, succeed in looking as intrinsically amusing as the activities in which they were engaged.

One of the younger artists whose work began to invade the pages of *Punch* during the early thirties was Nicolas Bentley, a scion of Sherwood and Ridgewell, with a very decorative, sharply defined interpretation, full of pungent tonal contrast, and an acute eye for the incongruous and absurd in social mannerisms.

Unlike Bentley, whose contributions to *Punch* were, although sustained, sporadic, Graham Laidler—or 'Pont' as he styled himself—was one of the few artists whose services were exclusively retained by the magazine. The discovery of art editor E. V. Knox, 'Pont's' drawings appeared regularly in

William Heath Robinson, 'Restoring the belfry of a village church shattered during the war'.

Punch until his tragic death at the early age of thirty-two. Quarrying for his material into that rich vein of latent humour, the British Character, Pont became an instant success for his cunningly decorous lampoons on British modes and manners. His popularity was almost certainly due to the fact that his followers failed to recognise that it was they—and not their more outrageous friends—that he was satirising. Although his series *The British Character*, contained his best known work, he also produced a steady stream of drawings quite outside this field; drawings whose value is still so highly appreciated that an anthology of Pont illustrations, assembled by Bernard Hollowood, has recently been issued, twenty-nine years after his untimely death.

Bernard Partridge, who despite his wish to retire, was persuaded to remain with *Punch* until his death in 1945, was succeeded as first cartoonist by a superb Welsh illustrator, Leslie Illingworth. By juxtaposing deftly-wrought detail with areas of thunderous black, Illingworth has achieved a richness and authority that distinguish his work from all his contemporaries. A consummate draughtsman, Illingworth's cartoons have been aptly likened to some of the earlier works of Sir John Tenniel, and they certainly match, in emphasis and pungent vigour, the best of Raven Hill.

During the editorships of Malcolm Muggeridge and William Davis, spanning the 1950s and 1960s, the number of distinctive and experimental stylists admitted to *Punch* has increased prodigiously. Although there is no space here to catalogue all the brilliant innovators who have, over the past twenty years, sustained the magazine's position as the world's leading humorous journal, a selection of *Punch's* most outstanding latterday cartoonists must be mentioned, especially those whose personal contribution, assimilated into the mainstream of graphic comedy, continues to influence contemporary drawing styles.

Among the advance-guard of the new stylists were Douglas England (Douglas), who employs an elegant, decorative line to telling effect when burlesquing the foibles of smart society; William Scully, who couples an ethereal, fantastic humour with a vigorous and dynamic style of drawing; L. H. Siggs, a consistently witty artist, whose style has calmer, less frenetic

qualities than Scully's; and W. A. Sillince, a firm draughtsman who has experimented with a variety of styles and textural effects during his long cartooning career. R. S. Sherrifs, who took over the vignettes for the film-critiques from J. H. Dowd, is a deft caricaturist whose sculptural attacks on the human face remind one irresistibly of some of the early work of Picasso.

Norman Mansbridge, while essentially a figurative artist, makes copious use of such stock cartoon effects as distortion and ellipsis, while the latter device is even more characteristic of David Langdon, who has distilled and boiled his lines down to their barest essentials. Like Bert Thomas before him, Langdon reaches a wider audience than many *Punch* artists because of the broad range of social classes from whose behaviour he draws his inspiration.

A highly individual approach was that of Roger Pettiward (Paul Crum), who was killed early in the last war. From the moment he began to contribute to *Punch*, Pettiward's unconventional and slightly disarming brand of humour, which coupled dreamlike, sometimes almost demented situations, with an elemental yet meticulous style of drawing, was widely appreciated; and his influence on subsequent specialists in illogical and near-surrealist graphic humour, beginning with Kenneth Mahood and, more particularly, Eric Burgin, has been profound and enduring. Between them Pont and Crum probably did more to influence post-war trends in pictorial humour and style of presentation than any other British artists.

Crazy humour of the Crum variety gained further impetus with the work of J. W. Taylor, whose somewhat Langdonesque style—even barer and more rudimentary than Crum's—was ideally suited to his particular brand of nonsense. Others in the van of the new 'irrational' humour— which was also revitalized from across the Atlantic by the influence of Thurber and Saul Steinberg—were L. H. Starke, whose monks and company directors are the denizens of a limbo-land on the borders between fantasy and reality, and the late Mrs Antonia Yeoman (Anton), whose elegant manner of execution owed much to the sophisticated type of drawing favoured by fashion magazines and was refreshingly free of most

of the more repetitive cartoon clichés.

Ronald Searle, one of the most distinctive and influential of Britain's post-war graphic humorists, initially joined *Punch* to take over the dramatic criticism vignettes from G. L. Stampa, but his work rapidly spread throughout the magazine. Best known for the diabolical denizens of St Trinian's School for Girls, Searle has a vast repertoire of characters, all based on recognisable stock prototypes, yet all presented in an inimitably decorative and finely wrought style. Searle's mannerisms, particularly his

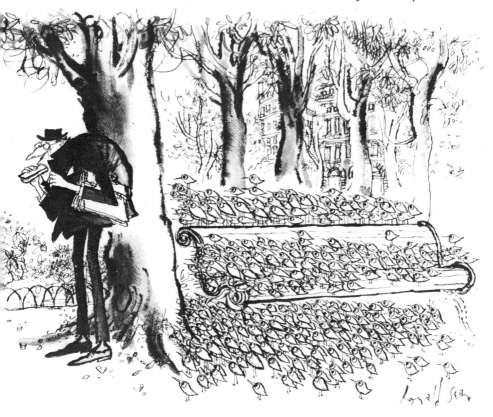

Ronald Searle cartoon from **The Square Egg**

use of spindly, spiky limbs and rhythmically elegant embellishments, soon began to be affected by his devotees and are now among the most distinctive earmarks of contemporary British cartooning.

While less extreme in his use of distortion and exaggeration than Searle, William Hewison—currently responsible for *Punch's* film vignettes—has produced a succession of distinguished studies, deftly executed with an incisively biting line. Michael ffolkes and the Australian, George Sprod, are the leading exponents of the more filigree type of decorative cartooning: ffolkes (who also illustrates Peter Simple's 'Way of the World' feature in the *Telegraph*) specialising in delectable rococo whorls and arabesques, Sprod in less aetherial yet equally engaging effects.

One of the most indelible influences on British cartooning in latter years, both from the point of view of style and humour, has been that of André François. A Parisian of Romanian extraction, François exploits the most unlikely situations, which he interprets in a deceptively rough-hewn, almost slovenly, method of execution that is startlingly arresting and quite compelling. Alongside Searle's techniques, François's devices and distinctive brand of crazy humour must be regarded as among the most significant innovations in British graphic comedy since Paul Crum's contribution.

Among the first British cartoonists to draw on the devices of François—whose methods, while firmly rooted in the long-established continental tradition of comic drawing, were quite unlike anything ever experienced before in this country—were Francis Smith (Smilby) and, more recently, Scherzo. Both these disciples of François have continued to blend his mannerisms most tellingly with their own distinctive touches which, particularly in Smilby's case, also betray more than a hint of Paul Crum's influence.

Among the individualists whose influence on later developments is less perceptible are Giovanetti (the Italian-Swiss creator of the endearing little hamster, Max), whose tradition of situations involving small animals and birds is being ably perpetuated by Hargreaves; Roy Davis, with his unmistakable, doll-like figures; Russell Brockbank and Norman Thelwell,

André Francois

both essentially realistic illustrators, the former specialising in motoring situations, the latter world famous for his shaggy ponies and juvenile equestrians; and two architects-turned-cartoonists, J. C. Armitage (Ionicus) and F. Hoar (Acanthus), both of whom specialise in meticulously executed drawings incised with pelucid linearity. Michael Cummings of the *Express* took over the regular 'Essence of Parliament' illustrations from A. W. Lloyd. Cummings' richly detailed style and copious use of cross-hatching often achieves a vibrancy reminiscent of the old *Punch* pioneer, Linley Sambourne, and have a certain affinity with those of Cummings' occasional *Punch* confrère, Edward Ardizzone (Diz), a prolific illustrator of children's books.

Today's *Punch* carries a constantly shifting kaleidoscope of talents, featuring such stalwarts as David Langdon and Michael ffolkes alongside some of the more *avant garde* of the younger cartoonists—men like Raymond Lowry, Glyn Rees and Anthony Lee Ross. Of the current *Punch* crop, the following are among the most consistently entertaining:— Hector Breeze, whose somewhat Thurberesque drawings are made pungent with pockets of densely textured black; Graham, an indefatigable commentator on the surburban middle class and creator of the popular *Daily Mail* feature, Fred Bassett; Stanley McMurtry (the regular topical cartoonist of the *Sketch*) whose style owes much to Michael ffolkes, yet is tougher-looking and less rococo; Minet, whose effects have been aptly described as 'tightened Siggs'; Chic Jacob (also known for his 'Chic feed' feature in the *Express*), who draws neat, chunky figures with truncated limbs; and Bill Tidy, a prolific contributor not only to *Punch* but also to *Private Eye*, the national press and several commercial journals (he draws 'The Fosdykes' for the *Mirror* and 'Grimbledon Down' for the *New Scientist*). Tidy has somehow contrived to infuse ffolksian elements into a basically vulgar, graffitic yet uproariously funny style of drawing; his highly original brand of humour is in many ways a graphic counterpart to that of the comedians, Morecambe and Wise, spiked with a strong dash of Thurber.

An increasing number of younger *Punch* cartoonists favour the fashionably grubby, unkempt manner of execution that often ends up looking like a crude travesty of André François at his most informal. McKee, Raymond Lowry, Barrington, Kevin Woodcock, Nicholas Baker, Anthony Lee Ross and others all make use of these deliberately clumsy, scribbling effects. Arnold Wiles, a longer established cartoonist, appears to have escaped these particular mannerisms and retains a sprightly immediacy of line whose vitality is made all the more telling by a suggestion of the unedited, preliminary drawing cutting through and underscoring the final layers. Saxon and Roy Raymonde are two debonair social satirists in the Pont tradition; both play a rich range of tonal washes against sharply incisive lines. Raymonde's deft watercolours are also a

welcome regular feature in both *Mayfair* and *Penthouse*. Birkett, Glyn Rees and Michael Heath are exponents of the 'tight doodle' as opposed to the 'loose doodle' epitomised by Quentin Blake. Blake, who sold his first cartoons to *Punch* while he was still at school, became known to readers of the magazine for his charming vignettes accompanying the 'In the City/In the Country' feature. His drawing style has immense distinction and his figures, despite their apparent bonelessness, are astonishingly articulate. Blake is certainly not a 'gag' cartoonist in the Bill Tidy sense and cites Picasso and Klee as his chief stylistic inspiration.

"Look out, it's . . . God, I'm awful with names!"

Bill Tidy

Of the many *Punch* artists employing a deliberately chaotic scrawl, Petty comes nearest to achieving complete incoherence; an impression that gives his work a frantic urgency that is the absolute antithesis of Edward McLachlan's. McLachlan ranges for his subject matter over the entire spectrum of human behaviour; from zany comedy situations in the Paul Crum tradition to social and moralistic themes that are often highly elaborate in construction. His hunched, gross-bodied figures are scratched down with a ruthless finality and a jaggedly astringent line.

Edward McLachlan, poster for London Transport

Both Mike Williams and Albert specialise in a rough-cut, splintery angularity. Williams, whose work is becoming less brittle and more rollicking, frequently burlesques biblical and literary themes, while Albert's drawing style seems to be growing increasingly like that of McMurtry. Roy Nixon has managed to inject dashes of both ffolkes and Chic Jacob into his drawing style, a somewhat incongruous melding that gives his work an impression of clumsy solidity combined with sprightliness; Dickinson's lumbering figures are held together by judiciously

deployed areas of solid black and half tone, whilst Larry (Terry Parkes), one of the most prolific and unerringly funny of all the current graphic humorists, goes in for everyday situations which he dashes off in a deceptively ingenuous 'off the cuff' scrawl that emphasises, far more effectively than could an elaborately overworked illustration, the basic inanity of human activities.

Larry

Ruggedly individualistic though these current cartoon stylists may be, they display, almost without exception, an uninhibited attack, a casual informality and a healthy lack of concern for such academic niceties as scale, perspective and irrelevant clutter. These attitudes combine to give their work a uniformly uncouth vitality and rip-roaring immediacy that would doubtless have delighted Frank Reynolds, but would surely have caused Sir Bernard Partridge to recoil with revulsion. Certainly the standard of draughtsmanship has degenerated but photographic verissimilitude is the last objective of the modern graphic comedian; he has consciously jettisoned the old academic standards in favour of rawness, impact and immediacy.

Although *Punch* has, at one time or another, commandeered the talents of most of Britain's outstanding graphic satirists and humorists, there are many distinguished British cartoonists whose work has seldom, if ever, appeared on the pages of that illustrious publication. Of those who have made occasional 'guest' appearances in *Punch*, Randolph Caldecott, Sir John Millais, Arthur Rackham, Wally Fawkes and Feliks Topolski are among the best known.

Carlo Pellegrini and Leslie Ward (better known as Ape and Spy) were among the most popular contributors, along with the less celebrated Roland le Strange, to *Vanity Fair*, a short lived satirical weekly that was launched in 1868 by Thomas Gibson Bowles as a rival to *Punch*. Another brilliant caricaturist, Max Beerbohm, was repeatedly sidestepped by *Punch*'s cautious editor, Owen Seaman, on account of Beerbohm's unfashionable candour and scorching cynicism. Beerbohm was unique among the early twentieth-century British caricaturists in that he was utterly uninhibited in his portrayal of eminent literary, theatrical and political personalities. His cartoons matched his prolific essays for polish and wit, and his draughtsmanship grew appreciably more adroit during the course of his long career. His first book of illustrations, *Caricatures of 25 Gentlemen*, came out as early as 1896, when he was only twenty-four. These were followed by *The Poets' Corner* in 1904, *A Survey* in 1911, *Fifty Caricatures* (1913), *Rossetti and His Circle* (1922) and *Observations* (1925). With his rapier wit and acute eye for the salient facial clichés of his victim, 'Max' was closer in spirit to the earlier Georgian phizmongers than to most of his less intrepid contemporaries, in whom hypersensitivity had dulled the old cutting edge of caricature. His masterly 'antiportraits' of G. K. Chesterton, George Bernard Shaw, Joseph Conrad and Somerset Maugham became the standard symbols of these worthies. There were surprisingly few artists able to carry on the Beerbohm tradition of personal caricature; Edward Kapp of the swirling chalk flourishes, the linear Edmund Dulac and Powys Evans, master of the tight-knit cross-hatch, were his three most worthy successors.

Three other eminent early cartoonists whose work is not generally

associated with *Punch* were Sir Francis Carruthers Gould (best known for his drawings in the *Westminster Gazette* and the *Pall Mall Budget* during the Victorian period); Bruce Bairnsfather, a journalist, writer and officer who illustrated several of his own reminiscences of life in the trenches during World War I and created the famous character of Old Bill; and Walter Crane, whose naively scribbled illustrations to his children's books, *King Lucky Boy, Baby's Opera, Slate and Pennsylvania*, etc, have a perennial charm.

Undoubtedly the most outstanding British political cartoonist, an artist whose long and unchallenged reign straddled four decades, was Sir David Low. A New Zealander of Scots/Irish extraction, Low was a self-taught draughtsman who was already contributing cartoons to a local newspaper at the age of eleven—even younger than Phil May had been at the beginning of his professional cartooning career. By the time he was eighteen, Low was an established and highly successful artist, and soon combined his freelance activities with a regular post on the *Sydney Bulletin*. His impudent caricatures of the Australian prime minister, 'Billy' Hughes (published as an anthology in *The Billy Book* in 1918) brought him a deal of notoriety, and in 1919 the London *Daily News* invited him to Britain. He found himself, however, on the *Star*, where he remained until 1927, when he was invited by Lord Beaverbrook to join the *Evening Standard*. It was with the *Standard*, producing cartoons that ran squarely against the grain of the paper's right-wing policy, a tactic astutely encouraged by the *Standard*'s proprietors, that Low produced some of his most celebrated work. Reaching the zenith of his formidable power during the late 1930s and the early years of World War II, Low, like Vaughn Shoemaker in the States, earned world fame, and the particular hatred of Adolf Hitler, for his devasting exposés of fascism and the Nazi regime. It was at this time that his immortal fictional character, 'Colonel Blimp', the embodiment of diehard reaction, began to appear in the *Standard*.

Low's conception was dramatically bold, simple and assertive, and his facile brushwork has been aptly likened to the techniques of Oriental painting. The combination of Low's dazzling drawing technique with his

devastating powers of irony have been equalled but once in the present century, by Louis Raemakers of the Amsterdam *De Telegraaf* whose work was syndicated by the Hearst newspapers throughout the United States during World War I. Of Low's contemporaries on the Continent, however, neither Sennep of the Paris *Figaro* nor Fritz Meinhard of the *Stuttgarter Zeitung*, brilliant political satirists and competent caricaturists though they may have been, were of Low's calibre. In 1950, Low left the *Standard* for a short spell with the *Daily Herald*, which had previously featured the work of another antipodean cartoonist of strongly socialist persuasion, Australian Will Dyson (an incomparably sounder draughtsman than Low), and spent the last ten years of his life, from 1953, submitting three weekly cartoons from semi-retirement to the *Guardian*. Over thirty anthologies of Low's work have been compiled, from *The Years of Wrath* (1949) featuring his collected war cartoons, to *The Fearful Fifties* (1960).

The antecedents of Victor Weisz (Vicky) were even less conventional than those of his early friend and mentor, Sir David Low, yet, ironically, this diminutive Hungarian jew turned out to be one of the most perceptive graphic satirists of the British way of life. Vicky's first assignment, after his arrival in London from Berlin in 1938, was with the *News Chronicle*— with which paper he remained until 1958. Subsequently, he worked for the *Mirror* and then, until his death in 1966, with the *Evening Standard*, maintaining all the while his established connection with the *New Statesman*. Despite—or, more likely, because of—his utterly un-English origins, Vicky was able to see all the inanities and inconsistencies of Anglo-Saxondom in high relief—and to depict what he saw with disarming accuracy; it was he, more than any other cartoonist, who was responsible for establishing the stock caricature types of such British political luminaries as Harold Macmillan ('Supermac'), Edward Heath and R. A. Butler.

The topical cartoon is, by definition, an ephemeral affair. Intended as an instant comment on a specific happening on the political or social scene, its original potency and subtle associations soon dissipate as the event which inspired it recedes into history. One of the most depressing aspects of the topical cartoon is the speed with which it—and, inevitably, its

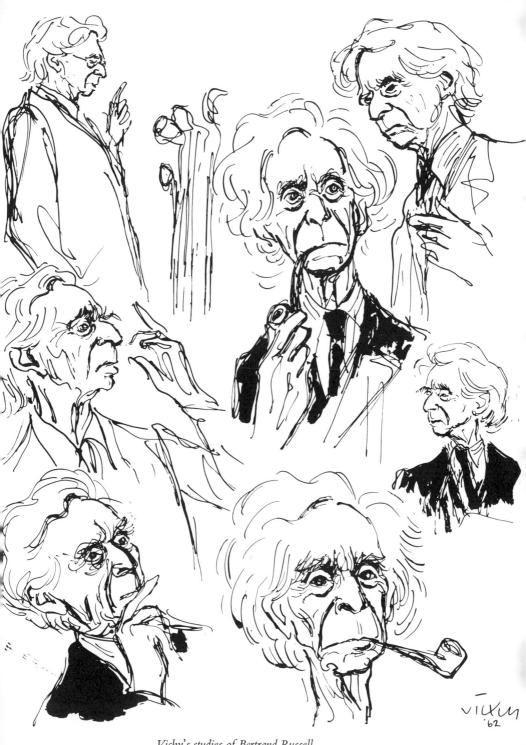

Vicky's studies of Bertrand Russell

creator—pass into oblivion. If the memories of Vicky and Low are already beginning to fade, what then of such earlier perennials as Sidney Strube and 'Poy', whose names were, only a short time ago, as familiar as are those of Giles and Illingworth today?

Strube's thirty-six years with the *Daily Express* (from 1912 to 1948) must surely be one of the longest ever associations between a newspaper and its political cartoonist. To three generations of Britons, his 'Little Man' ('the common denominator of humanity') was an institutional figure . . . yet he would seem pathetically out of context in the second half of the twentieth century. So, too, would Dilly and Dally, 'Poy's' diehard reactionaries who appeared regularly in the *Evening Standard* between the wars. Today, these two bewhiskered characters, with their stovepipe hats and their bemused yet pithy observations on the rapidly accelerated pace of life and technology, seem more quaintly antediluvian even than Strube's Little Man, while their creator himself was long ago consigned to an obscure cranny in the archives of British cartoon history.

Of the surviving contemporaries of 'Poy' and Strube who are still practising cartoonists—apart from Bentley, Langdon and Illingworth mentioned above—Osbert Lancaster and Carl Giles are by far the most productive. Lancaster is a prolific writer and distinguished theatrical designer besides being a cartoonist; Maudie Littlehampton and other upper-crust denizens of his *Express* 'Pocket Cartoon' are the lineal successors of Pont's pre-war types. Giles, another *Express* stalwart, is probably the best known of the older generation of newspaper cartoonists in Britain. He began his artistic career as an animator in Dean Street, and had his first regular strip, 'Young Ernie', published in *Reynold's News* as long ago as 1936. Another representative of the senior generation of topical cartoonists is John Musgrave Wood (Emmwood), one of the most distinctive stylists, and a regular contributor to the *Daily Mail* since 1957. Soon after the war he drew the 'Emmwood's Aviary' feature for the *Tatler*, and describes this series of caricatures as 'very fierce—much fiercer for their day than Steadman's and Scarfe's are now'.

Stylistic variety is indeed one of the most salient attributes of the con-

temporary editorial cartoon in Britain today. There are, to be sure, certain mannerisms of drawing favoured more by the younger generation of cartoonists than by the older practitioners, many of whom, in their turn, display stylistic earmarks that give their work an unmistakably archaic stamp. (This applies, of course, solely to their actual manner of execution, not to their ideas.) Recognising this discrepancy, the art editors of certain national newspapers feature representatives of both the older and the younger generation of cartoonists, contrasting them in such a way that one enhances and complements the other. The *Sunday Telegraph*, for example, uses John Jensen, one of the most consistently inventive and aesthetically pleasing of the younger cartoonists, as a foil to Nicolas Bentley whilst the *Sunday Express* juxtaposes the older Giles with the more contemporary style of the Australian artist, Bill Martin.

To enumerate the dozens of fine artists who currently contribute topical cartoons to the British national press would be a tedious exercise, yet a few must be singled out on the basis of their individuality alone. The *Guardian* features a splendid bouquet of graphic commentators, including Arthur Horner and New Zealander Les Gibbard, who recently replaced Bill Papas. The *Mirror* currently carries a formidable array of variegated cartoon talents—notably those of Stanley Franklyn and the New Zealander Keith Waite. *The Times* features topical vignettes by Mark Boxer (Marc), Mel Calman and Derek Alder (an artist in the Quentin Blake vein), while the *Sun* offers Margaret Belsky's small column breakers alongside the larger political cartoons of Paul Rigby, another of the many Australians working in Britain.

The national evening papers have always featured topical cartoons of a particularly high calibre. The *Standard* currently features the work of Raymond Jackson (Jak—a Gilesian cartoonist and specialist in cockney and pub humour) and Peter Maddocks, while the *News* (once the home of Lee's nightly 'London Laughs') has Bernard Cookson, Don Myers, who draws in a style somewhat reminiscent of Arnold Wiles, Doug Smith and George W. Smith (Gus).

Besides featuring topical cartoons as a graphic amplification of the

editorial opinion, most British newspapers, like their counterparts abroad, carry 'situational' cartoons. These are invariably single frame drawings whose subject matter is primarily inspired by universal human relationships rather than by current events. Probably the oldest of these 'situational' features is the *Mirror's* 'Useless Eustace', which its creator, Jack Greenall, has been drawing daily since 1935. 'Considering he was originally given a six weeks' run,' comments Greenall on his cartoon's exceptional longevity, 'I think this is pretty good going'. Situational cartoons are not infrequently based on animal characters, typical examples from the British national dailies being Will Spencer's 'Animal Crackers' in the *Mail*, and the *Evening News'* 'Marmaduke' by Brad Anderson and 'Almost Human' by Ark.

Single frame sports cartoons have long been a feature of many British dailies. Roy Ullyett, one of the longest established, says of his feature in the *Express*, 'Anyone who wades through to the back page of a newspaper *deserves* a laugh'. Jon (W. P. J. Jones) who now draws the 'Sporting Types' in the *Mail*, first established a reputation as a cartoonist during the war with the 'Two Types', the characters who won him the MBE and who, said General Sir Bernard Freyberg, 'did more good for my troops than all the medical comforts'.

Until 1961, *Punch* reigned supreme and virtually unchallenged as the vehicle for graphic humour and satire in Britain. Throughout the previous 130 years of its existence, the magazine had seldom had much to fear in the way of serious competition from other publications. There were, to be sure, a number of journals that regularly carried cartoons—*Vanity Fair* and *The Yellow Book* in the early days, for example, and *Lilliput* and the *Tatler* at a later date—yet it was not until 1961 that the first potentially serious rival to *Punch* as an exclusively satirical paper arrived in the form of a rather unprepossessing pamphlet bearing the title *Private Eye*. Unprepossessing it may have been, yet cartoonists were quick to appreciate that here, at last, was an outlet for strong, barbed humour that would have been utterly unacceptable—not to say abhorrent—to the editorial staff of *Punch*.

Founded in London by a group of inconoclastic young artists and writers—Peter Usborne, Andrew Osmond, Richard Ingrams (the present editor), Christopher Booker and the cartoonist, William Rushton—*Private Eye* was, from its very first issue, clearly cut from a very different cloth to *Punch*. The unrestrained savagery of its attacks on individuals and institutions, its ruthless and unremitting crusade against every type of social and political corruption, carried British satire—both graphic and verbal—back in one single leap to the place where Gillray had left it nearly 150 years earlier. Indeed, the similarity of the new publication to the little penny scandal sheets that flourished in such numbers during the Regency and early Victorian periods was not lost on cartoon antiquarians or social historians. Somehow, despite repeated financial buffets—many of them arising from law suits filed by individuals claiming, rightly or wrongly, to have been slandered by the magazine—*Private Eye* has survived an entire decade. During this time its satire has steadily become subtler and incomparably more penetrating.

Apart from Rushton, whose appalling old roués, cadaverous matrons and degenerate city gents are incised with an almost painfully sensitive line, *Private Eye* also features the work of Nicholas Garland—who has been the political cartoonist in the *Daily Telegraph* since 1966. For the *Eye*, Garland illustrates, in his uncouth, deceptively untutored style, Barry Humphreys' strip, 'Barry MacKenzie', which follows the sordid escapades of an Australian innocent in London. Bill Tidy's strip, 'The Cloggies' ('an everyday saga in the life of clog-dancing folk') shares a page with Garland's, while other caustic contributions come in regularly from such cartoonists as Wally Fawkes (Trog), Frank Dickens, Michael Heath, William Scully, Larry and Hector Breeze, most of whom were well established long before the arrival of the *Eye*. Needless to say, *Private Eye* provides an occasional and highly appropriate outlet for Britain's two most brutal graphic satirists, Gerald Scarfe and Ralph Steadman.

Many excellent cartoonists are also featured in the magazine *Penthouse*, which first appeared in 1965 as a British counterpart to Hugh Heffner's American *Playboy* and has gone from strength to strength. Among its

'Thank goodness they don't make cartoonists like that any more . . .' (Kenneth Mahood)

... don't they, though? (Gerald Scarfe)

regular cartoon contributors are the macabre galgenhumorists Tony Escott and Eglesfield; the monstrous Tony Hall (Fieldvole) who claims that his mother thinks up most of his ideas; Colin Leary whose caligraphic flourishes give his drawings the appearance of banknotes; and the magazine's editor, Bob Guccione, who contributes regular 'dialogue' and 'soliloquy' cartoons in the manner of the American satirical artist, Jules

Feiffer. Other frequent *Penthouse* contributors are S. Gross (also a *Private Eye* regular) who favours a sparse, elemental style of drawing reminiscent of Saul Steinberg, and Gilbert, who like *Playboy's* Eldon Dedini, paints pink and pulchritudinous maidens with undisguised relish.

Of the dozens of *soi-disant* 'satirical' magazines that have surfaced in the wake of *Private Eye*, none has yet come anywhere near their mentor in sophistication or in the quality of their cartoons. Besides their debt to *Private Eye*, they also draw their inspiration from such longer established American underground publications as *The Yellow Dog, The Berkeley Barb, Zap* and *The East Village Other*. The standard of artwork in the bulk of these selfstyled 'underground' publications is as pitiful as the text—peevish, boringly obscene, predictable and often utterly incoherent. From the entire motley farrago, only the drawings of the *Punch* and *Private Eye* stalwart, Raymond Lowry, and of *Cyclops'* artist, Malcolm McNeill, have any real distinction. Guest appearances by such top calibre American underground cartoonists as Mad John Peck are regrettably rare.

6 Growth in Other Soil

During the first few decades after the founding of *Punch* in 1841, illustrated satirical periodicals inspired by Mayhew's magazine and by Philipon's Parisian journals began to proliferate in the larger European cities. At worst, they were effete carbon copies of their French and British prototypes; at best, they rapidly became the vehicles of pungent political and social satire and outlets for some of the most distinguished graphic wits in Europe.

The pick of the German language crop included *Ulk* (lark, spree) and *Kladderadatsch* (mess, muddle) in Berlin; *Fliegende Blätter* (flyleaves) and Schleich's vehemently anti-Prussian *Punsch* in Munich; *Der Floh* (the flea), *Kikeriki* (cockadoodledoo) and the *Wiener Witzblatt* in Vienna. Best known of all was a somewhat later publication, *Simplicissimus*, which first appeared in Munich in 1896. It took its name (Latin for 'utter simpleton') from a seventeenth-century satirical book by Hans Jakob von Grimmelshausen, *The Adventurous Simplicissimus*, concerning the escapades of a court jester of that name, and became a mouthpiece for anti-British opinion during World War I.

Apart from Philipon's publications, Paris boasted *Le Rire*, *Le Pilori* and *Le Grilot* (the famous weekly *Le Canard Enchaîné* is a relative parvenu, and did not come out until 1915); Turin had its *Fischietto:* Amsterdam its *Notenkraker* (Nutcracker) and Rome its *Don Pirlone*. In Madrid there were *El Sol* and *Don Quixote*, in Athens *Scrips*, in Warsaw *Mucha* (Flea), in Cracow *Djabel* (Devil), in Naples *L'Arlechino* (The Harlequin), in Budapest *Ustökös* and *Bolond Istok*, and in Prague *Humoristické Listy*. Even pre-revolutionary Russia had its illustrated satire sheets, such as *Budilnik* in Moscow and *Strezoka* in Petersburg.

Between many of these continental publications and such London counterparts as *Vanity Fair* and *The Yellow Book* there was much interflow of talent, so that the devotee of pictorial satire in Sidcup or Sunderland had the opportunity of being on as familiar terms with the work of Gill and Gulbransson as with that of 'Ape' and 'Spy'.

Fliegende Blätter regularly featured the work of such brilliant graphic humorists as Adolf Hengler and Adolf Oberländer; *Kladderadatsch* had Ludwig Stutz, G. Brandt and Willibald Krain; whilst *Simplicissimus* drew at various times on the talents of Ernst Barlach, Karl Arnold, J. C. Engh, Jules Pascin, A. Durrer, Ferdinand van Reyniek, Thomas Heine, Rudolf Wilke, Eduard Thöny, Bruno Paul, W. Schultz, 'Blix' and the Norwegian expatriate, Olaf Gulbransson. Among the French contingent were such masters of pictorial contumely as Steinlen, Cham (Amédèe de Noé), Charles Léandre, André Gill, Jean Louis Forain, Henri de Toulouse Lautrec and a Parisian of Russian extraction, Emmanuel Poiré, whose pseudonym—'Caran d'Ache,' was merely the Russian word for a pencil, *karandash*, in thin Gallic disguise. To the late *Punch* cartoonist, H. M. Bateman, 'Caran d'Ache' was 'the best of them all'.

Across the Atlantic, a lusty school of polemical illustration—which, in its aspirant days, was largely dependent for its inspiration on the established traditions of the motherland—had been flourishing since pre-revolutionary days. Publications combining graphic with verbal journalism, however, emerged somewhat tardily in the infant United States.

An indigenous school of American graphic satire may be traced back to the first of the original designs to be issued by the silversmith, engraver and staunch separatist, Paul Revere, who had begun his publishing career by distributing copies of English prints sympathetic to the colonial cause. During the 1812 altercation with Great Britain ('America's Second War of Independence') the works of the American cartoon pioneers James Akin, Elkanah Tisdale, Amos Doolittle and Alexander Anderson were widely disseminated. So were those of William Charles, a Scots exile who had been forced to emigrate to the States after the graphic aspersions he had cast on the moral integrity of the clergy. Despite his stylistic debt to

Rowlandson and Gillray, Charles was no mere plagiarist, and purveyed a rough, Rabellaisian brand of humour that found immediate favour among his American hosts.

William Charles, 'The cat let out of the bag'

During the 1820s, the torrent of personal caricature, that had been initiated by the Revolution and sustained by the 1812 war, abated some-what, although a vigorous school of comic-book and facetious print illustration, transplanted from Europe and sporadically replenished by the arrival of immigrant artists from Britain and the Continent, continued to thrive. The fledgling United States could boast, however, no caricaturist of the stature of Gillray or his protegés on the far side of the Atlantic. The founding fathers of the Union were evidently considered too sacro-sanct to caricature, although a few unflattering studies of Aaron Burr and Alexander Hamilton were produced in a somewhat Gillravian vein by

amateur plagiarists of the great British master.

It was not until the 1830s that personal caricature began to reassert itself in America with a flurry of little pamphlets and broadsheets carrying cartoons whose robust and coarse-grained humour was surpassed only by the uncouth quality of their production. The trail was blazed by *The American Comic Almanac* in 1831; hard on its heels followed *The Comic Token*, *Broad Grins*, *Elton's Comic All-My-Neck*, *The John Donkey*, *Yankee Doodle*, *The Rip-Snorter*, *Whim-Whams* and *The Devil's Comical Texas Oldmannick*—whose titles alone give a fair indication of the execrable standard of humour they contained. The appearance of *Punch* in 1841 provided the impetus for a number of rank American imitations of the London journal—among them *Punchinello*, *American Punch* and *Southern Punch*—some of which did not even go into a second edition.

While there was no dearth of cartoonists in pre-Civil War America, scarcely half a dozen were to contribute anything of enduring merit or originality. Napoleon Sarony, Henry James Finn and Thomas Butler Gunn stand out from the farrago of lesser practitioners, as do the somewhat later David Claypoole Johnston and Edward Williams Clay. Clay's 'Life in Philadelphia' series contained witty lampoons on the affectation of modish manners by freed Negro citizens, while Johnston was sometimes referred to as 'the American Cruikshank'—not through any stylistic kinship with the English cartoonist but because, like Cruikshank, he published annual anthologies of his work.

It was not until well after the civil war that the first competent counterpart to *Punch* and the Parisian journals of Philipon was launched in the United States. This was *Puck*, founded by Joseph Keppler, Sr, an actor manqué of Viennese birth. Soon after his arrival in America, Keppler had founded a German language satire sheet, *Die Vehme*, in St Louis, centre of a large German-speaking region. The first *Puck* was wholly in German. Subtitled an '*illustrirtes, humoristisches Wochenblatt*', it carried cartoons by such imported Viennese artists as Karl Edler von Stur and F. Graetz. Graetz, it was said, spoke so little English that cartoon ideas had to be translated for him into German. For the English version of *Puck*, Keppler

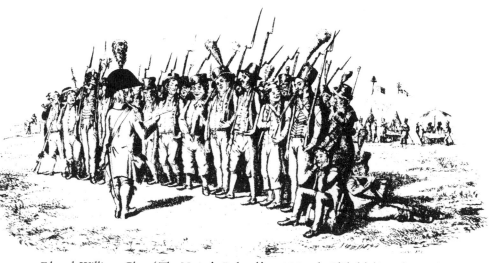

Edward Williams Clay: 'The Nation's Bulwark', satirising the Philadelphia militia and said to feature several well known local figures

himself produced an impressive succession of brilliant satirical studies, including the memorable 'Puckographs'—a series of witty antiportraits of prominent citizens. Discontinued after Keppler's death, the 'Puckographs' were later resuscitated by Frank Nankivell, an Australian-born cartoonist whose Beerbohmesque caricatures added a distinctly modernistic note to the fin-de-siecle *Puck*. One of Keppler's most talented artists on the infant *Puck* was Barnard Gillam, an Englishman who later transferred his allegiance to a rival publication, *Judge*, which James A. Wales brought out in 1881. The hiatus left by Gillam in *Puck* was subsequently filled by such first rate native cartoonists as Eugene Zimmerman, Louis Dalrymple, C. Jay Taylor, S. Erhart (a specialist in Negro and Irish immigrant types) and Syd B. Griffin, who produced some hilarious animal fables and graphic skits on hunting themes.

Technically flawless though the work of Keppler and Gillam assuredly was, their talents as pictorial satirists were completely overshadowed by the master of the late nineteenth-century American cartoon, Thomas

Nast. A native of Landau in Germany, Nast had been brought to America by his mother at the age of six. By 1855, when only fifteen, he was working as a regular draughtsman on *Frank Leslie's Illustrated Weekly*; at nineteen he was on the staff of *Harper's Weekly* and at twenty was dispatched to London by the *New York Illustrated News*. While in Europe, Nast went to Italy to cover Garibaldi—sending drawings both to the *Illustrated London News* and to several American publications.

On his return to the States, Nast, still only twenty-two, won widespread acclaim for his cartoon 'After the Battle', which attacked Northerners opposed to intensifying the war against the South. This and subsequent drawings in *Harper's Weekly* prompted President Lincoln to refer to the cartoonist as 'our best recruiting sergeant'. The South, at this time,

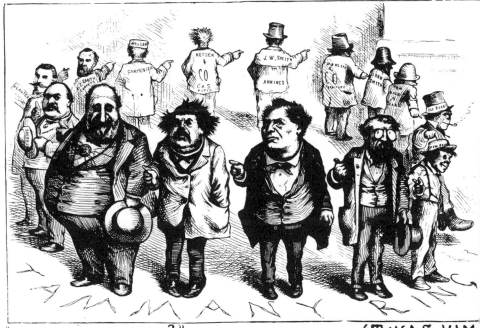

"WHO STOLE THE PEOPLE'S MONEY?" — DO TELL . N.Y.TIMES 'TWAS HIM.

Thomas Nast, one of his anti-Tweed cartoons

could boast no graphic propagandist of Nast s stature, although Dr Adalbert J. Volck, another German expatriate and a dentist by profession, produced a number of fine pictorial satires for the Confederate cause.

After the war, Nast turned his predatory pen against the activities of William M. Tweed and his henchmen, a pack of grafters including 'Brains' Sweeney, 'Slippery Dick' Connolly and Mayor 'OK' Hall. 'Boss' Tweed, as Grand Sachem of Tammany Hall (the executive committee of the Democratic Party of New York County) had bludgeoned his way to absolute power within the organisation and later, while serving as a state senator, had forced a new city charter creating a board of audit enabling him and his unscrupulous cohorts—the 'Tweed Ring'—to seize control of the city treasury, which they proceeded to drain of some two hundred million dollars. Nast's relentless cartoon crusade against Tweed did much to expose the corrupt practices of the Ring, and his numerous caricatures of the Grand Sachem served the police as an 'Identikit' which led to the arrest of Tweed in Vigo, Spain. In 1902, Nast, now impecunious as the result of a series of ill-placed speculations, was appointed US Consul General at Guayaquil, Equador, where—until his death from the dreaded 'Yellow Jack'—he devoted his final years to book illustration. Outside the field of individual caricature, Nast was one of the most prolific inventors of cartoon symbols, his best known personifications being the Republican Party Elephant, the Democratic Donkey and the Tiger of Tammany Hall, inspired, it is said, by John Tenniel's 'Bengal Tiger'.

One of Nast's associates in his early days as a graphic journalist for Frank Leslie was William Newman, an English exile and former *Punch* cartoonist who had been ostracized by his fellows on the staff of Mayhew's magazine on account of his 'lack of breeding and common manners'. Newman's sharp sense of satire and the pungent ribaldry of his humour won him great popularity in the less squeamish United States, and his work was a regular feature of *Phunny Phellow, Comic Monthly, Jolly Joker, The Budget of Fun* and other humorous periodicals from Frank Leslie's stable.

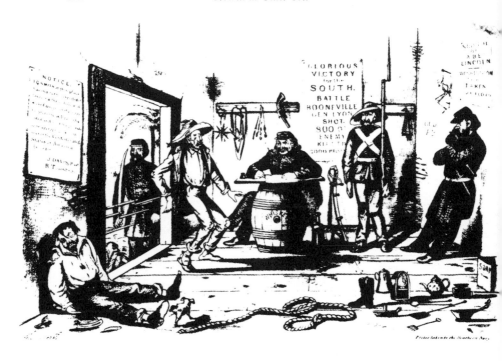

Thomas Worth. Note the effigy of 'Old Abe' hanging from a nail in the wall.

Although dominated by the figures of Keppler, Gillam and Nast, the field of American graphic humour during the last three decades of the nineteenth century was rich in distinctive minor talents. One of the star contributors to the short lived *Punchinello* was H. L. Stephens, who mingled cloudy blacks with shimmering webs of cross-hatching in the most decorative fashion. J. Bowker's crude, deceptively ingenuous style bore unmistakable echoes of Lear and misty foreshadowings of Thurber. Augustus Hoppin made up for a rather shallow sense of humour with his impeccably academic draughtsmanship. Livingston Hopkins was a cutting caricaturist who later emigrated to Australia to work until his death

for the *Sidney Bulletin*. One of the most prolific American cartoonists at this time was Frederick Burr Opper, who made his name at the age of nineteen with the magazine *Wild Oats* in 1876, went on to illustrate Bill Lye's humorous *History of the United States* in 1894, and was later known for his seminal strip cartoons—'Happy Hooligan', 'Maud the Donkey' and 'Alphonse and Gaston'. Perhaps the most impressive of all the American cartoonists around the turn of the century was Frank Bellew, another British import, of whom Charles Dickens' London magazine, *All the Year Round*, observed: 'He probably originated more, of a purely comic nature, than all the rest of his comic brethren put together'. There was also Sol Eytinge, whose illustrations to the American editions of Dickens' novels are, though wholly appropriate, stylistically far removed from those of the novelist's British illustrator, Halbôt K. Browne (Phiz).

A Chip Bellew strip cartoon from 1895. Chip was the son (or 'chip off the block') of cartoonist Frank Bellew.

Matt Morgan was another of the many nineteenth-century British cartoonists who made America their home. Morgan, who had established a formidable reputation in his own country for his vicious graphic canards against President Lincoln, was brought to New York in the early 1870s by his erstwhile compatriot, Frank Leslie (who, incidentally, had been born Henry Carter in Ipswich). Leslie's intention was to pit Morgan against Thomas Nast in the Grant-Greeley contest for the Presidency, but Morgan proved unequal to the task. His grasp of the subtleties of American politics was weak and he apparently 'never learned to draw an American face; all his figures, good or bad, were cockneys of the purest water'. Having crumpled ignominiously under Nast's thundering broadsides, Morgan turned to less hazardous pursuits—such as theatrical design and the decoration of pottery.

Two other American cartoonists by adoption were the Canadian, Palmer Cox, and the dandyish Englishman, C. Grey-Parker. Cox illustrated his own books, such as *Hans von Pelter's trip to Gotham* (the adventures of Hoboken German in New York City), and also created the well-loved 'Brownies' range of characters for the *St Nicholas Magazine*. C. Grey-Parker's lampoons on fashionable society mirrored those of *Punch's* George du Maurier, whose relish for elegant and statuesque women he shared; he also drew intermittently for the *Graphic*, the first American newspaper to feature daily illustrations.

When, in 1883, John Ames Mitchell and Edward S. Martin founded *Life*, their avowed intention was to introduce a satirical weekly of 'higher artistic merit' than such 'colored contemporaries' as *Puck* and *Judge*. While appreciably more decorous and less pungent than their counterparts in the longer established comic weeklies, the early *Life* cartoons afford us a priceless glimpse into the social customs, prejudices and pretensions of late nineteenth-century middle class America. Besides Mitchell himself, F. W. Attwood, H. W. McVickar and W. H. Hyde provided the social satire, as, initially, did Palmer Cox. Cox, however, was not a satirist of the first water, and his illustrated animal fables were incomparably funnier than his social cuts. The infant *Life* also featured the exquisitely tasteful

drawings of Charles Dana Gibson, a stylish illustrator whose admiration for Phil May was undisguised. The 'Gibson Girls', sophisticated and elegant young socialites, rapidly became a national institution, and exerted a long-sustained influence on the fashions, deportment and mannerisms of a generation of American belles. Although a social satirist par excellence, Gibson occasionally dabbled in portrait caricature and helped to establish the stock cartoon types of such political luminaries as Woodrow Wilson and Theodore Roosevelt. The cool suaveté of Gibson's style, and his emphasis on academic finesse at the expense of humorous content, were two features perpetuated by his three most notable disciples, James Montgomery Flagg, J. Conacher and Orson Lowell. Another specialist in *beau monde* themes was Gibson's contemporary, S. W. van Schaick, who depicted gracious ladies with all the panache, but somewhat less of the technical expertise of his English mentor, du Maurier.

By contrast, Michael Angelo Woolf was enthralled by scruffy little slum children, whom he represented with humour and pathos, and executed in a style that, notwithstanding its overtones of Cruikshank and Leech, still looks remarkably fresh and undated. Woolf's repertoire of little horrors were the lineal descendants of Busch's Max and Moritz and second cousins to Rudolf Dirks' Katzenjammer Kids. Equally engaging were the 'Humor in Animals' illustrations of William Holbrook Beard, a specialist in gentle whimsy, and T. S. Sullivant, one of America's most gifted draughtsmen, whose use of distortion for comic effect became more pronounced as his style ripened.

One of the increasing number of American cartoonists to establish an international reputation was *Life's* Hy Mayer, an artist of German extraction. During his several visits to Europe, Mayer contributed a great deal of work to the Parisian *Figaro*, to Berlin's *Fliegende Blätter* and to *Jugend* (Youth) of Munich. One of Mayer's contemporaries, Clifford Berryman of the *Washington Post*, takes the credit for creating the teddy bear which has become a universal nursery toy. His 1902 cartoon, 'Drawing the line in Mississippi', was inspired by an incident during one of Theodore ('Teddy') Roosevelt's hunting trips, during which the President refused to

shoot a bear cub. So popular was the cartoon, that Berryman adopted the cub as his 'dingbat' or pictorial signature, and soon teddy bears based on his prototype drawing were being marketed throughout the world.

In 1911, *The Masses*, a new humorous periodical of outspokenly socialist and pacifist leanings, first appeared; it was destined to run until the closing months of World War I. The most distinguished of its artillery of fine cartoonists were John Sloan (joint editor with Max Eastman); the grotesque and rough-grained George Bellows; the thundering cynic, Boardman Robinson, Bob Minor (who later quit cartooning to stand as Communist Party candidate for the governorship of New York) and the inimitable Art Young, one of America's most superb graphic commentators. Two years after the US government's suppression of *The Masses* in 1917, Art Young launched *Good Morning*—'the weekly burst of humor, satire and fun', whose leftish bias was scarcely less pronounced than that of *The Masses*. During its two year run, *Good Morning* featured the work of such astringent pictorial satirists as William Gropper and Alfred Frueh, who, like Art Young, was later to appear regularly on the pages of the *New Yorker*.

This latter publication, which was launched by Harold Ross in 1925, resembled the infant *Punch* in its aspirant days. Urbanely witty, suavely satirical and replete with fashionable chit-chat, the *New Yorker* catered specifically for the intelligentsia, and its presentation and brand of whimsy were suitably sophisticated. From the outset, the *New Yorker* was shot through with the irrational, 'zany' element that is so ingrained a feature of American humour, and it was Ross's magazine that accelerated the erosion of all gratuitous verbiage from cartoon captions.

The influence of both these practices on *Punch* was not immediately appreciated; indeed, 'mad' humour and elliptically worded cartoons did not begin to infiltrate the British journal in any numbers until E. V. Knox had succeeded Owen Seaman as editor in 1932. Seaman's initial reaction to the brash transatlantic parvenu, with its glossy appearance, outlandish brand of whimsy and somehow 'suggestive' quality, had been to make *Punch* even more obdurately old-fashioned than it had been hitherto. By

the outbreak of World War II, however, the innovations in graphic humour initiated by the *New Yorker's* artists had won a firm toehold in *Punch*, and there has since been an almost unbroken transatlantic traffic of influences between these, the two most distinguished satirical journals in the English-speaking world.

Among the most outstanding of the early *New Yorker* cartoonists was Alfred Frueh—already mentioned in connection with *Good Morning*. A decorator in the Toulouse Lautrec tradition, Frueh specialised in caricatures of stage personalities. Ralph Barton had a penchant for depicting superbly degenerate old roúes; Rea Irvine's fulsome females were delineated with an almost Oriental elegance and economy of line, whilst Gluyas Williams, a sharp business satirist, judiciously combined chiaroscuro effects with a meticulously calligraphic line and was aptly likened both to Bateman and to Beardsley. Undoubtedly the most influential of the early *New Yorker* cartoonists was Peter Arno, who was to the magazine what Gibson had been to the pre-war *Life*. Arno's favourite subject matter—ritzy metropolitan society—his vigorous drawing style and his effective use of half tone washes were plagiarised by a succession of later, and invariably lesser, contributors to the *New Yorker*.

While Arno and the other *New Yorker* pioneers were little known abroad, save among cartoon cognoscenti, the works of James Thurber, a somewhat later contributor to Ross's journal, rapidly won international recognition. Thurber, a writer/artist with a childishly elliptical style of drawing, purveyed a singular brand of whimsy that was seldom wholly rational and seemed on occasions to issue directly from some dreamlike region of the subconscious. Although Thurber's devotees are legion, it is impossible to account precisely for his wide appeal. His idiosyncratic and barely logical humour is the result of a very rare kind of mental alchemy that perfuses his vast repertoire of comic situations with a distinctive charm that is as indefinable as it is irresistible.

C. E. Martin is one of the few contemporary American cartoonists to have succeeded in capturing something of the Thurber essence, although most of his confrères on the current *New Yorker* are more squarely in the

deep-rooted tradition of American 'situational' humour. Such are William
Steig, one of the archetypal American cartoonists of the forties and fifties
and still producing a steady stream of splendid ideas; Alain, who looks to
British eyes rather like a transatlantic Sprod; Perry Barlow, who blends
a casual drawing style with decoratively fluid ink washes; and two expo-
nents of the sophisticated, 'short-hand' method of social lampoonery so
typical of American pictorial satire, the suave Barney Tobey and the
somewhat more declamatory Mulligan.

Thurber apart, how many American cartoonists are widely known
outside their own country—particularly in Britain? Probably as many as
the number of British cartoonists familiar to Americans, who regularly
see the work of Ronald Searle, Norman Thelwell, Kenneth Mahood
Anton, Smilby, Michael ffolkes and others in the *New Yorker* and other
high class humorous publications in the United States. Britons are acquain-
ted, thanks to *Punch*, with such graphic commentators of the American
scene as Arnold Roth and J. B. Handelsman. Charles Addams' repertoire of
ghouls, Otto Soglow's Lilliputian characters, Jules Feiffer's extended
conversation pieces and Saul Steinberg's remarkable creations are well
known east of the Atlantic, as is Charles Schulz' strip, 'Peanuts', which
has been a feature of the *Daily Sketch* for many years. Mort Walker's
incompetent GI, Beetle Bailey, appears somewhat incongruously in the
weekly *TV Comic;* one wonders just how many of the subtle psycholo-
gical innuendoes and social asides with which Walker's strip bristles are
appreciated by the child·readers of this publication. The tradition of
publishing American comic strip features in British humorous periodicals
goes back, in fact, to the days of James Henderson's broadsheet *Scraps*
in the early 1880s: besides culling strips from such American publications
as *Harpers Weekly*, Henderson also featured series by well-known continen-
tal artists, among them Wilhelm Busch, the creator of Max and Moritz.

Another hoary American character, Ernie Bushmiller's Nancy, appears
in the D. C. Thomson comic, *The Topper,* in the strange company of
such native British concoctions as Dopey Joe, Beryl the Peril and Splodge,
the Last of the Goblins. *Playboy*'s cartoonists, such as Cahan Wilson (the

The absence of Prejudice between generations is most marked by constant dialogue based on mutual understanding and disdain.

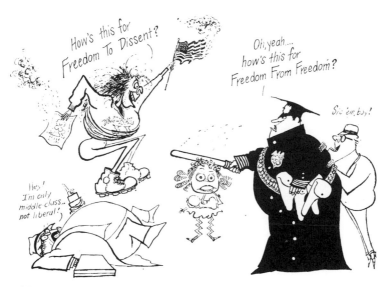

Arnold Roth, who, like J. S. Handelsman, regularly interprets the American scene in cartoon terms to the British

American equivalent of Britain's Tony Escott—both in drawing style and brand of humour), Aldon Erikson, Marty Murphy, Howard Shoemaker, Phil Interlandi, Dink Siegel, Jack Sohl, Shelby Silverstein and Buck Brown are no doubt even more familiar to British readers than their *New Yorker* counterparts.

American cartoonists figure prominently in the publication, *Linus*—which, while new to Britain, where it styles itself 'a serious magazine devoted to all aspects of cartooning', has been available in Italy since 1964. Frank Dickens is the editor and Ralph Steadman the art editor of the British version, which takes its name from one of Charles Schulz' 'Peanuts' range of characters. Apart from articles by the cartoon authority, Michael

Bateman (author of a recent illustrated biography of his namesake, H. M. Bateman) the first edition of *Linus* has graphic contributions from the Britons, ffolkes, Steadman, Dickens, Larry and Johnny Hart. The Americans are represented by the moderns, Schulz, Feiffer and Walt Kelly, the pioneers, Winsor McCay and George Herriman, and by the little known artist, Gustave Verbeek, the pre-World War I strip cartoonist whose features in the *New York Herald* were unique in being legible both upside down and right way up. (See p above.)

The magazine *Mad*, long an institution in America, is now a familiar item on British news-stands. It perpetuates, in contemporary garb, the deep rooted American tradition of irrational humour, and some of its most regular contributors—Mort Drucker, Norman Mingo, Paul Coker, Dave Berg and the superb Don Martin—have already made a profound impression on British trends in pictorial satire, particularly in the field of the so-called 'Underground' publications. One of these, *Friends*, carries the work of such specialists in 'freak fantasy'—laced with a liberal infusion of social satire—as Robert Crumb.

The recently instituted *Punch* feature, 'As they see it', affords Britons the opportunity to savour the reactions of cartoonists all over the world to significant international events. So far, American cartoonists have tended to predominate:—Pat Oliphant of the *Denver Post* (with his 'cartoon within a cartoon', featuring Punk the Penguin), Paul Conrad of the *Los Angeles Times*, and Herbert L. Block (Herblock) of the *Washington Post*, whose drawings also appear sporadically in the *Daily Telegraph*. The *Punch* feature also showcases the work of such fine European political cartoonists as the Germans, Hicks of *Welt am Sonntag*, Köhler of the *Frankfurter Allgemeine* and Murschetz of the *Süddeutsche Zeitung;* Behrendt of the Amsterdam *Parool*, Moisan, Grum and Escaro of the Parisian *Canard Enchaîné*. Cartoon comments from behind the Iron Curtain also appear, such as Szymon Koblynski's drawings from the Warsaw *Szpilki*, and the work of such Soviet pictorial commentators as Lissogorsky, Semyonov, Shukayev and Yefimov, from the official satirical magazine *Krokodil*.

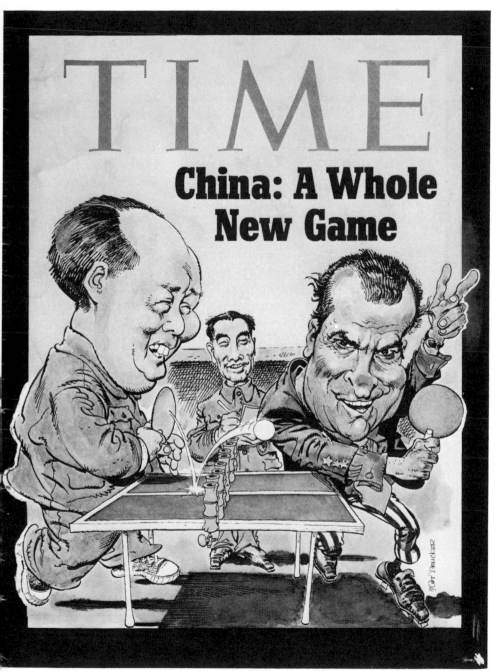

*It is not often that a cartoonist is accorded the honour of designing the cover of **Time**. Mort Drucker is one of the stalwarts of **Mad** magazine, and one of America's most distinctive cartoon stylists*

Of the continental cartoonists, the French are far and away the best known in Britain. André François exerted a catalytic influence on both the style and the content of British graphic humour, and more recently his compatriots, Sempé, Siné and Minet have made contributions. Raymond Peynet's delightful drawings, too, are known in Britain, particularly to *Sunday Mirror* readers, whilst Jean Effel's cartoon version of the Book of Genesis, translated as *In the Beginning*, is proving enormously successful north of the Channel. The exquisitely drawn adventure anthologies of 'Asterix the Gaul', by Uderzo, are appreciated by young and old, as is the equally finely wrought 'Lucky Luke' by Morris.

Italian graphic humorists have also contributed to the British idiom; Giovanetti's hamster, Max, was a *Punch* institution for many years, whilst Enzo Apicello is currently making his mark in several British publications. The sophisticated, international flavour of *Penthouse* is in no small measure due to the fact that the magazine frequently carries the work of such distinctive overseas cartoonists as the German, Hans Georg Rausch, and the brilliant Brazilian satirical artist, Ziraldo. So far, few Scandinavian cartoonists are widely known in Britain—although Lars Jansson's Moomin tribe are an established children's favourite in the *Evening News*.

Australian and New Zealand graphic humour has always been noted—and admired—for its pungency and for the highly individual drawing styles of its practitioners, and antipodean cartoonists have made a disproportionately large contribution to comic illustration both in Britain and the United States. Many of the finest newspaper cartoonists in Britain, from Will Dyson and David Low to Paul Rigby, John Kent, Keith Waite, Arthur Horner, Bill Martin, John Jensen and Bruce Petty, were originally from 'down under', as were the pioneer American animator, Pat Sullivan (creator of Felix the Cat) and Pat Oliphant of the *Denver Post*. Much first-rate Australian and New Zealand comic art, however, remains little known abroad. Of the many superb Australian comic strips, only James Bancks' 'Ginger Meggs' is at all familiar overseas, while the singular talents of such fine graphic wits as Norman Lindsay,

Percy Leason, Frank Dunne, Unk White, William Ellis Green, Ken Maynard and the caricaturist, George Finey, are virtually unknown to non-Australians.

Whilst this is emphatically no reflection on any shortcomings on the part of draughtsmen, it may be due in part to the fact that the bulk of their work is created specifically for the home market. A certain amount of parochialism of this type is, unfortunately, as inevitable in the cartoon as in any form of humorous expression; what is deemed screamingly funny in Ballarat may be meaningless in Battersea or Buffalo.

On the whole, however, it is true to say that the continuous percolation across national and cultural boundaries of graphic innovations and trends in pictorial comedy—as well as the actual interchange of individual talents—has made the cartoon the most universal form of humorous expression.

7 Zap, Wham and Pow

Of all the many paradigms of humorous illustration, probably none is more popularly associated with the concept 'cartoon' than is the comic strip. Although the strip cartoon, in its mature form, is essentially a twentieth-century genus, going back no further than the 1880s, its basic ingredients and techniques are deeply rooted in earlier vernacular illustration, and some of its stock devices—such as 'speech balloons' and horizontal banks of pictures—can be traced back to antiquity.

In the late eighteenth and early nineteenth centuries, illustrated children's books, which may be hailed as the forerunners of the later comic papers and strip cartoons, were already evolving parallel to the type of graphic journalism practised by Rowlandson, Gillray, the Cruikshanks and other pioneers of the satirical and propaganda cartoon. Indeed, may of these selfsame artists were as active in the field of whimsical drawing for the juvenile market as in that of tendentious comic illustration for specifically adult consumption. George Cruikshank, Sir John Tenniel and, in America, E. W. Kemble and A. B. Frost (the latter inseparably associated with Joel Chandler Harris' Uncle Remus tales) are as well known for their children's book illustrations as for their political and social satires; as, on the Continent, is Wilhelm Busch, creator of 'Max and Moritz' and, at the same time, regular contributor to the Munich satirical journal, *Fliegende Blätter*.

Although the genealogy of the juvenile strip cartoon may be followed back via the illustrations contained in the seventeenth-century pedagogic works of Comenius and Bertuch, and thence through the medieval popular print to the animal fables depicted on the narrative papyrus paintings of Bronze Age Egypt, it was not until the eighteenth century

that illustrated pamphlets began to be produced expressly for the infant market. It was in the year 1744 that the London publisher, John Newbery, decided to devote a large portion of his output to illustrated versions of *Giles Gingerbread, Goody Two Shoes, Timothy Ticklepitcher* and other children's tales which he sold, under the collective title *Little Pretty Pocket Books*, from his premises in St Paul's Churchyard.

While Newbery's venture represents an important advance in the evolution of the illustrated children's book, his publications occupy a peripheral position in the pedigree of the strip cartoon. More directly in line with the late nineteenth-century 'Penny Dreadfuls' and their modern offspring, the story, horror and adventure comics, were the Chapbooks, which were sold in vast quantities during the eighteenth and early nineteenth centuries. The Chapbooks (so named from the chapmen, or itinerent pedlars, who hawked them about the land) were cheaply produced pulp pamphlets containing narrative stories, sometimes in serial form. Illiteracy was widespread in Britain at the time of their flourishing and to many generations, especially in outlying country districts and the more benighted slums that had grown up as a result of the Industrial Revolution, the Chapbooks represented the only available form of literature. Drawing their subject matter from traditional legends and popular romances, the Chapbooks presented a wide spectrum of heroes, from the gods of classical mythology to Robin Hood, Jack the Giant Killer and other familiar pantomime figures, whose exploits were followed with as much avidity as were those of their adventure comic descendants, Batman, Captain Marvel and the Incredible Hulk, by later generations. Well thumbed and dog-eared, the Chapbooks—whose little woodcut vignettes condensed within a single frame all the salient associations of the story—were still in circulation among the common folk until well into the last century.

While the Chapbook, like Newbery's *Pocket Books*, occupies a somewhat marginal position in the genealogy of the comic strip, the same cannot be said of the broadsheets cheaply produced by the London printer, Jemmy Catnach, in the early 1820s, for these are as near to the

full blown strip cartoon as were the physiognomic caprices of Abraham Bosse to the caricaturists proper. It was in 1822 that Catnach released the first of his pastiches of Pierce Egan's popular *Life in London* (illustrated as we saw on page 73 above, by George Cruikshank)—subtitling it *The sprees of Tom and Jerry attempted in cuts and verse*. In this broadsheet and its successors (*Tom and Jerry's Rambles in France* and *The Charlie's Holiday or The Tears of London at the Funeral of Tom and Jerry*), Catnach's artists established the essential form of the comic strip—the only typographic difference between their layouts and those of the contemporary strip cartoonists being that the captions—including the dialogue—were set beneath the frames rather than in balloons or boxes within the frames.

It was in 1830—that seminal year in cartoon history during which Philipon founded the first of his satirical journals and Thomas MacLean began to issue his sensational *Monthly Sheet of Caricatures* in London— that a short-sighted Swiss schoolmaster, Rodolphe Töpffer, produced the first of the original novels that he illustrated for his pupils' delectation with simple, cartoonlike drawings. Töpffer's disability, his acute myopia, prevented him from overfilling his frames with superfluous detail, and his influence on the 'shorthand', epigrammatic style of drawing that became the stock-in-trade of the later strip cartoonists was thus partly unpremeditated. Having discovered the effectiveness of the childish doodle as a medium for graphic narration, however, Töpffer developed and refined his technique still further. He continually experimented with new linear effects and produced, in 1845, a brief *Essay on Physiognomy*— in which he demonstrated, by means of primitive thumb nail drawings, the almost limitless range of types and expressions that could be achieved by the mere manipulation and reshuffling of random squiggles. Thanks to the patronage of Goethe, a great admirer of his illustrated novels, a number of Töpffer's works—including *Monsieur Jabot*, *Le Docteur Festus* (a satire on Faust) and the story of *M. Cryptogramme*, were published during the 1840s in the Paris magazine *L'Illustration*.

It was largely as a result of this exposure that Töpffer's drawings, originally intended merely as a diversion for his students, became so

widely known and began to influence the manner of execution and presentation practised by a number of other proto-strip-cartoonists.

In 1847, soon after *L'Illustration's* publication of the Töppfer strips, a German doctor named Heinrich Hoffmann brought out the first edition of *Struwwelpeter* (Shock-headed Peter), an anthology of admonitory anecdotes that was destined to exert a catalysing influence on a long succession of children's books and, more obliquely, on the robust and hard-hitting comic strips of the 1940s and 1950s. The star performers in Hoffmann's tales were diabolical children (Foolish Harriet, Fidgety Philip, Little Suck-a-thumb, Johnny Head-in-Air and, of course, Peter himself) whose reprehensible behaviour invariably visited upon them the direst of consequences. *Struwwelpeter*, which made a sharp break with tradition by featuring delinquent infants rather than the angelic little cherubs who had hitherto been the heroes and heroines of juvenile literature, was (possibly via the intermedium of an obscure Prussian caricaturist named Adolf Schrödter) a precursor of Wilhelm Busch's *Bilderbogen* (picture sheets). The best-known of Busch's anthologies featured the two poisonous little tearaways, Max and Moritz. Arch perpetrators of every conceivable blasphemy, Busch's terrible twins apotheosized that sadistic brand of humour known in Germany as *Schadenfreude*—pleasure derived from the discomfiture of others. Busch, a prolific illustrator and occasional contributor to *Fliegende Blätter*, unleashed his *schreckenskinder* in 1860, and the English version of their escapades, entitled 'A Bushel of Merry Thoughts', proved an immediate success in both Britain (where Busch drawings were featured regularly in James Henderson's proto-comic, *Funny Folks*), and in the United States. In the latter country, they inspired a German immigrant artist, Rudolph Dirks, to create, in 1897, his infamous 'Katzenjammer Kids' (Katzenjammer=hangover, possibly suggested by the title of a Busch story, *Der Katzenjammer am Neujahrsmorgen*). This has become one of the longest lived of all the strip cartoons, its latest redivivus, under the title 'Tales from Bunkum Island' being in the D. C. Thomson weekly, *Topper*.

The influence of Hoffmann's *Struwwelpeter* is also discernible in much

Wilhelm Busch, a scene from one of his 'Max and Moritz' series

of the work of Edward Lear, an English ornithological artist of Danish extraction, whose first *Book of Nonsense* was published in 1864. Lear's kinship with the German doctor, however, is little more than skin-deep; where, with Hoffmann, the cruel, sadistic streak was never far beneath the surface, Lear's creations were imbued with avuncular geniality and wholly free of vitriol. His nonsense poems won instant popularity on both sides of the Atlantic, and although he was plagiarised from the start, not even the best of his imitators—the Americans, Clinton and Cresson (who brought out a Learlike *Book of Bubbles* in the mid-sixties) were able to create more than effete carbon-copies of Lear's inimitable prototypes. Lear's influence, both as a humorist and a draughtsman, is still appreciable today, but his singular qualities, like Thurber's have proved elusive of imitation. The only recent humorist who has come near to capturing their flavour is Spike Milligan, whose strikingly Learlike doodles are a perfect counterpart to his hilariously zany verse.

While Lear, Busch, Hoffmann and Töppfer loom large in the immediate pedigree of the juvenile comic strip, the selfsame devices that these artists employed—simplified drawing styles, continuous sequences of (usually framed) pictures, and (sometimes) speech balloons—were being

exploited by practitioners of adult-orientated pictorial satire. Such early *Punch* cartoonists as Dicky Doyle, John Tenniel and B. Riviere often resorted to the comic strip form of presentation, as did James Sullivan of the penny weekly *Fun*.

In outward appearance, therefore, there was nothing particularly revolutionary about the full-blown strip cartoon, which emerged in its definitive form during the 1880s. First in the field was *Ally Sloper's Half Holiday*, which was released in London by the Dalziel Brothers in 1884 and ran uninterruptedly until 1923. This earliest comic featured the escapades of Ally Sloper, a reprehensible East End sloven (created seventeen years earlier, in 1867, by Charles Ross for the weekly comic sheet, *Judy*) whose irreverent attitude towards authority and the standards of polite society endeared him immediately to the first generation of young working class literates who had benefited from the Education Act of 1870. Ironically, although this, the first of the true comic papers, was a British publication, the artist who drew Ally and the other characters was an American, W. G. Baxter, whose style resembled that of John Leech but whose manner of presentation owed much to the *Punch* artist, Priestman Atkinson, creator of the popular feature, Dumb Crambo.

Two years after the appearance of *Ally Sloper*, the *New York World* followed suit by bringing out its first regular supplement of strip cartoons. From the outset, the comic strip in America evolved along totally different lines from its counterpart in Britain. Whereas comic papers in Britain are aimed, and always have been, almost exclusively at children, the American strip cartoon, which began life as an outgrowth of the editorial newspaper 'cut', is generally intended for adult readers. While *Ally Sloper* was not intended for a particular age group, *Jack and Jill*, released in 1885, was explicitly subtitled 'An Illustrated Weekly for Boys and Girls'. This publication, and its successor, *Snacks* (1889), were the first in a long line of British children's comics.

It was the young Alfred Harmsworth (later Lord Northcliffe), chairman of Amalgamated Press, who launched the first of his 'Ha'penny Bloods', comic papers crammed from cover to cover with cartoon features

140 *Zap, Wham and Pow*

specifically designed for children. Harmsworth's *Comic Cuts* and *Illustrated Chips* were both launched in 1890. Their very titles betray their method of production, for these were still the transitional days when the old boxwood 'cut' had not completely yielded to the metal 'process'. *Comic Cuts* lasted over sixty years, until 1953, when it was absorbed into the *Knockout* comic.

The standard of artwork that *Chips* and *Comic Cuts* offered was incomparably superior to that of the 'Penny Dreadfuls'—the vulgar and garish descendants of the Chapbook—which Harmsworth eventually succeeded in crowding off the market. Two of *Chips'* best loved and longest lived characters, Weary Willie and Tired Tim, the creations of Tom Browne, shuffled on for fifty-nine years, until the demise of the comic in 1953. In 1896, *Chips* and *Comic Cuts* were joined on the paper-stands by *Wonder*, and this advance-guard trio were followed during the years leading up to World War I by a veritable cloudburst of comics, of which *Puck* (no connection with Keppler's American publication of the same name), *Rainbow*, *Chuckles* and *Butterfly* were the most memorable.

After the war, the comic ranks were swollen further, this time by *Film Fun*, *Playbox*, *Tiger Tim's Weekly* and many others, all of which—with the exception of the three mentioned, which lasted until the 1950s—made a brief and unsensational appearance before sinking into oblivion with scarcely a ripple.

Although the strip cartoon had been pioneered in the United States by James Swinnerton, whose feature 'Little Bears and Tigers' appeared irregularly in the *San Fransisco Examiner* from 1892, it was the explosive arrival, four years later, of the sensational 'Yellow Kid' in a Sunday supplement to Joseph Pulitzer's *New York World*, that had the greatest single catalytic effect on the genre in America. The rough and tumble little reprobates in the 'Yellow Kid' were the brain children of Richard F. Outcault, whose equally rumbustious but decidedly more patrician Buster Brown first appeared in the *New York Herald* in 1902. Outcault's repertoire of juvenile roustabouts were the predecessors of a long succession of comic strip *enfants terribles*. Outcault, whose 'Yellow Kid'

made his volcanic appearance in February 1896, was, in the same year, lured away from the *World* by Pulitzer's chief rival, the publishing magnate, William Randolph Hearst, and from October onwards, the 'Yellow Kid' was a regular feature of Hearst's *New York Journal*. Mr Hearst described the *Journal's* garish comic supplement as 'eight pages of iridescent polychromous effulgence that makes the rainbow look like a piece of lead pipe.' Later, Outcault was bought back by Pulitzer at a higher price, but Hearst valued the artist's services so highly that he outbid Pulitzer yet again. Pulitzer conceded defeat and hired George Luks to draw the 'Yellow Kid' for the *World*, while Outcault remained with Hearst until 1897, when he went over to the New York Herald to draw, first, 'Li'l Mose' and, later, 'Buster Brown'. One outcome of this frenetic bout of haggling after Outcault's services was the expression 'Yellow Journalism' (inspired, of course, by the 'Yellow Kid') which is still applied to newspapers of an unscrupulously sensational character.

Hearst soon filled the hiatus left by Outcault with Rudolf Dirks, whose irrepressible German immigrants, Hans, Fritz and the other 'Katzenjammer Kids', were based unabashedly on Busch's 'Max and Moritz'. Hearst's enthusiasm for the Busch characters had first been fired on one of his visits to Germany. The early history of the 'Katzenjammer Kids' was stormy: as the result of a 1912 lawsuit, Dirks lost his right to the original title of his strip. He was, however, permitted to keep the characters, which he continued to draw, under the title 'The Captain and the Kids', for the *New York World*, while Hearst employed another artist, H. H. Knerr, to perpetuate the feature for him under the original title. Two versions of the same strip were thus being produced concurrently on either coast. With the intensification of anti-German sentiment in the years leading up to World War I, Knerr's strip was rechristened the 'Shenanigan Kids', but the original title was later restored, and it is under this name that Joe Musial continued to draw the strip for King Features. (King Features, incidentally, take their name from Moses Koenigsberg, who, as editor of the *Chicago American* in 1904, inaugurated the first regular cartoon strip to run across the top of an

ordinary editorial page—'A. Piker Clerk'—drawn by Clare Briggs.)

Despite the tremendous gusto and vivacity that Dirks and Outcault put into their work, their drawing was, stylistically, still closer to the traditional, richly documented type of illustration practised by E. W. Kemble and A. B. Frost than to the bold, uncluttered type of presentation that is such a hallmark of the present day comic strip. The first cartoonist to combine large, forceful shapes with a simple yet dynamic line—and thus to achieve a strikingly modern effect—was none other than James Swinnerton, America's pioneer comic strip artist, who, in 1905, made a come-back with his 'Little Jimmy' feature in the *New York Sunday Journal.*

Credit for the first daily strip cartoon must go to Bud Fisher, whose popular 'Mutt and Jeff' appeared briefly on the west coast in 1907 before being bought by Hearst for the *San Francisco Examiner;* whilst George McManus was another to be lured by Hearst away from Pulitzer's *New York World.* Like Dirks' 'Katzenjammer Kids', McManus' most celebrated strip, 'Bringing up Father' (whose chief protagonist, an Irish immigrant named Jiggs, bore a striking facial resemblance to McManus himself) was destined to long outlive its creator.

George Luks (who perpetuated Outcault's 'Yellow Kid' for Pulitzer) and Frederick Burr Opper (hired by Hearst in 1899 to draw 'Happy Hooligan', 'Maud the Mule' and 'Alphonse and Gaston'—the latter based on the antics of an impossibly over-courteous brace of Frenchmen) were but two of the many artists who were enticed into strip cartooning by its financial rewards. This drainage away to the Sunday colour supplements of men of the calibre of Greening, Keadle, Haworth and Charles E. Schultze had a debilitating effect on the old satirical periodicals, and neither *Puck, Judge* nor *Life* survived World War I by more than a year or so.

In Britain, strip cartoons were slow to gatecrash the national press in the way that they had done in America. Britain has no counterpart to the bulky Sunday cartoon supplements that are so well established in America, and the great mass of strip-cartoonists continue to work, as

they did in the days of Harmsworth's early Ha'penny Bloods, for children's comics. Until a comparatively late date, the only strips followed regularly by adults in Britain were such American syndicated features as Al Capp's 'Li'l Abner,' Chic Young's 'Blondie', and Charles Schultz's 'Peanuts'. Until the post-war advent of Wally Fawkes' 'Flook', Britain had no homegrown equivalent to America's long-standing 'Gasolene Alley', 'Little Orphan Annie', 'Barney Google' or 'Pogo'—all of which reflect and comment upon, sometimes directly, sometimes obliquely, the social and political scene. Flook, however—originally written by Sir Compton MacKenzie, later by Humphrey Lyttelton and now by George Melly—has a strong satirical content, as has the more recent feature in the *Evening Standard*, Harry Smith's 'Billy the Bee'.

The earliest strips to be featured regularly in the British Press—the *Mail's* 'Teddy Tail', the *Mirror's* 'Pip, Squeak and Wilfrid' and the *Express's* 'Rupert Bear' (from 1915, 1919 and 1920 respectively) were all aimed at young readers, and it was not until 1921 that the *Sketch* broke new ground by introducing the first adult-orientated strip cartoon, Millar Watt's portly and jovial 'Pop'. A year later, the *Star* followed with 'Dot and Carrie', a strip with an office ambience, drawn for forty years by the cartographer and cartoonist, J. K. Horrabin. In the years leading up to World War II, the *Mirror* began to feature such diehards as 'Just Jake', 'Ruggles', 'Beelzebub Jones' and Norman Pett's saucy pin-up girl, 'Jane', whose impromptu stripteases were eagerly anticipated by servicemen from Singapore to the Sahara. These particular *Mirror* strips were closely linked with events in the world at large—whereas their running mates, such as 'Buck Ryan' and 'Garth', were pure fantasy.

In marked contrast to the imposing battery of regular American features that have established toeholds in the European press, all but a few of the British strip cartoons are intended for local consumption. Their humour and associations are invariably insular and their protagonists little known abroad. Two notable exceptions are Reg Smythe's 'Andy Capp' and Frank Dickens's 'Bristow', both of which are widely syndicated overseas. Smythe joined the *Mirror* to draw the 'Laughter

at Work' feature in 1954, and created his Geordie layabout three years later. Andy Capp may be a dyed-in-the-wool Tynesider, but his appeal has proved universal; his incorrigibly slothful habits have won him the affection of readers from Seattle to Istanbul, and he appears regularly in thirteen languages, including Russian. Dickens's 'Bristow' originally appeared in an anthology of the artist's work called *What the Dickens* (1961), and he is now an organic and indispensable part of the *Evening Standard*. To thousands of workers doomed to dull office jobs, Bristow epitomises the tedium of the nine to five routine; they tend to identify with him, and with his pathetic attempts to rebel against the system—many going so far as to write to Dickens about their personal problems.

Today, most of the national British dailies and Sunday newspapers run at least one strip cartoon. In serious content, these range from Arthur Horner's 'Thoughts of Citizen Doe' and John Kent's delightfully risqué 'Varoomshka' in the *Guardian* to the uncomplicated and uncontroversial 'Fred Basset', drawn for the *Daily Mail* by Alex Graham, who was cartooning for *Punch* as long ago as 1945 and whose 'Briggs the Butler' strip ran in the *Tatler* for seventeen years. One of the most ingratiating of the regular newspaper strips is Dennis Collins' 'The Perishers' in the *Mirror*. Featuring an amiable Old English sheepdog called Boot and a cast of ill-clad infants, Collins' strip bears a superficial spiritual resemblance both to Charles Schulz 'Peanuts' and to Walt Kelly's 'Pogo'—although there is little stylistic similarity. The *Sketch* also carries Hugh Morren's feature, 'Wack', which devolves around a philandering Scouse factory hand. Morren's is the only British cartoon strip with a purely industrial background, and owes its origin to the artist's own experience on the factory floor. Wack is a quintessentially British character, whose appeal is decidedly less universal than that of Andy Capp. The same applies to the *Mirror's* 'Larks', a feature which reflects the daily round of the middle class suburbanite. Few of the situations presented in this strip would be any more intelligible to non-Britishers than 'Coronation Street'. Barry Appleby's 'Gambols' strip in the *Express*, however, has a

much wider appeal and is syndicated in even more countries than 'Bristow' and 'Andy Capp'. 'I've reached the ideal solution of fighting the strain of producing the 365-laughs-a-year cartoon strip', quips Appleby, 'I married a girl who can draw and supply ideas.' Peter Maddocks—creator of the late lamented 'Four D Jones' strip which last appeared in the *Express* in 1966, has recently made a welcome return to the Sunday edition of that newspaper with his satirical feature, 'Number 10'.

Both London evening papers carry comic strip features alongside such adventure series as 'Paul Temple' and 'Modesty Blaise'. A neighbour of 'Bristow' on the cartoon page of the *Standard* is 'Clive', written by the award-winning columnist, Angus McGill and enchantingly drawn by a young Dutch artist, Dominic Poelsma. The *Evening News* has Hargreaves' 'Hayseeds', and 'The Wizard of Id' with Johnny Hart's hilarious illustrations.

The longest established, and most consistently witty, of the satirical British newspaper strips is Wally Fawkes' 'Flook' in the *Mail*. Launched in 1949 under the name 'Rufus' (the boy hero of the feature and Flook's constant companion), the strip has always been closely in step with current events—topics of the day being cunningly woven into the unfolding story and public figures appearing as discrete yet instantly recognisable caricatures. Flook's story goes back to 1948, when Lord Rothermere suggested that the *Mail's* art department might concoct a strip similar to a feature he had lately seen in a New York paper. The American feature had starred a little boy and his magic uncle: Rothermere proposed that *his* strip might devolve around a little boy with a magic pet for whom Humphrey Lyttelton coined the name 'Flook', Away from 'Flook', Fawkes has proved himself—with his brilliant *portraits chargés* in the *Spectator*, *Observer* and *New Statesman*, one of the masters of caricature in Britain.

While the first regular strip cartoons were being established in the British national press in the 1930s, the juvenile comic paper received a fresh boost from across the Atlantic by the appearance of the American

New Fun—the first periodical devoted entirely to specially created characters. It was the D. C. Thomson Company of Dundee who took the initiative by releasing the first of their hardy perennials, *Dandy*, *Beano* and *Magic*. These were soon challenged by Amalgamated Press' *Knockout* and *Radio Fun*, whose battery of characters were every bit as hard-boiled and iconoclastic as Thomson's brawling reprobates. The reprehensible roughnecks thrown up by this mid-thirties eruption— Minnie the Minx, Korky the Cat, Biffo the Bear, Desperate Dan, Bully Beef, Keyhole Kate, Pansy Potter the Strongman's Daughter—and their successors in such later Thomson comics as *Sparky* and the *Beezer* (Esky Mo, Hungry Horace, Smiffy, Hocus Pocus, and the Banana Bunch) had more in common with *Struwwelpeter*, with Busch's 'Max and Moritz' and with the 'Katzenjammer Kids' than with the gentle Tiger Tim and other mild-mannered denizens of early British comic strip tradition.

The pint-sized hooligans who zapped and powed their way across the garish pages of *Beano*, *Dandy* and *Knockout* were uncouth and alarmingly robust, displaying not a pinch of respect either for established codes of behaviour or for people in authority, and eschewing every social grace. Partly to offset this uncompromising earthiness and to upgrade what was (often unjustly) considered the abysmal gutter quality of these red-blooded comics, the Rev Marcus Morris launched, in 1950, *Eagle*, first of the hugely successful Hulton weeklies for children. *Eagle* and its later stablemates—*Robin*, *Swift* and *Girl* (now *Princess*)—were imbued with the most commendably Christian virtues which, at times, made them appear positively milk and water in comparison with the profane ribaldry of the established comics that Hulton's hoped to eclipse. *Eagle* and its younger siblings were the first of the post-war British comics to provide information alongside pure entertainment. The comic is now released by IPC magazines (Fleetway Publications) who have grafted it onto the old established story comic, *Lion*.

Beano, *Dandy*, *Sparky* and the *Beezer* are still with us, having lost none of their old gusto; and IPC have recently launched their own *Buster* and *Cor!!*, which are closely akin in spirit to the Thomson indomitables.

Buster features such quintessential strip cartoon types as The Cruncher, Helicopter Hal and the Twitopians, whilst *Cor!!* has Percy Puffer, The Gasworks Gang, Stoneage Brit the Ancient Nit (no relation of the earlier Stonehenge Kit, the Ancient Brit) and Freddie Fang—the Werewolf Cub.

The question of the possible corrupting influence of this type of feature—with its emphasis on violence and irreverence—has been repeatedly raised. So far, however, there is not a shred of evidence that children take their comics seriously enough to be influenced by them in any way. The idea that the comic strip *could* exert any kind of influence on the juvenile reader is based on the false premise that the infant psyche is intrinsically pure and unsullied by aggressive impulses or wicked thoughts. 'Freud has shown', writes Professor Ernest Jones, 'that the child's mind contained in its depths much besides the innocence and freshness that so entrance us. There were dark fears of possibilities that the most gruesome fairytale had not dared to explore, cruel impulses where hate and murder rage freely, irrational phantasies that mock at reality in their extravagance.' Compared to the amorality and the unmitigated savagery that lace the child's imagination, the rough and tumble of the comic strips is mild fare indeed.

The resilience of Lord Snooty and his ilk lies in their very toughness and profanity; their brashness seems to assure them of a longevity denied to the more decorous denizens of the cartoon strip. Lamentable though the fact may be to adults, it is blasphemy and wickedness—not gentility and good manners—that most commend a comic character to its child afficionados, and the life expectancy of a Korky the Cat or a Biffo the Bear is predictably longer than that of a Beatrice Buttercup, a Percy Pickle or a Lettice Leefe. It is not competition from the more abrasive comics alone, however, that has caused the demise of so many of the less aggressive cartoon characters; television has also taken its relentless toll. The increasing tendency is for the children's comic—and its annuals—to draw on television characters—Dougal, the Flintstones, Tom and Jerry, Basil Brush and their ilk—at the expense of the bona fide strip cartoon protagonists. Paradoxically, this situation is exactly counter to

that which prevailed in the early days of the cartoon film, when most of the animated characters were inspired by such established comic strip stalwarts as Krazy Kat, Mutt and Jeff, Little Nemo and Happy Hooligan.

If the children's comic strip in Britain *does* have any serious shortcomings, these are likely to be connected with their actual drawing style rather than their subject matter. The graphic clichés characteristic of the British comic have their origins in the mannerisms of the 1930s and early 1940s. The style as a whole seems to have advanced little since it was first crystalised and defined by such pioneers as the D. C. Thomson artist, Baxandale, and seems to be well-nigh impervious to the influence of more recent developments in adult humorous drawing. Even today, the typical drawing style of the juvenile comic in Britain has a much closer affinity with Donald McGill's seaside postcards than with the work of ffolkes, Mahood, McMurtry and the other influential stylists in the adult field.

What is the future of the strip cartoon? In America, the cartoon supplement and the pulp comic have become so institutional that any forseeable decline in their popularity is almost beyond conception. This would seem to apply as much to such hoary features as 'Blondie' and 'Gasolene Alley'—which Marshall McLuhan believes to have been invalidated by television—as to such comparative parvenus as *Mad* magazine and its imitators.

In Britain, although the outlets for the comic strip are somewhat different from those in the States, the future seems equally assured. While the circulation figures of the juvenile comic weeklies—which have no exact counterpart in America—are said to have fallen to about half what they were in the middle 1950s, there is as yet no appreciable decrease in the number of children's comics on the news-stands. Television has undoubtedly decimated their ranks, yet new comics appear to surface almost as rapidly as others submerge. Ironically, if children's comics in Britain *do* suddenly plunge into a precipitous decline, this will be due rather to the increasing attraction of other entertainment media than to the efforts of well-meaning but misguided adults who see the strip cartoon as a potentially pernicious influence. Reactionary pedagogues and other

self-appointed custodians of infant innocence have been waging war on the comic since the days of Ally Sloper, yet their protests can scarcely be said to have hindered its lusty growth.

The British newspaper strip, particularly the variety that sustains itself on current events as opposed to sheer fantasy, also appears to be well ensconced. Indeed, the comparatively recent appearance of regular strips in such 'establishment' newspapers as the *Observer* and the *Guardian*, which obdurately resisted them for decades, suggests that the validity of this form of presentation as a vehicle for social and political comment is becoming increasingly appreciated. While it is hardly conceivable that the strip will ever usurp the single frame editorial cartoon, it is possible that this format will eventually become an integral part of all our national dailies.

8 Cartoons on the Screen

In the context of the cinema, animation refers to the art of giving apparent movement to inanimate objects; these objects are usually, though not always, hand-drawn images which, when projected one after another in a certain sequence and at a critical speed, fuse together to create an illusion of continuous movement. Although by no means every hand-drawn film is a 'cartoon' in the sense that it features characters similar to or identical with comic strip protagonists, the popular use of the term 'cartoon' as a synonym of 'animated film' is long-established and probably indelible. The equation doubtless owes its origin to the work of such pioneer American animators as Blackton, McCay, Sullivan and Fleischer, most of whose films featured cartoon characters, and the association was later reinforced by the universal popularity of Mickey Mouse, Bugs Bunny, Popeye and other celluloid heroes.

Since time out of mind, artists have sought for ways to make a two dimensional drawing come to life. Ingenious though their methods often were, the ideal remained tantalisingly out of reach until the 1890s. It was then that Georges Méliès discovered that a strip of film consisting of a series of little pictures could, if projected at a certain speed, give the impression of uninterrupted movement.

Among the earliest indications of the artist's striving after the effect of motion are the lifelike representations of wild animals painted between twenty-five and forty thousand years ago on the walls of caves in the south of France and Spain. In one particularly memorable example, the

cave-man artist has created the impression of swift movement by giving eight legs to his subject—a running boar. This is by no means an isolated case; indeed, Palaeolithic cave paintings showing the beasts of the chase frozen in motion far outnumber those depicting them at rest. In 1962, a team of French researchers under Mme Prudhommeau photographed a disconnected series of Stone Age paintings of bison, arranged them in a congruous sequence and projected them onto a cinema screen. The resulting animation, though naturally far from fluid by Disney standards, was remarkably lifelike and a credit to the Palaeolithic artists' acute observation of animals in motion.

This preoccupation with the problems of depicting movement continued over the millenia to hold the graphic artist in thrall. Among the Egyptian papyrus paintings, it is the exceptional one that does not feature the human and animal protagonists participating in some sort of action. One particular frieze from the third millenium BC, showing two athletes in the progressive stages of a wrestling bout, bears an almost laughable resemblance to a sequence of 'key positions' as prepared by a modern film animator. Unable to record every tiny nuance linking one 'key position' to another, the Egyptian artist was forced to produce tier upon tier of drawings which need only the fractional 'in between' stages— and the facilities of a stop-frame camera—to bring them to life.

Later, Greek designers decorated terracotta vases with continuous ribbons of drawings showing the successive phases of a single action— warriors exchanging blows, for example, or gymnasts disporting. When the vessel carrying such a sequence was spun in the hand, the pictures melded together in what appeared to be unbroken action.

Leonardo da Vinci was one of the many great artists to be intrigued by the problems of animation, and a number of his anatomical studies show the limbs in various positions on a single torso. The modern film animator does precisely this when he wants to make an arm or leg move on an otherwise static body, although, unlike Leonardo, he draws the moving parts on separate sheets of transparent acetate and superimposes them over the static parts. The cartoonist, David Low, in an article

comparing Walt Disney with Leonardo, was convinced that, had the great Italian painter been alive today, 'he would have been in his back room inventing simplifications of animating processes and projection devices.' Indeed, the first attempt to animate drawings by mechanical means was made less than a hundred years after Leonardo's death. In 1640, Father Athanasius Kirchener demonstrated to the citizens of Rome a primitive magic lantern with which he appears to have achieved a crude form of animation.

This desire for movement was by no means restricted to artists in the Western graphic tradition. Japanese continuity paintings or *emakimonos*, designed to be read with the unrolling of a scroll, show that Oriental draughtsmen were as ingenious in their efforts to simulate natural movement as their Occidental counterparts. Extended ribbons of narrative pictures were also produced in considerable numbers during the European Middle Ages—mostly as a means of recording the exploits of heroes. In many of these picture sequences, actions begun in one 'frame' are continued in the next in strict chronological progression. The Bayeux Tapestry is thus not merely a forerunner of the strip cartoon, it also anticipates the 'storyboard', the scene-by-scene blueprint of thumbnail sketches referred to by the modern animator at every stage in the production of a cartoon film.

Animation 'in the round' has, of course, been known to puppeteers for hundreds, if not thousands, of years; but a technique for bringing to life two- (as opposed to three-) dimensional figures appears not to have been exploited in the West until the eighteenth century, when cut-out silhouettes known as *ombres chinoises* (chinese shadows) began to be imported into Europe from south-east Asia as novelty toys. This method of making two-dimensional figures move—a tradition rooted in Chinese and Indonesian antiquity—has become the basis for certain stylized animation techniques, and has been refined to an astonishing degree of sophistication by Lotte Reiniger in her exquisite little films.

The first step towards the animation of hand-drawn images on flat surfaces—rather than cut-outs—were taken as early as the sixteenth

century, when 'flipbooks' came into fashion. These contained sequences of (frequently rather lewd) little pictures, which appeared to move when riffled together. There is no way of divining who first hit upon this simple yet effective trick; the idea was doubtless 'discovered' independently in several places. Indeed, the principle of the flipbook is so elementary that there is probably not a schoolboy alive who has not at some time drawn a series of little pin men cavorting about on the top right hand corner of his Latin primer and, in moments of distraction, flipped them into life with his thumb. The popularity of flipbooks continued throughout the nineteenth century—when they were sometimes known by the portentious name of 'kineographs'—and they are still available today. The method is employed by the film animator who constantly resorts to it when checking a sequence of drawings at the early, pencil stage.

A scientific explanation for the illusion of movement created so convincingly by this ingenious trick was first offered in 1825 by Peter Mark Roget. He accounted for the phenomenon by explaining that the retina of the human eye had the faculty for retaining a visual image for a tenth to a twentieth of a second after the actual object had been removed from view. This 'faculty', of course, was an imperfection of perception, and the optical illusion it created had been perplexing scientists since the time of Ptolemy at least. In order to demonstrate the principle, which he called 'persistence of vision', Roget constructed a simple gadget consisting of a cardboard disc threaded onto a string. On one side of the disc he drew a bird, and on the other a cage. When this 'Thaumotrope', as he dubbed it, was rapidly spun, the bird appeared to be inside the cage.

Roget's discovery pointed the way towards novel methods of creating the illusion of unbroken movement, and artists and scientists alike were not slow to exploit the new technique. In 1831, Professor Joseph Antoine Plateau, a native of Ghent in Belgium, invented a Heath Robinson contraption which he named, grandiloquently, the 'Phenakistoscope' (Greek: *phenakos*=deceit+*skopein*=to see or view). An elaboration of Roget's Thaumotrope, the Phenakistoscope consisted of two discs mounted on an axle. The inner disc, which carried a sequence of separate

drawings showing the successive stages of a single movement, was
rotated and viewed through apertures in the walls of the outer disc.
When the inner disc reached a critical speed, the individual drawings
flashed past the viewing slots so briskly that they appeared to fuse together
into an unbroken movement.

Three years after Plateau's experiment, the same optical illusion was
exploited both in Vienna, by a professor of geometry, Baron Von
Stampfer, who called his version the 'Stroboscope', and in Bristol by
W. G. Horner, who developed an almost identical apparatus which he
christened the 'Zoetrope' or 'Daedalum'. It was Horner's model that was
patented in the United States as the 'Wheel of Life' by William Lincoln
in 1867.

The first entrepreneur to recognise the commercial potential of this
method of making moving pictures was Professor Emile Reynaud, who
carried the idea a stage further by employing angled mirrors rather than
viewing slots. The prototype of the 'Praxinoscope' which later won
Reynaud wide acclaim, is said to have been made out of a cake tin for the
amusement of his housekeeper's son, but it was not until 1882 that the
professor introduced his invention to the public at his little Théâtre
Optique in the Musée Grévin in Montmartre. By this time, Reynaud
had added a new dimension to the Praxinoscope by coupling it with
lanterns and reflectors which projected the images onto a screen set in a
miniature proscenium.

Reynaud was not, in fact, the first to combine a magic lantern with a
projector. As early as 1853, an Austrian artillery officer, Baron Franz
von Uchatius, had performed an elaborate experiment involving a dozen
or more phenakistoscopes. Filling each lantern with a drawn diapositive,
the Baron trained them on a common target on the wall and then played
light through each of them in rapid succession with a torch, so that the
separate images seemed to flow together in a continuous movement.
Reynaud, however, was the first to put the idea to commercial use;
whereas previously only one spectator had been comfortably able to
view the pictures at a time, squinting at them through slots in the outer

drum, sizeable audiences were able to attend Professor Reynaud's performances at the Théâtre Optique.

Between 1882 and 1900, Reynaud presented several thousand moving picture shows—many of them in full colour—to an enchanted Parisian public. However, there were serious technical limitations to his primitive method of animation and his audiences were gradually weaned away from the little Théâtre Optique by the early films of Reynaud's competitors, the Lumière brothers, Méliès and other pioneers of the live action film. In 1910, in a fit of melancholy, Reynaud threw most of his equipment into the Seine, and died at the end of World War I in a sanatorium.

Among the most delightful of Reynaud's moving picture shows were those commissioned from his old confrère, Emil Cohl. This pioneer animator, who had served his cartoon apprenticeship under the great caricaturist, André Gill, was later (between 1912-14) to work with the American humorous artist, George McManus—creator of the strip 'Bringing up Father'. Together, McManus and Cohl created the popular animated character, Baby Snookums, and Cohl continued to produce an almost unbroken succession of little cartoon gems until 1918. Ruined by the war, he was unable to persevere with his animation projects, and he died in poverty in the 1930s. Among his early masterpieces was a two minute *tour de force* entitled 'Phantasmagorie' (1908), for which he produced over 2,000 separate drawings. One of the first animators to take advantage of the techniques of the cinematograph, as developed by Méliès and the Lumiéres during the 1890s and refined by Edwin Porter of the Edison Laboratory in the United States, Cohl pioneered the backbreaking method of frame-by-frame animation that has remained essentially unaltered to the present day. Each of his drawings continued, by almost insensible gradations, the movements that had already been completed in the preceding frames. Drawing after drawing was produced until the entire sequence, photographed in chronological order and projected onto a screen, coalesced into an organic, moving whole. Although technical refinements have somewhat simplified the animator's task since the days of Emile Cohl, there are now, as then, distressingly

few short cuts to drawn animation—notwithstanding recent attempts to computerise the craft. A lightbox, a stopwatch, a storyboard, a camera, exposure chart (or 'dope sheet'), a stack of bond paper, an unlimited supply of pencils and a profound grasp of Newton's three Principles of Movement—these (apart from unflagging dedication to what sometimes seems an interminable task) remain the basic necessities of the animator. He has to live with the fact that the impression of continuous and relatively fluid movement can only be achieved by projecting twenty-four separate images in a single second, and that even a ten-minute 'short' will ideally need to consist of over 14,000 individual drawings.

During the first decade of this century, frame-by-frame animation, as developed by Cohl and his fellow trailbreakers, was systematically exploited in the United States. The first indigenous American animated film was James Stuart Blackton's *Humorous Phases for Funny Faces* (1906), which he drew in white chalk on a blackboard. This was followed in brisk succession by the earliest of Manny Gould and Ben Harrison's *Krazy Kat* films (based on George Herriman's strip cartoon) and by Winsor McCay's *Gertie the Trained Dinosaur*. Two years later, McCay based a series of shorts on his popular 'Little Nemo' character in the *New York Herald*. In 1913, John R. Bray and Shamus Culhane brought out their *Colonel Heeza Liar* series, whose chief protagonist was a cruel caricature of Theodore Roosevelt, and in the same year Sidney Smith produced his *Old Doc Yak*.

Having solved the basic problem of making a two dimensional object move on a flat surface, the animators were now free to experiment with every imaginable visual trick, and to take whatever liberties they chose with the physical laws that govern reality. In the fantasy milieu of the cartoon film, the natural principles of gravity, perspective, substance, scale and motion could either be entirely disregarded or manipulated to suit the artist's whim. With absolute impunity, a figure could walk through a solid wall, snap off bits of his anatomy and turn himself into whatever object best suited his immediate needs. With the additional optical effects of slow motion, wipes, dissolves, mixes and irises, there

were virtually no limits to the outrageous feats of visual legerdemain the animator could achieve. Far from holding up a mirror to the real world—as the live action film makers were obliged to—the animator seized every opportunity to abrogate reality and create an environment in which nothing was impossible. Cows jumping over the moon, canaries chasing cats, rhinoceroses blowing fanfares through their horns—these were no longer figments of the imagination; they were the very stuff of the cartoon film.

During the first few years of the Great War, a number of technical advances were made, the cumulative effect of which was somewhat to ease the animator's onerous burden. In 1915, Earl Hurd introduced a method of tracing the animator's drawings onto sheets of transparent celluloid, a novel idea that simplified the problem of photographing more than one character at a time. Prior to Hurd's discovery (for which incidentally, he was still receiving royalties from the entire animation industry until the expiry of his patent in 1940) both background and figures had to be redrawn for virtually every change of frame. Now it was possible for a single background to remain in a fixed position for an entire scene, while the transparent sheets carrying the moving parts of the picture were superimposed above it and photographed one after the other.

In 1916, Bill Nolan (an inventive animator who first perfected such stock effects as 'follow through' and the rubbery action characteristic of so many cartoon characters) introduced the elongated 'panning' background. Designed to slide on metal runners along a table top below the static cells that carried the moving parts of the picture, the panning background greatly enhanced the illusion of fluid movement—although it was, of course, the background itself, not the figures (however fast they seemed to be travelling) that was on the move.

Another luminary in the rapidly expanding constellation of early American animators was Paul Terry (an English expatriate and founder of the famous 'Terrytoon' studio) who made a memorable series of little films about his hayseed character, 'Farmer Alfalfa'. Terry later collaborated with Bud Fisher to produce a series based on Fisher's 'Mutt and Jeff'

duo—the first daily comic strip characters. Together with Louis Glackens, Fisher perfected the technique of painted animation, in which the underside of the cell was coated with opaque emulsion paint, leaving the outlines sharp and undisturbed on the shiny surface.

Probably the best loved of all these early cartoon series were those which the Australian born Pat Sullivan based on his appealing Felix the Cat—inspired, it is said, by Kipling's 'Cat who walked by himself'. The Felix series and others, such as those based on Rudolf Dirks' 'Katzenjammer Kids' and Frederick Burr Opper's 'Happy Hooligan', 'Jerry on the Job' and 'Silk Hat Harry', were amalgamated in 1917 into the International Film Service Organisation. Unlike their European counterparts (painters like Georges Braque, Francis Picabia and Viking Eggerling) who were preoccupied with the animation of abstract forms, these American pioneers of the hand drawn film were more engrossed in figure animation. It is conceivable that, had the films of the early European experimenters been better known and more widely disseminated than those of the American studios, the popular equation between 'cartoons' and animated films might never have arisen.

By the early post war years, the technical innovations introduced by Nolan, Glackens, Bud Fisher and others had made it possible for a single studio to turn out an ever increasing volume of animated films. Where formerly a small team of animators would have been responsible for every stage in the production, from conception to camera—it was now necessary for an aspiring unit to take on additional staff to fill the departments created by the increasingly complicated methods of working. By the mid-twenties, the successful animation company resembled a factory production-line rather than an atelier. With the introduction of cell animation, tracers were needed to transfer the animator's drawings to the transparent sheets, and opaquers to paint in the coloured areas. Artists specialising in backgrounds, layouts, character models, storyboards and special effects were brought in to speed up the process and, as the volume of work increased, checkers were required to ensure that each batch of animation reached the rostrum camera team in the correct sequence for

shooting. Later, with the coming of sound and then colour, studios expanded still further to accommodate colour mixers, sound dubbing technicians, music composers and sound effects experts. In the midst of all this seething activity, the animator, of course, remained the nodal figure; no longer required to be a jack-of-all-trades, however, he was now able to devote his full attention to the business of perfecting and refining his craft.

In 1923, a modest little production called *Alice and the Three Bears* heralded the arrival to the screen of Walter Elias Disney, a former ambulance driver and commercial artist who was to become the doyen of the hand-drawn film in America. It was not, however, until 1928 that Disney introduced, in a film called *Steamboat Willie*, the character with whom his own name was to become synonymous—a character known in those early days as 'Mortimer' Mouse.

Disney's first essay into the field of humorous illustration had been inauspicious. *Life* magazine consistently rejected the cartoons he sent them from the Front, and it was not until after the war, while working for the Kansas City Film Advertising Company, that he—and a coterie of fellow spirits (including his life-long associate, Ub Iwerks)—began to experiment with animated films. Their earliest *Laugh-o-grams* achieved a modest success, though not great enough to enable Walt to give up his part time job as a freelance cameraman.

After the collapse of his first company, Disney tried in vain to break into Hollywood as a director. Undeterred, he and his brother Roy formed a second company and managed to sell a series of shorts to a west coast chain of cinemas. It was in 1923 that they secured a contract for fifteen films under the title *Alice in Cartoonland*—which combined animated drawings with a real-life little girl. The Alice series kept Disney and his team of animators busy for three years, until, in 1926, Walt decided to turn to an all-cartoon formula featuring an animal star, Oswald the Rabbit. Oswald's early career, however, was disappointing for his creator. Disney had overlooked two clauses in the contract with his New York distributors, one depriving him of the rights of the character, the

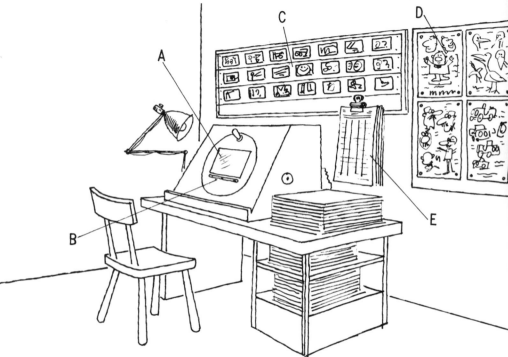

*Animation desk. The animator's drawing board or 'light box' carries a turntable into which is set a pane of ground glass (A) illuminated from below. A sheet of animation paper has three holes which match up with three 'registration pegs' (B) on a metal bar. This ensures that each drawing remains firmly in position when others are placed above it for animation. The animator has constantly to refer to the 'storyboard' (C) (a device attributed to Webb Smith of the Disney Studio) which consists of a sequence of cameo drawings illustrating the successive stages of a scene—and model sheets (D) showing the physical characteristics and relative proportions of the main protagonists in the film. Each drawing is charted on a camera exposure chart (E) (or 'dope sheet'—sometimes referred to as the 'music score' of animation) along with instructions for camera movements. The key animator's drawings are passed to 'in-betweeners' who provide the linking phases between two key positions; each of the pencil drawings is then traced onto an acetate sheet and the areas of colour filled in with opaque paints on the **under** side of each cel to avoid obliterating the drawn lines.*

other giving the distributor an option on Disney and his artists which they could take up unless he reduced his prices. Disney abandoned Oswald and returned to Hollywood. Not that the rabbit went to earth for long; in 1928 Universal Pictures began to release a series of cartoon shorts featuring the erstwhile Disney character, and Oswald films were later produced in a steady stream by Walter Lantz and his team.

Back in California, Disney and Iwerks conjured up the character of Mortimer (later Mickey) Mouse. Although the distributors were reticent at first, unwilling to risk money on an unknown character, the manager of Broadway's Colony Theatre eventually agreed to give the Mouse a chance. Iwerks, however, was disappointed; convinced that his own 'Flip the Frog' had more potential than Mortimer, he broke temporarily from Disney in an unsuccessful attempt to launch his character. He later rejoined Disney but their relationship, it was said, was never again as fraternal as it had been in the old Kansas City days.

Steamboat Willie was not, in fact, the very first Mickey Mouse film; Walt had already produced two shorts—*Plane Crazy* and *Galloping Gaucho*—featuring his star performer. *Steamboat Willie*, however, had a sound track, and that fact alone prompted Disney to release it before the other two films in the series were even sold. In the annals of the cinema, *Steamboat Willie* is conventionally credited as the earliest sound cartoon. In point of fact, Hugh Harmon, another of Walt's Kansas City associates, had already made a cartoon, *Bosco, the Ink Talk Kid*, which had a sound track, at least a year before *Steamboat Willie*, although Harmon has seldom received credit for his innovation.

By 1929, the Mickey Mouse series was proving so successful that Disney was able to expand his studio and he had given up drawing himself when *The Skeleton Dance*, the first of his *Silly Symphonies*, came out that year. With this series, Disney hoped—and managed—to widen his scope and to break away from his exclusive association with the Mouse.

Among the menagerie of strange beasts who made their debut in this highly productive series was Donald Duck, who (complete with his inimitable voice—provided by Clarence Nash, an ex milk-roundsman

whom Walt had heard on a radio talent spot) first appeared in a production called *The Wise Little Hen* in 1934. By this time, Pluto and Goofy, Disney's two other most popular characters after the Mouse, were already well established members of Mickey's entourage.

Disney's fascination with animals—a love that was to perfuse both his cartoon and live action films—had first been kindled in his infancy on a Missouri farm. He was by no means the first cartoonist, of course, to give his animal creations the attributes and mannerisms of humans. The anthropomorphic representation of animals and birds had a long and vigorous tradition in American comic art, stretching back to the bestiaries of such early twentieth-century strip cartoonists as Walt Kuhn, T. S. Sullivant, J. S. Pughe, Bob Addams and Harrison Cady, and to Disney's two great predecessors in the animation field—Pat Sullivan and Max Fleischer, an Austrian born artist who had been cartooning for the screen since his *Koko the Clown* and *Betty Boop* days in the 1920s.

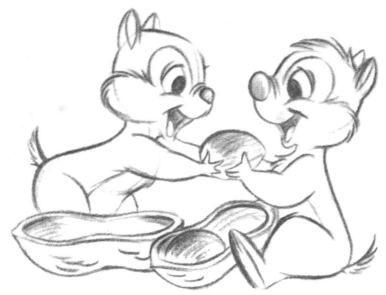

Walt Disney chipmunks

Disney's first colour cartoon, another Silly Symphony called *Flowers and Trees*, (an allegory about a love affair between a boy tree and a girl tree) won him an Oscar in 1933, and from the hugely successful *Three Little Pigs* (1933) onwards, all his productions were in Technicolor. Disney's was by now the largest animation studio in America. At the end of *Snow White*, in 1938, Disney had about 750 artists and technicians in his employ, and was even able to indulge in such luxuries as setting up an art school for his growing team of designers to improve their standards of drawing.

In his early days, Disney had been regarded by cinema savants as a craftsman and innovator on a par with the great live action directors, Mack Sennett and D. W. Griffith. His earliest films had an ingenuous appeal and a spontaneous vitality that is almost completely lacking from his later work. These qualities palpably receded in proportion to his burgeoning financial success, to be replaced by slickness, pretentiousness and maudlin sentimentality. Such elements, already discernible in the shorts he produced during the middle 1930s, completely contaminated the full length features of the immediate pre-war years. Indeed, by this time, cinema audiences had come to expect from Disney a diet of un-alloyed saccharine. Perhaps it had something to do with the atmosphere of the time when they were produced, with the unmistakable tremors of impending doom reverberating in the air; perhaps it all stemmed from Walt's own sentimentality and lack of aesthetic discrimination. Whatever the cause, it is difficult to imagine anything more blatantly lachrymatory than some of the scenes in *Snow White*, *Bambi* and *Dumbo*. Gone were the brash little toughies of the early Disney shorts—they had been transmogrified, one and all, into adorable powderpuffs, gooey eyed and offensively chic. No doubt they captivated Disney's infant patrons (and, after all, it was basically to them that he was catering); but to those who recalled the zest and sparkle of his early work, they were quite nauseating. This is not to deprecate the contribution to the art of animation of such superlative Disney craftsmen as Milt Kahl, Eric Larson, Ollie Johnson and John Lounsbery; but the individualism even of such

brilliant artists as these tended to be embogged in the syrupy morass of
meta-realism that now perfused almost every aspect of Disney's films.

In 1936, Disney embarked on his first full-length animated cartoon,
Snow White. Released two years later, the film was an immediate box
office sensation; over thirty years after its launching, it is still doing the
rounds of the cinema circuits, as are its successors—*Pinocchio* (1939),
Fantasia and *Dumbo* (1941) and *Bambi* (1942). Uncharitable though his
critics may be—on purely aesthetic grounds—in their evaluation of the
full-blown 'Disney style', there is little doubt that the evergreen appeal
of these wartime confections is due as much to their lush stylings as to
their impeccable animation. In *Snow White* were crystallised all the
quintessentials of Disney's graphic style; the hyper-realism, the melting
tones, the rich and vibrant areas of colour, the fulsome contours and
sumptuous backgrounds which either repulse or captivate the viewer.

The 'mature' Disney style (if 'mature' can be used of such a scrambled
artistic mongrel) was in fact an uneasy melange of influences randomly—
though certainly not indiscriminately—plundered from every conceivable
source. In concocting the style and settings of his feature films, Disney's
designers turned to the European masters—from Breughel and Botticelli
to the Impressionists—and to the more formalised conceptions of the
Persian, Indian and Japanese graphic traditions. This eclectic and ill-
assorted ragbag of artistic ingredients was spiked with droll effects lifted
straight from the folk art of central Europe—particularly the woodcuts of
Ludwig Richter and other early illustrators of Grimm's *Hausmärchen*.

In Disney's postwar crop of cartoon epics, from *The Three Caballeros*
(1945), *Make Mine Music* and *Song of the South* (1946) to *101 Dalmatians*
(1960), *Jungle Book* and *The Aristocats* (the last two released after Disney's
death), the over-ripe settings so typical of his earlier full-length features
were seen to yield—albeit almost imperceptibly—as the more individual-
istic mannerisms of designers like Basil Davidovich, Ed Starr, Al Zinnen,
Martin Provensen and Eyvind Earle began to assert themselves.

The recent series based on the *Winnie the Pooh* stories managed to adhere
reasonably faithfully to the original limpid style of Milne's illustrator,

Ernest Shepard, whilst the 1953 film, *Toot, Whistle, Plunk and Boom* (a cartoon history of musical instruments) was Disney's first and only concession to 'limited animation'. The humorous potential of this novel method of animation, in which realism was sacrificed in favour of pixilated, intrinsically comic movements, had for long been beguiling the more progressive and less tractable of Disney's younger artists. In stark contrast to the entrenched Disney style of animation—in which every effort was made to simulate natural movement—limited animation made no pretence at aping reality. Movement was formalised and elemental, restricted to the salient parts of the design. Crude though this sounds in theory, the effects of limited animation are incomparably funnier and more in keeping with the stylised cartoon characters than the pseudo-realism of Disney-style animation. In the Disney tradition, a figure walking across the screen would have as many parts of his body and clothes in motion as possible; hair would bob, folds and creases appear on material, eyes twinkle and fingers twitch. Using the limited method, the artist would animate perhaps only the legs and feet, leaving the rest of the body uncompromisingly rigid.

So anxious was Disney to sustain the illusion of verisimilitude that he even made it standard practice for his artists to base their animation on filmed sequences of living models—both human and animal. As one who worked on *Bambi* said in later years, Disney 'might as well have gone out and taken pictures of real deer, that was the quality he was driving for in the animation'.

Today, when limited animation is the rule rather than the exception, we no longer find the jerky, jagged movements of Yogi Bear or Huckleberry Hound outrageous in the least. Some twenty years ago, however, when Disney grudgingly allowed Ward Kimball and his confreres to use the method in *Toot, Whistle, Plunk and Boom*, limited animation was still daringly innovative. Although the film won an Academy Award, Disney never allowed the experiment to be repeated. But Kimball had proved his point. 'Limited animation', he said, 'can be the best way to put over a humorous idea. Supposing I wanted to show a

couple of teenagers jitterbugging. The best way to show it would be to keep the upper half of their bodies completely still, as *they* do, while their feet are moving furiously'.

Alarmingly novel though the effect of limited animation may have seemed to cinema audiences in the early fifties, it was old hat to the animators—who had long ago realised its humorous potential. Kimball himself had used it sparingly in one scene of a wartime Donald Duck short, and as long ago as 1934, two French artists, Anthony Gross and Hector Hoppin, had exploited the technique—linking it with a simplified style of drawing—in an avant-garde little film called *Joie de Vivre*.

While Disney bestrode the American animation scene like a colossus between the 1930s and 1960s, he did not entirely monopolise it. As early as 1933, the popularity of Mickey, Goofy, Pluto, Donald and other established Disney favourites was threatened by the arrival of the spinach guzzling mariner, Popeye. Originally the star of a strip cartoon by Elzie Segar, Popeye—together with his doting, pipe-cleaner limbed sweetheart, Olive Oyl, and his arch enemy, Bluto—was at first animated by the

Animation camera. Few of the ingenious visual effects that we have come to associate with the modern cartoon film would have been conceivable but for the technical innovations and refinements of John Oxberry, the American cartoonist and engineer responsible for the present form of rostrum camera. This drawing shows a few of the essential features of the animation stand.

A **motion picture camera** *(A) is positioned directly above the artwork, with its lens pointing downwards towards the surface of the* **animation table** *(B). The finished cel, held fast by two sets of 'registration pegs' matching the holes on the animator's drawing board, is flattened by a glass platen over its background. The table top is the movable working area of the animation stand. A* **field position bar** *(C) carries numbered markings which indicate the 'field' (the size of the area to be photographed), whilst* **follow-focus cams** *(D) automatically adjust the focus of each shot to the successive moves of the field position bar. The camera is connected to a* **stop-motion mechanism** *(E), which enables the cameraman to photograph each frame or film separately.*

More recent refinements to this basic set-up include 'multiplanes' of independently lit glass layers which enhance the illusion of perspective (a development pioneered in the Disney studio in the 1930s), and Oxberry's system of 'aerial image back projection'—which enables flat cartoon animation to be superimposed over a live-action image.

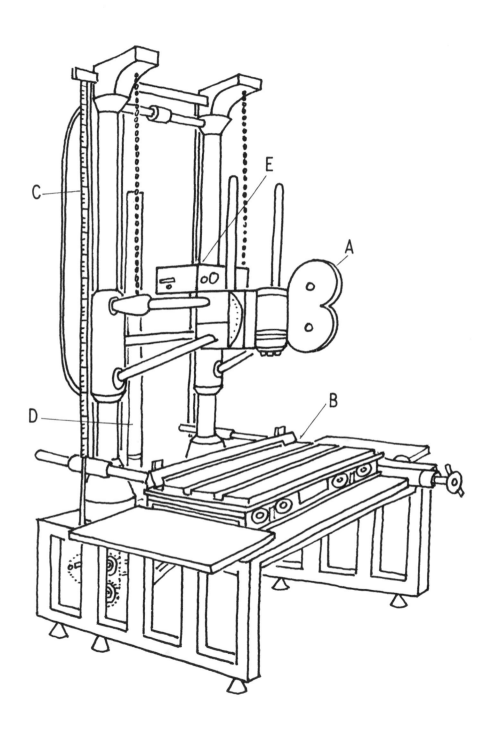

veteran Max Fleischer, but there have been many more recent Popeye series, including one made by the British animation studio, Halas and Batchelor. In 1938—the year of *Snow White*—another rival to the Disney menagerie arrived in the form of Chuck Jones' smart-aleck lagomorph, Bugs Bunny, whose popularity is proving as durable as Popeye's. (Apart from the inexhaustible Bugs Bunny series, Jones has also been responsible for the many *Road-Runner* shorts and has recently launched his first extended feature, *The Phantom Tollbooth*.)

By the early 1940s, the restrictions on experimental work imposed by Disney on his artists had become so intolerable that an exodus took place, a bid for freedom of expression that deprived the Disney organisation of some of its most distinctive talents. This exodus included cartoonists of the calibre of Walt Kelly and Virgil Partch. In 1941, a coterie of these disenchanted animators and designers coalesced to form the nucleus of a group that eventually emerged as United Productions of America. From the outset, UPA's style of presentation was blatantly and aggressively anti-Disney. Their whole philosophy was an eschewance of everything their former employer held sacred. The rigid canons of dimension, proportion and perspective were abused and every concession to reality ruthlessly pruned away until the requisite degree of abstraction had been achieved. Figures were reduced to bold geometric shapes, backgrounds formalised to the point of non-existence. Raw and astringent colours were punched towards the viewer by strident tonal contrasts. These innovations were experienced through the entire animation world as a mighty shock wave and their influence provided a timely infusion of fresh ideas into an art form that was in imminent danger of floundering into a quagmire of superbly executed yet utterly irrelevant detail.

Far and away the most successful of UPA's early ventures was the myopic Mr Magoo, who first blundered onto the screen in 1949. Another favourite with cinema audiences was Bob Cannon's Gerald McBoing-Boing, a little boy who twanged like a jew's harp every time he opened his mouth. Less well known was Ernest Pintoff's human rectangle, Flebus—introduced in 1957. By no means every UPA film, however,

featured original characters. Bob Cannon based one on Ludwig Bemelmans' Parisian schoolgirl, Madeleine, and in 1953 Bill Hurtz brought out his brilliant interpretation of James Thurber's surrealist fable, *Unicorn in the Garden*. An animated film was also made of some of Saul Steinberg's drawings.

Unlike the monolithic Disney organisation, UPA was, from the start, a centrifugal unit; its members were too individualistic in both their styles and aims to form a cohesive, let alone an enduring group, and, before its first decade had passed, most of UPA's founding fathers had struck out to form studios of their own. Despite their rugged individuality, however, each has remained true to the aesthetic ideals of the parent unit, the ideals that drove them, thirty years ago, to flee from the suffocating aegis of Disney. Rudimentary drawing styles, simple animation and, above all, an irrepressible vitality and a healthy loathing of naturalistic effects, still stamp the work of Hurtz, Pintoff, Hubley, Pete Burness, Gene Deitch (now working in Prague) and the other UPA alumini.

Stark linearity, bold shapes, skeletal backgrounds and jangling juxtapositions of tone and colour are equally characteristic of the work of Tex Avery and his disciples. This particular school, however, resorts to violence and sadism much more often than do their fellows at UPA. Avery himself, who first began animating in the early thirties and later joined Walter Lantz on the *Oswald* series, is obsessed with images of destruction, and his horrendous effects have earned him the soubriquet of 'a Walt Disney who has read Kafka'. The incessantly warring Tom and Jerry are the best known of the characters created by Avery's protégés, William Hanna, Joe Barbera and Fred Quimby. These three head the team of MGM animators responsible not only for Tom and Jerry but also for a veritable deluge of other characters—Top Cat, Huckleberry Hound, The Ant Hill Mob, Yogi Bear, Scooby Doo, Quick Draw McGraw, Penelope Pitstop, Ruff and Reddy and the Flintstones—all of them as familiar to television viewers as to cinema audiences. Avery's most engaging character, a penguin called Chilly Willy, has, regrettably, been given

much less exposure than the harder-hitting MGM delinquents.

The same ingredients of limited animation, linear simplicity and violent action favoured by Avery and his faction also stamp the cartoons of Universal's Walter Lantz, the veteran animator, who, besides inheriting Oswald from Disney, worked on some of the early Katzenjammer films. Lantz was also responsible for such popular characters as Andy Panda and Woody Woodpecker. Brutality is less in evidence in the work of Lantz's former collaborators, Friz Freleng (creator of the moustachioed Mexican mouse, Speedy Gonzalez and currently co-director with David de Patie of the west coast studio responsible for the popular *Pink Panther* television series) and Robert McKimson, to whom Daffy Duck owes his origin.

While adults may deplore the non-stop violence typical of so many of these films, maintaining that it has a pernicious effect on juvenile viewers, there is no evidence to support the view that the animated film is potentially any more harmful than the comic strip. Certainly, no Tom and Jerry cartoon is known to have corrupted a child—any more than did Busch or Hoffmann. Although cartoon violence is pure make-belief, it is no sham, for we witness it taking place, see heads severed, victims stretched like india rubber or rolled flat; yet, despite the violence that wracks the screen, few, if any, cartoon characters are killed or sustain any more than momentary disability as a result of the gruesome treatment they receive. In this way, cartoon violence may be compared with the kind of mock atrocities that take place in children's own games, during which, in the thick of battle, with bombs exploding and naked steel being drawn in all directions, Mum's call to the protagonists to get ready for tea is sufficient to put an immediate end to hostilities.

It is somewhat unusual for an artistic movement to originate in America only to find its most sophisticated expression in Europe; more often, the reverse is true. Yet this is precisely what has happened in the case of the cartoon film, and it is in eastern Europe, notably in Poland, Czechoslovakia, Hungary and Yugoslavia, that the highly simplified brand of drawing evolved by the ex-Disney founders of UPA during the 1940s

and 1950s has found its most receptive and inventive practitioners. Not that this state of affairs need occasion undue surprise, for it was in these eastern marchlands of the continent that the starkest, most brutally economical style of satirical drawing—exemplified in the work of the Romanian born cartoonists Saul Steinberg and André François—first found expression. It was hereabouts, too, that the Expressionist movement, with its exploitation of crude graphic shock tactics and deliberate clumsiness of execution, flourished so rankly during the earlier decades of this century.

The Czechs Lehky and Brdečka, the Poles Borowczyk and Lenica, the Hungarians Csermák and Macskassy and the Yugoslavs Vukotić and Kristl, have each created cartoon milieux that have nothing in common with the slavish realism and lush abundance of Disneyland. Their settings are uniformly elemental and their performers so drastically formalized that they either look as if they have been drawn by children or stamped out of metal. The world of the Iron Curtain cartoon film is harsh and uncompromising; totally unrelated to the world of reality, it is an environment where even the most fundamental principles of space, scale and motion attain incredible dimensions. Together, these effects combine to convey an impression of raw immediacy that is often absolutely electrifying. In emphasising the cruder aspects of animation, the exponents of the Iron Curtain 'multiplication film' (as the idiom is styled, for obvious reasons, in eastern Europe) are more akin to the early America 'primitives'—Bray, Hurd, Fleischer and Sullivan—than to Disney. In content, however, few of these east European films have the remotest affinity with their western counterparts. Whereas in America (and, to a somewhat lesser extent, in western Europe) the primary function of the cartoon film is still to divert and entertain, in the east the medium is employed as a vehicle for satire and penetrating social comment. The stylistic predilection of the east European animator for ferocious visual effects is admirably suited for achieving the requisite degree of emotional frisson.

In marked contrast to the savage little cartoon cameos produced in the

satellite states of eastern Europe, are the flat, lacklustre efforts of the Soviet Union itself. The earliest Russian animated films, produced between the mid 1920s and 1930s, were rough-edged and fiercely satirical. In the 1940s and 1950s, however, a tendency towards more naturalistic drawing and an increasing reluctance to be controversial in

A Boris Kolar character from the film 'Concerto for Submachine Gun'

content have drained the Soviet cartoon film of its former gusto. The same is true of the enormous number of animated films churned out for mass consumption by the state owned studios of Communist China. Here, dull realism, unenlivened by the merest hint of imagination or flair, is coupled with banal subject matter to produce an overall effect of bland insipidity.

None of these criticisms, fortunately, can be levelled at the contemporary British cartoon film. In Britain, a flourishing indigenous school of animation goes back via G. E. Studdy, Len Lye, Anson Dyer and the early work of Paul Terry (before he went to the States) to *The Hand of the Artist*, a short feature produced in London in 1907 and believed to be the work of one Walter Booth, a conjurer turned film maker.

The animated cartoon in Britain has always been strongly individualistic; there has never been a British Disney to shadow the field, and the idiom has been repeatedly invigorated by infusions of fresh talent from abroad. Terry Gilliam, for example (noted for his work on the satirical television programme, *Monty Python's Flying Circus*) is an American, Bob Godfrey is an Australian, Dick Williams and George Dunning Canadians. But Britain has probably exported as many brilliant film cartoonists as she has gained. John David Wilson, who started with the Rank Organisation just after the war, went to the States in 1950 to join UPA, where he worked on the Magoo and Gerald McBoing-Boing series. After a few years service with Disney (where he was involved in *Peter Pan*, *Lady and the Tramp* and many Mickey Mouse and Goofy shorts) Wilson formed his own Fine Arts Film studio. Since 1954, he has produced an impressive array of award winning animated films, including *Petrouchka* (for which Stravinsky adapted his ballet score) and the recent *Archy and Mehitabel*— based on the escapades of a cat and a cockroach invented by the American humorist, Don Marquis.

The longest established and most productive of the British studios is that founded in the late 1930s by Hungarian John Halas and his wife, Joy Batchelor. As early as 1934, Halas was making his own cartoons in Paris and before that had assisted his compatriot, the artist and puppeteer,

George Pal, in producing animated films featuring three dimensional
models. Throughout the more than three decades of its existence, the
Halas and Batchelor studio (best known to cinema-goers for their full-
length version of Orwell's *Animal Farm* and to television viewers for their
recent series based on the drawings of the late Gerard Hoffnung) has
maintained a consistently high standard, producing a steady flow of
public service, educational and commercial films as well as entertainment
material for the British and overseas market.

Television commercials constitute the bulk of the output of such smaller
British animation units as Larkins, Biographic, Nick Spargo's Nicholas
Films, World Wide, Digby Turpin's studio and the ateliers run by the
two Canadian expatriates, George Dunning and Richard Williams. At
present, Williams, Dunning and Bob Godfrey are the most distinctive
cartoon stylists on the British animation scene. Williams, who settled in
London in 1955, made his debut with the widely acclaimed *Little Island*,
which he followed in 1962 with *Love me Love me Love me*. He has also
been responsible for many of the more imaginative cartoon commercials
on television. His elder compatriot, Dunning, whose fluid manner of
execution suggests a stylistic affinity with the French film designer,
Barthold Bartosch, arrived in Britain in 1956, bringing with him a
distinguished reputation, and established the still thriving TV Cartoon
studio in Dean Street, Soho. The themes of many of Dunning's films are
so irrational as to verge on the surrealistic, and his conceptions have been
aptly likened to the fantasies of both Kafka and Lewis Carroll.

Bob Godfrey, one of the founders of the Biographic studio (now run
by Nancy Hannah and Vera Linnecar) is a prolific maker of both live-
action and cartoon films. Among his *chefs d'oeuvres* in the latter idiom are
Polygamous Polonius, *Alf, Bill and Fred*, *Do-it-yourself Cartoon kit* and the
recent *Henry 9 to 5*, which takes a satirical look at the erotic preoccupations
of a typical suburban commuter.

As a result of the peripatetic habits of its practitioners, the animated
cartoon has been more strongly exposed to stylistic influences derived
from the graphic traditions of different cultures, European, African,

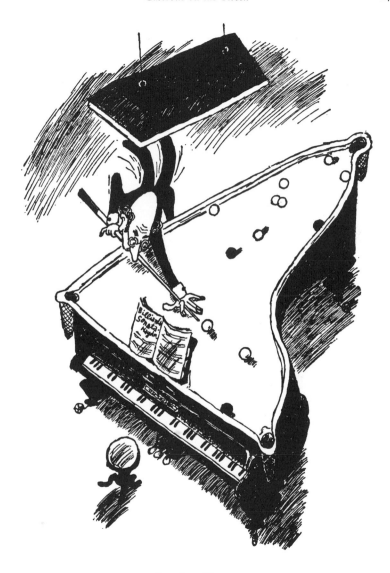

Gerard Hoffnung

Asian—even aboriginal Australian—than has any other form of pictorial whimsy. Just as the animated cartoon drew, in its formative days, on established styles of graphic comedy, so it has now begun to reciprocate that influence by leaving its mark on non-moving humorous illustration. The tendency towards greater simplicity of line and boldness of presentation that increasingly stamps all graphic humour has unquestionably been accelerated and emphasised by the exploitation of identical devices in drawn animation. On a more superficial level, such mannerisms as disproportionately large heads and the reduction of the number of fingers on a hand from five to four (both of which began as utilitarian film conventions) have long since been assimilated into the stylistic repertoire of the non-film cartoonist. This influence may well be due to the fact that many 'still' cartoonists served their apprenticeship in film studios—as did Carl Giles and Stanley McMurtry—while equally many established newspaper and strip cartoonists, such as Peter Maddocks and Edward McLachlan, have experimented extensively with film animation.

It is impossible to bring within the narrow purview of this fleeting survey all the artists who have contributed to the rapid evolution of the animated cartoon and extended the art form to its present broad horizons. The highly idiosyncratic work of Morton and Mildred Goldscholl in the States; of Norman McLaren and Al Sens in Canada; of the Hungarian, Peter Foldes, in Paris; and of the Japanese artist, Yoji Kuri, must, however, be mentioned. While by no means all 'cartoonists' in the sense used in this book, each of these innovators has added new and exciting dimensions to the art of graphic comedy and satire in motion.

The modern animated cartoon has almost wholly severed the umbilical cord that linked it, in its formative years, with static comic art; during its relatively brief life span—which barely covers eighty years—it has struck off boldly at a tangent from the mainstem of pictorial whimsy to become a vigorous and virtually autonomous form of graphic expression.

Bibliography

ADHÉMAR, J. *Honoré Daumier: drawings and watercolours.* (London, 1954).

ARUNDEL, R. M. *Everybody pixilated.* (Boston, 1937).

ASHBEE, C. R. *Caricature.* (London, 1928).

BATEMAN, M. *The man who drew the 20th century.* (H. M. Bateman). (London, 1969).

 ,, ,, *Funny way to earn a living.* (London, 1965).

BECKER, S. *Comic art in America.* (New York, 1959).

BERGER, A. *Li'l Abner—a study in American satire.* (Twayne, 1970).

BERRYMAN, C. *Development of the cartoon.* (Columbia, Missouri, 1926).

BIRD, K. ('FOUGASSE'). *The good-tempered pencil.* (London, 1956).

BUSS, R. W. *English graphic satire.* (London, 1874).

BYRNES, G. L. *The complete guide to cartooning.* (New York, 1950).

CARCO, F. *Les humoristes.* (Paris, 1921).

CECIL, D. *Max—a biography.* (London, 1964).

CERAM, C. W. *Archaeology of the cinema.* (London, 1965).

CHASE, J. *Today's cartoon.* (New Orleans, 1962).

DAVIS, R. *Caricature of today.* (London, 1928).

EHRENZWEIG, A. *The hidden order of art.* (London, 1967).

EVERITT, G. *English caricaturists.* (London, 1886).

FIELD, R. D. *The art of Walt Disney.* (London, 1947).

FRAYDAS, S. *Graphic humor.* (Reinhold, 1961).

FREUD, S. *Wit and its relation to the unconscious.* (London, 1917).

FUCHS, E. *Die Karikatur der europäischen Völker.* (Berlin, 1901).

 ,, ,, *Die Juden in der Karikatur.* (Munich, 1921).

GEORGE, D.M. *Hogarth to Cruikshank: social change in graphic satire.* (London, 1967).

 ,, ,, *English political caricature.* (Vol I, to 1792, Vol II, 1793 to 1832). (Oxford, 1959).

GOMBRICH, E. *The cartoonist's armoury.* (London, 1962).

 „ „ *The experiment of caricature* in *Art and illusion.* (London, 1960).

 „ „ and KRIS, E. *Caricature.* (London, 1940).

GRAVES, C. L. *Mr Punch's history of England.* (London, 1922).

GREGO, J. *Rowlandson the caricaturist.* (1880).

HALAS, J. and MANVELL, R. *The technique of film animation.* (London, 1959).

 „ „ „ *Design in motion.* (London, 1962).

HANCOCK, L. *American caricature and comic art.* (New York, 1902).

HESS, S. and KAPLAN, M. *The ungentlemanly art: a history of American political cartoons.* (New York, 1968).

HIGHET, G. *The anatomy of satire.* (London, 1962).

HILL, D. *Mr Gillray the caricaturist.* (London, 1965).

HODGART, M. *Satire.* (London, 1969).

HOFFMANN, W. *Caricature from Leonardo to Picasso.* (New York, 1957).

HOGBEN, L. *From cave painting to comic strip.* (London, 1949).

KELLER, M. *The art and politics of Thomas Nast.* (Oxford, 1968).

KLOSSOWSKI, E. *Honoré Daumier.* (1923).

KRIS, E. *'The psychology of caricature'.*

KRIS, E. and GOMBRICH, E. *'The principles of caricature'.*

(Both essays in *Psychological explorations in art.* (New York, 1964).

LEVINE, J. *Motivation in humor.* (New York, 1969).

LINDESAY, V. *The Inked-in Image—a survey of Australian comic art.* (Melbourne, 1970).

LOW, D. *Autobiography.* (London, 1956).

LYNCH, B. *A history of caricature.* (London, 1936).

MAURICE, A. B. and COOPER, F. T. *The history of the 19th century in caricature.* (New York, 1904).

McLEAN, R. *George Cruikshank, his life and work as a book illustrator.* (London, 1948).

MIKES, G. *Humour in memoriam.* (London, 1970).

MURRELL, W. *A history of American graphic humor.* (Vol I 1747-1865, Vol II, 1866—ca. 1930). (New York, 1933).

NEVINS, A. and WEITENKAMPF, F. *A century of political cartoons.* (New York, 1944).

PARTON, J. *Caricature and other comic art.* (New York, 1877).

PENN, A. *The growth of caricature.* (The Critic, 1882).

PERRY, G. and ALDRIDGE, A. *The Penguin book of comics.* (London, 1967).

PRICE, R. G. G. *A history of Punch.* (1957).

ROSE, J. *The drawings of John Leech.* (London, 1950).

SCHICKEL, W. *Walt Disney.* (London, 1968).

SHERIDAN, M. *Comics and their creators.* (Boston, 1944).

SPIELMANN, M. H. *A history of Punch.* (London, 1895).

STEPHENSON, R. *Animation in the cinema.* (London, 1967).

THOMAS, B. *The art of animation.* (New York, 1958).

TOBIAS, R. *The art of James Thurber.* (Ohio U.P., 1969).

WAUGH, C. *The comics.* (New York, 1947).

WHITE, D. and ABEL, H. *The funnies—an American idiom.* (New York, 1963).

WHITE, R. G. *Caricature and caricaturists.* (New York, 1862).

WRIGHT, T. *A history of caricature and the grotesque in literature and art.* (Reprint by Ungar, 1968).

A Cartoon Chronology

1483	Martin Luther—the first to make use of pictorial propaganda on a massive scale.
1494	First edition of Sebastian Brandt's *Narrenschiff* (Ship of Fools) containing burlesque woodcut illustrations by Albrecht Dürer.
1529-c1830	Word 'Antic' used in English to describe monstrous, grotesque and fantastic representations in the animal or vegetable kingdom.
1530	Giuseppe Arcimboldo—1593.
1557	Agostino Carracci—1602.
1560	Annibale Carracci—1609.
1568	During revolt in Netherlands, Holland becomes chief source of pictorial propaganda.
1576	Fox's *Book of Martyrs* features satirical cuts.
1585	Geoffrey Whitney's *Choice of Emblems* boosts popularity of emblem books in England.
1592	Jacques Callot—1635.
,,	Johann Amos Comenius—1670. Produces didactic books for children—illustrated with simple woodcuts.
1598	Giovanni Lorenzo Bernini—1680.
1600-10	Coke's *Reports* mention various forms of libel as 'writings, emblems *and pictures*'.
1602	Abraham Bosse—1676.
1609	Adriaen Brouwer—1638.
1610	Christoph Jamnitzer's *Nieuw Grottessken Buch.* (Nuremberg).
1640-41	English polemical prints come into their own.
1643	Adj 'grotesque' first used in English to describe figures or designs comically distorted or exaggerated.
1649	Mosini's *Diverse Figure*—first recorded use of the word 'Caricatura'.
1656	Raymond La Fage—1690.

1673	Claude Gillot—French comic courtly painter—1722.
1674	Pier Leone Ghezzi—first professional cartoonist—1755.
1697	William Hogarth—1764.
1740	Arthur Pond publishes album of twenty-five caricatures in London.
1744	John Newbery starts to issue his *Little Pretty Pocket Books* in London.
1748	Word 'caricature' first recorded in English.
1752	Robert Dighton—1814.
1755	Philibert Louis Debucourt—1832.
1756?	Isaac Cruikshank—1811?
1756	Thomas Rowlandson—1827.
1757	James Gillray—1815.
1758	Carle Vernet—1836.
1761	Louis Leopold Boilly—1845.
,,	(May) John Almon's *Political Register*—first monthly magazine to feature satirical drawings.
1773	Printseller Matthew Darly holds first exhibition of caricatures in London.
1792	George Cruikshank—1878.
c1794	Robert Dighton introduces Ghezzi's *portraits chargés* to London.
1795	Senefelder invents lithographic process.
1799	David Claypoole Johnston—1865.
1803	Grandville (J. I. I. Gérard)—1847.
1804	Paul Gavarni (Suplice Chevalier)—1866.
1805	Henri Monnier—1877.
,,	Adolf Schrödter—1875.
1806	Charles Philipon—1862.
1808	Honoré Daumier—1879.
1812	Rowlandson's 'Dr. Syntax'—first cartoon strip character.
1817	John Leech—1864.
1820	John Tenniel—1914.
1822	Jemmy Catnach publishes his proto-comic 'The sprees of Tom and Jerry' in London.
1823	Charles Keene—1891.
1830	MacLean's Monthly Sheet of Caricatures.
,,	Philipon's weekly *Le Caricature*.
1831	'The American Comic Almanac'—first regular US satirical sheet.

1832	Gustave Doré—1883.
"	Philipon's daily *Charivari*.
"	Plateau invents the Phenakistoscope.
1834	George du Maurier—1896.
"	Horner invents the Daedalum or 'Wheel of Life'.
1838	Jaine's *Musée de la Caricature* contains pictorial satire from the fourteenth to the nineteenth century.
1838	Joseph Keepler Sr—1894.
1839	Introduction of black and white photography.
1840	Thomas Nast—1902.
"	André Gill—1885.
1840s	Rodolphe Töppfer's illustrated novels begin to appear.
1841	*Punch* founded.
1843	*Punch* (15 July) uses the word 'Cartoon' for the first time in the sense of satirical drawing.
1845	Adolf Oberländer—1923.
1847	Heinrich Hoffmann's *Struwwelpeter*.
1848	*Kladderadatsch* founded in Berlin.
1854	Harry Furniss—1925.
1855	Frank Leslie's *Illustrated Newspaper* founded in New York.
"	Melbourne *Punch*.
1858	'Caran d'Ache' (Emmanuel Poiré)—1909.
1859	Bernard Gillam—1896.
1861	*Kikeriki* founded in Vienna.
1864	Phil May—1903.
"	Edward Lear's first *Book of Nonsense*.
1865	Champfleury's *Histoire de la Caricature*.
"	Thomas Wright's *A History of Caricature and Grotesque in literature and art*.
"	Wilhelm Busch's 'Max and Moritz'.
1866	Art Young—1943.
1867	*New York Evening Telegram* first US daily to use cartoons on a regular basis.
"	Charles Dana Gibson—1944.
1868	*Vanity Fair* founded in London.

1872	Max Beerbohm—1956.
,,	William Heath Robinson—1944.
1873	Olaf Gulbransson—1958.
1875	Jacques Villon (Gaston Duchamp).
1876	Joseph Keppler founds *Puck*.
1880	Sydney *Bulletin* founded.
1881	James A. Wales founds *Judge*.
1882	Reynaud projects images from a Praxinoscope onto a screen at the Theatre Optique in Paris.
1883	*Life* founded.
,,	First Roll-film camera.
1884	*Ally Sloper's Half Holiday*, first British comic paper.
1885	'*Jack and Jill*—an illustrated weekly for Boys and Girls' published in London.
1887	H. M. Bateman—1969.
Early 1890s	Introduction of metal or 'Process' block.
1890	Harmsworth's *Comic Cuts* and *Illustrated Chips*.
1891	David Low—1963.
,,	Sidney Strube—1956.
1892	First US comic strip, Swinnerton's 'Little Bears and Tigers'.
1894	*Yellow Book* founded in London.
,,	*Le Rire* founded in Paris.
,,	James Thurber—1961.
1895	First cinema opened.
,,	Introduction of half-tone method of reproduction.
1896	*Simplicissimus* founded in Munich.
,,	Outcault's strip 'The Yellow Kid', first US colour strip.
1897	Rudolph Dirks' strip the 'Katzenjammer Kids'.
1901	Walt Disney—1966.
1902	Outcault's strip 'Buster Brown'.
1906	J. Stuart Blackton's 'Humorous Phases for Funny Faces'—first US animated cartoon.
1907	Budd Fisher's strip 'Mutt and Jeff'.
1910	George Herriman's strip 'Krazy Kat'.
1911-17	'The Masses'.

1913	George McManus' strip 'Bringing up Father'.
,,	Victor Weisz (Vicky)—1966.
,,	Harmsworth's *Rainbow* comic.
1915	Earl Hurd patents cel animation.
,,	Maurice and Jeanne Marechal found satirical weekly *Le canard enchainé* in Paris.
,,	'Teddy Tail', first British newspaper strip for children.
1916	Earliest of Gould and Harrison's 'Krazy Kat' films.
1917	Earliest of Pat Sullivan's 'Felix the cat' films.
1918	'The sinking of the Lusitania', first feature cartoon film.
1919	Art Young founds '*Good Morning*, the weekly burst of humor, satire and fun'.
,,	Billy de Beck's strip, 'Barney Google'.
,,	A. B. Payne's Pip, Squeak and Wilfrid strip in the *Mirror*.
,,	*Smith's Weekly* founded in Sydney.
1920	Term 'comic strip' first recorded in US.
1921	The first of Disney's 'Laugh-o-grams'.
1922	Horrabin's 'Dot and Carrie'—first British strip cartoon for adults.
,,	Soviet satirical paper, *Krokodil*, founded.
1923	Disney's first 'Alice in Cartoonland' films.
1924	Harold Gray's strip 'Little Orphan Annie'.
1925	Harold Ross founds the *New Yorker*.
,,	James Banck's 'Ginger Meggs' strip founded.
1928	Disney's first Mickey Mouse film, 'Steamboat Willie', first sound cartoon.
1929	'Skeleton Dance'—the first of Disney's 'Silly Symphonies'.
1930	First colour cartoon film, Disney's 'Flowers and Trees'.
,,	Pluto's first appearance in Mickey Mouse film 'The Chain Gang'.
,,	Chic Young's strip 'Blondie'.
1933	Max Fleischer's first 'Popeye' films.
1934	Al Capp's strip 'Li'l Abner'.
1935	US comic *New Fun* founded.
1937	Disney's first full length cartoon feature, 'Snow White'.
1938	Chuck Jones launches 'Bugs Bunny'.
1945	United Productions of America founded.

1949	UPA introduce 'Mr Magoo'.
,,	Wally Fawkes' strip 'Rufus' (later 'Flook') in *Daily Mail*.
1957	Hanna/Barbera studio founded.
,,	Reg Smythe's 'Andy Capp' in *Daily Mirror*.
1961	*Private Eye* founded in London.
1964	*Linus* magazine launched in Italy.
1968	*Smith's Weekly* revived in Australia.
1970	National Portrait Gallery in London holds 'Drawn and Quartered' exhibition of British newspaper cartoons.
,,	*Cyclops* ('the first English adult comic paper') founded.
,,	British edition of *Linus* magazine (Editor: Frank Dickens; art editor: Ralph Steadman) founded.
1971	Institute of Contemporary Arts in London holds a 'Celebration of Comics'—a retrospective exhibition tracing the evolution of the strip cartoon.
,,	(May) the new style tabloid *Daily Mail* inherits Stanley MacMurtry, topical cartoonist of the now defunct *Daily Sketch* and continues to carry such stalwarts from the old, broadsheet *Mail* as Wally Fawkes (Trog), Alex Graham and John Jones (Jon). The new *Mail* also features Charles Schulz's 'Peanuts' (formerly in the *Sketch*), single frame contributions by Bernard Cookson and vignettes by Haro Hodson.

Acknowledgements

I should like to thank my father for his help with the proof-checking, and my wife, Eileen, for long-sufferingly listening to—and offering advice about—all the many versions of this survey.

Index